Screen Sirens Scream!

Dedicated to our wives,
Donna Parla and Roberta Mitchell,
who also deserve full credit for this volume

Screen Sirens Scream!

Interviews with 20 Actresses from
Science Fiction, Horror, Film Noir
and Mystery Movies, 1930s to 1960s

by PAUL PARLA *and*
CHARLES P. MITCHELL

McFarland & Company, Inc., Publishers
Jefferson, North Carolina, and London

Library of Congress Cataloguing-in-Publication Data

Parla, Paul, 1955–
 Screen sirens scream! : interviews with 20 actresses from
science fiction, horror, film noir and mystery movies, 1930s to
1960s / by Paul Parla and Charles P. Mitchell.
 p. cm.
 Includes index.
 ISBN 0-7864-0701-8 (illustrated case binding : 50# alkaline paper)
 1. Motion picture actors and actresses—United States—
Interviews. 2. Actresses—United States—Interviews.
I. Mitchell, Charles P., 1949– II. Title.
PN1998.2 P375 2000
791.43'028'092273—dc21

 99-55379

British Library Cataloguing-in-Publication data are available

Manufactured in the United States of America

*McFarland & Company, Inc., Publishers
 Box 611, Jefferson, North Carolina 28640
 www.mcfarlandpub.com*

Contents

Preface . vii

1. RAMSAY AMES
 Reminiscences of the Doomed Ananka 3

2. CLAUDIA BARRETT
 Ro-Man's Mate . 13

3. JEAN BYRON
 The Byronic Heroine . 21

4. LINDA CHRISTIAN
 Mermaid Enchantress . 35

5. SANDY DESCHER
 Child Star and Space Child 47

6. FAITH DOMERGUE
 This Island Faith . 57

7. AMANDA DUFF
 Karloff's Screen Daughter 79

8. EVANGELINA ELIZONDO
Cinderella of Mexico 85

9. MARGARET FIELD
Meeting the Man from Planet X 93

10. MIMI GIBSON
Unleashing the Monster That Challenged the World 105

11. MARILYN HARRIS
Flower Girl from *Frankenstein* 115

12. KITTY DE HOYOS
Memoirs of a Lady Werewolf 123

13. DONNA MARTELL
Indian Princess and Space Commander 133

14. JOYCE MEADOWS
The Beauty and the Brain 143

15. MARY MURPHY
Wild One's Sweetheart 159

16. NOREEN NASH
Encountering the Phantom from Space 175

17. CYNTHIA PATRICK
Mole-Man Memories 189

18. PAULA RAYMOND
Pursuing the Beast from 20,000 Fathoms 197

19. JOAN TAYLOR
The Indian Maid vs. The Flying Saucers 213

20. JUNE WILKINSON
Defying Macumba Love 223

Index 239

PREFACE

There is a dramatic moment in *Murders in the Rue Morgue* (1932) when Bela Lugosi emerges from a coach to witness a brutal scene along the foggy banks of the Seine River in Paris. It is late at night, and Bela watches closely as two men fight with knives and a woman, played by Arlene Francis, stands by helplessly. Both men are finally killed in the struggle, and Lugosi slowly approaches the woman, his close-up filling the screen. "A lady in distress?" he asks with an eerie inflection in his voice. Here indeed was a damsel in distress, one of the first screen sirens to scream.

This book concentrates on many of the silver screen's damsels in distress, from the early thirties through the heyday of the drive-in films of the fifties and sixties. The 20 actresses interviewed in this book have all played women in peril. They have appeared in different genres, including science fiction, horror, *film noir* and mysteries. In these roles, they often battled giant monsters, alien invaders and other creatures. A few encountered the "classic" monsters like the Mummy or Dracula, while others faced the giant mutations who populated many of the films of the fifties. They also confronted murderers, juvenile delinquents, mobsters, and run-of-the-mill criminals. They faced desperados in the old west and future perils in outer space. Sometimes, too, these actresses faced a different type of distress behind the scenes. These were the days when just being a beautiful young starlet in Hollywood invited the attention of some less than honorable casting directors or producers. While facing all these perils, these actresses have entertained film lovers around the world for generations.

Some were only children when they faced their screen hazards. Others were romantic heroines, who sometimes alternated their leading lady performances with memorable portrayals as femmes fatales or scheming villains. Some were models who were offered the

opportunity to pursue a career in films and television. Still others were headline players in Mexican films, whose fame and notoriety crept north of the border when their films were dubbed in English or circulated on cable channels.

This book came to be written after my long association and friendship with Paul Parla and his wife, Donna. I have been a writer and professional librarian for many years. I knew the Parlas as enthusiastic film fans. Paul started to collect film memorabilia as a youngster and has assembled a magnificent and rare collection of international posters. When Paul and Donna moved to California, they began to encounter numerous celebrities from the films of the fifties. Paul did not consider himself a writer, merely a motion picture enthusiast. But he developed a knack for uncovering, meeting and befriending many little-known and interesting individuals from the film era he loved. Most of these people had never granted interviews. Some were rather reluctant at first, but Paul was able to win their confidence. That is how he persuaded some publicity-shy performers, such as the wonderful Faith Domergue, to talk about their careers. After an aborted attempt to work with another writer, Paul started to write his own articles with the help of Donna Parla.

Eventually, Paul approached me to conduct an interview with Sandy Descher, the little girl who confronted giant ants in *Them!* (1954). He also asked me to help rewrite many of his earlier interviews, and to develop new ones with him as well. We began to set up a cooperative routine that produced many wonderful interviews. You are holding in your hand the result of our collaboration.

Paul is very indebted to Donna, who helped him by setting appointments, asking questions during interviews, and providing general encouragement. Equally, I am indebted to my wife, Roberta, who has proofread and edited every word in this book. Her suggestions concerning style were priceless. She has also helped with the revision of a number of Paul's earlier pieces.

The following interviews are done in question-and-answer format from tape recordings. In some cases, when there was much reorganization of the material, the actresses have reviewed and approved the edited interviews.

A number of individuals helped us along the way, besides the patient and wonderful actresses themselves. These include Hector Argente, Don Bastien, Dr. William K. Bergman, Brian Bukantis, William Chadwick, Tony DiSalvo, Dennis Druktenis, Lee Gold, Skipper Johnson, Roger Karnbad, Bob King, John Marven, Ted Okuda, Ralph and Grace Parla, Fred Peralta, Martin Roddenberry, C. Robert Rotter, Brennan Salsbury, the Sanchez family, Jan Schray, Dr. Ron Schwartz, John Skillin, Bob Skotak, Jim Smeal, Michael Stein, Laureen Thompson, Samuel Torsiello, Alex Walker, Reginald Walker , and Mitchell Austin Wellington, as well as countless others along the way.

—Charles P. Mitchell
Fall 1999

THE INTERVIEWS

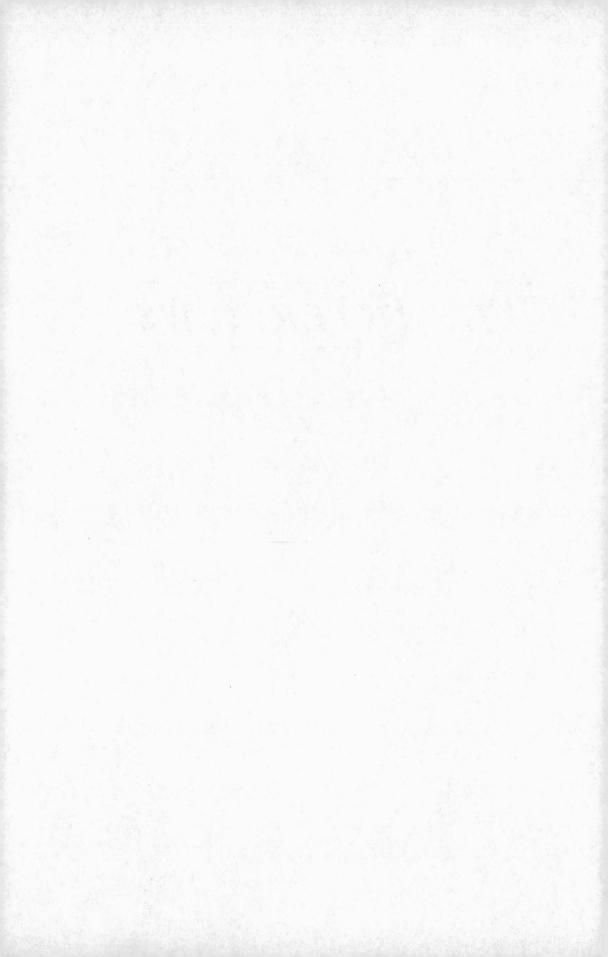

1

RAMSAY AMES

Reminiscences of the Doomed Ananka

As the beautiful woman reclines on her bed, a shadow streaks across the room. She rises as it passes over her, and in a trance-like state leaves the room. She is dressed in a flowing white nightgown, and as she emerges from the house, a black cat silently crosses her path. This is Amina Mansouri's first contact with the mummy, as he seeks out the tanna leaves brewed by the college professor in his study. Amina walks in a fog until she catches a glimpse of Kharis after he kills the professor. She then faints and falls to the ground. Amina is played by Ramsay Ames and Kharis by Lon Chaney in *The Mummy's Ghost* (1944).

Universal's mummy films about Kharis are much beloved by fans, even though the plots are illogical and some-

times lack continuity. Consider the time frame of the plots for a moment. The action of the first film *The Mummy's Hand* (1940) occurs in 1941 according to a telegram seen in the film. The next two films *The Mummy's Tomb* (1942) and *The Mummy's Ghost* (1944) take place 30 years after the first film. That would set the action of these films in 1971. (Perhaps the viewers are expected to believe the action of the first film occurred in 1912, despite the cars and the references to the discovery of the tomb of Tutankamen). The final film, *The Mummy's Curse* (1944) then is set another 25 years later, apparently in 1996! Even more amazing, Kharis and Ananka had sunk in a swamp in Massachusetts, only to emerge from another swamp in Louisiana.

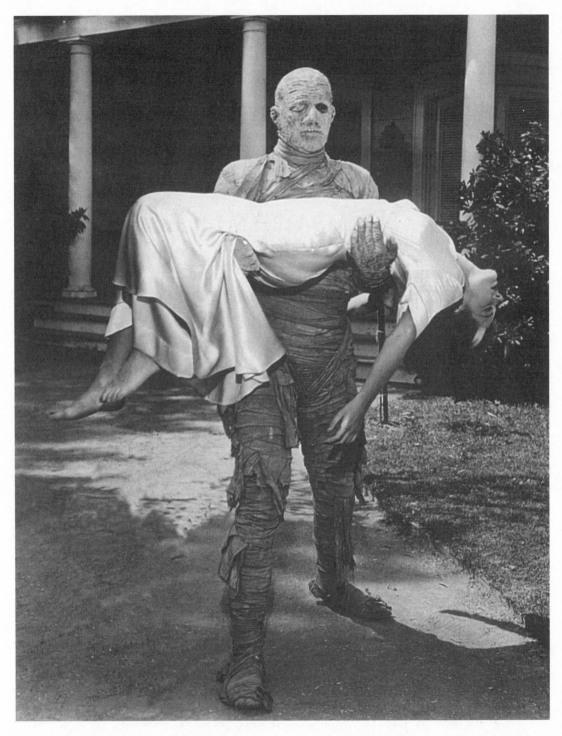

"I was afraid Lon would slip and land us both in the lake." Ramsey Ames and Lon Chaney, Jr., in *The Mummy's Ghost* (1944).

Still, these films have a charm and spirit despite their wacky plotlines. Part of the reason lies in the appeal of the four actresses who played heroines in these pictures: Peggy Moran (*The Mummy's Hand*), Elyse Knox (*The Mummy's Tomb*), Ramsay Ames (*The Mummy's Ghost*) and Virginia Christine (*The Mummy's Curse*). They each had a certain piquancy which heroines seldom display in horror films. Only Ames and Christine played Ananka. The Ananka seen in flashbacks in *The Mummy's Hand* was actually Zita Johann from the earlier version of *The Mummy* (1932), who played Anck-es-en-Amon. Finally, Ramsay Ames is unique in her performance as the only Universal heroine who was completely and unalterably possessed. Her transformation was externally noted by her change in hair color, from brunette to pure white. In no other film of this era does the heroine face such a tragic fate as Amina Mansouri. She not only loses her personality, but dies at the film's climax. In her last scene, she has aged thousands of years. Perhaps the fate of the doomed Ananka was inspired by the scene in *Lost Horizon* (1937) where the girl Maria reverts to her real age after she leaves Shangri-La. That ending, however, was foreshadowed throughout the last third of the film. In *The Mummy's Ghost*, the conclusion comes as a complete surprise.

Ramsay Ames is remembered for succeeding in this difficult role. But she has shied away from publicity for years, and finally consented to this brief interview. She was born Ramsay Philips in New York City and attended the Edgewood Park School in Briarcliff Manor. Ramsay also went to the Walter Hillhouse School in Briarcliff Manor. She also went to the Walter Hillhouse School of Dance where she specialized in Latin-style dancing. She quickly gained fame and popularity in the nightclub circuit in both New York and Florida as a singer and a key member of a popular rhumba band. Her fiery and spirited performance made her a headliner in such café establishments as "The Stock Club," "La Conga" and "The Beach-comber." She also was a member of a dance team billed as "Ramsay Del Rico." Ramsay modeled as well, and was part of the Eastman Kodak Company's fashion show at the New York World's Fair in 1939.

Q: How did you break into the motion picture industry?

AMES: Well, as you know, I was a dancer. Then I had hurt my back. I was at the airport in New York leaving for California to be with my mother, who was very ill at the time. I met Harry Cohn from Columbia Pictures, and we got talking. He told me to come see him when I got to Los Angeles.

Q: This chance meeting led to your film career?

AMES: Yes. I was finally able to see Harry Cohn, and I did a screen test. Afterwards, I made my first film, *Two Senoritas from Chicago* [1943].

Two Senoritas from Chicago was a musical vehicle for comedienne Joan Davis. She played a producer scheming to put on a show, unaware that the prop-

erty was stolen from the original author. Jinx Falkenburg and Ann Savage rounded out the cast. The film was in part a sequel to an earlier Davis film *Two Latinos From Manhattan* (1942).

Ramsay's next picture was *The Mummy's Ghost* which was filmed during the summer of 1943. Interestingly, Ramsay was not in the cast when the film began shooting. The role of Amina Mansouri was originally to be played by Acquanetta. The part called for an actress with exotic allure. Though she was promoted as "the Venezuelan Volcano," Acquanetta was actually part–Arapaho Indian. On the first day of shooting, when Amina passes out, Acquanetta was knocked unconscious when her head hit a rock. She assumed the rock was papier-mâché. It wasn't. She suffered a slight concussion and broke a small bone in her elbow. Producer Ben Pivar, who was considering Ramsay Ames for a future role, quickly drafted her as the new Amina.

Q: What do you recall about *The Mummy's Ghost*?

AMES: The Mummy film was a lot of fun, and Reginald LeBorg [the director] was real easy and pleasant to work with.

Q: Any outstanding memories of working with John Carradine?

AMES: John Carradine was especially nice. As you know, he played the villain in *The Mummy's Ghost*, and he was always saying or doing something hilarious during filming. In the scene where Lon captures me and I'm lying on this table, Carradine says to me, "I

am going to make you immortal!" Carradine would change the line slightly to make it sound quite comical. We would have to stop shooting for an hour or so because we would be laughing so much. He would do little funny things like this and make us laugh a lot. He was great to work with.

Q: Any recollections of Lon Chaney as the mummy?

AMES: There were a few incidents pertaining to Lon Chaney while making *The Mummy's Ghost* that I'd rather not discuss. Overall he was a nice guy to work with. We had a lot of fun. I remember one scene I did with Lon Chaney, and that was the shot where he is carrying me down to the lake. I remember the ground had been wet and slippery, and I was petrified hoping Lon wouldn't trip, landing both of us in the lake. Lon was very nice, but he did have his problems.

Director Reginald LeBorg concentrated on filming Chaney's scenes before two o'clock. He learned that Lon's problem with alcohol made late afternoon work difficult. Chaney did not use a double in the film, and wearing the mummy costume in the summer was grueling. LeBorg teased Chaney, saying in their next picture he could play a refined gentleman. Their next film turned out to be *Calling Dr. Death* (1943), the first of Universal's Inner Sanctum series which reunited LeBorg, Chaney and Ames. Lon Chaney indeed played an elegant dresser in this film as Dr. Steele. Ramsay played his unfaith-

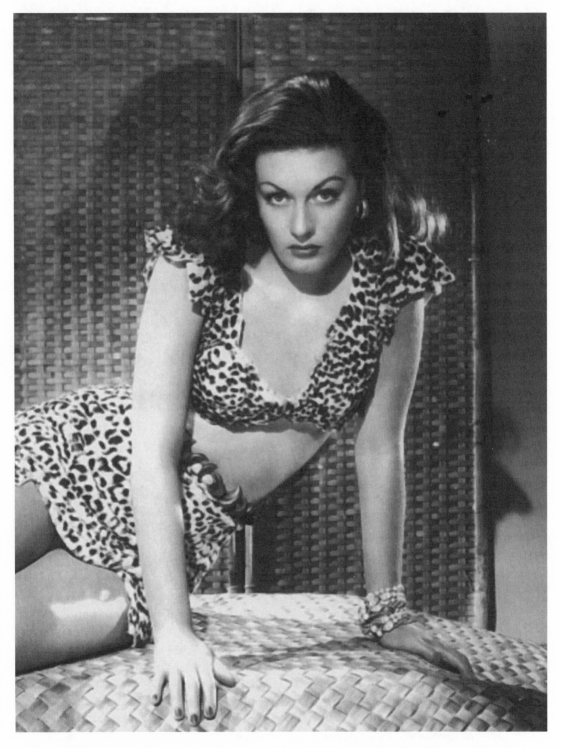

This 1942 publicity pose perhaps best defines Ramsay Ames' striking beauty.

The late Ramsay Ames in a 1990 studio pose.

ful wife, Maria Steele, who is bludgeoned to death with a poker. Chaney was a prime suspect for the murder, and J. Carrol Naish took the part of Inspector Gregg. The guilty party is finally revealed to be the doctor's nurse, played by Patricia Morison. The role had originally been intended for Gale Sondergaard.

Q: What stands out in you mind about *Calling Dr. Death*?

AMES: I absolutely adored J. Carrol Naish. He taught me a lot. He would always say that you can't carry a scene by yourself. You always need a good actor to bounce off. Naish taught me about what I needed to know to pursue an acting career. I really enjoyed all the films I did.

Q: What do you remember about working with Maria Montez in *Ali Baba and the Forty Thieves* [1944]?

AMES: [laughing] God, everything! Maria thought she was a princess. You know, she was quite gorgeous. She would walk into the studio commissary at midday and if everybody didn't turn around to look at her, she would walk back outside two or three times until she felt she could go back in and know everyone was looking at her! She was also a very funny woman without realizing it. I remember one day after lunch, they were about to film some

scenes with her. There she was in front of a mirror, and suddenly she yells, "Everyone, Stop! Stop!" So we all looked at one another and wondered, "What now?" Maria stands up and says, "I'm tired. My skin is tired and my pimples are showing, so I'm going home until tomorrow!" Arthur Lubin was the director, God bless him. He was a doll, and he used to call me "Miss Angel." After this incident with Maria, he called me over and said, "Let's do some close-ups with you." So that entire afternoon Lubin shot my close-ups instead of Maria Montez.

Q: What other pictures stand out in your mind?

AMES: I did a number of the *Cisco Kid* westerns with Gilbert Roland. He was so wonderful with all of us, because instead of playing "the big star," Gilbert would get us all together and work with us as a team. He would always say, "Although it is my film, a film is only as good as everyone in it." He was a doll.

Q: These films were *The Gay Caballero* [1946] and *Beauty and the Bandit* [1946]. Your work in the second film was cited as outstanding by many critics. In his guide to Western films, Michael Pitts wrote: "This film is greatly helped by the presence of the luscious Ramsay Ames as a female Robin Hood." Any memories of shooting the action scenes in this film?

AMES: One other gentleman I adored was director Bill Nye who did *Beauty and the Bandit*. Again, at this time I was very young and I had to ride a horse bareback down a very hilly slope. I had a wonderful double in this scene [Polly Burson] and she took me out riding. I said to her, "You know I'm a dancer and I'm not going to get sore muscles." She replied, "Honey, you're going to use muscles you have never used before!" Well, the first time I did this scene on the horse bareback, there were lots of trees in my way on this path, and all I could do was keep ducking and dodging the branches. Polly would yell to me, "Just grip the horse's side with your knees and hang on for dear life!" By the time we got down to the bottom of the hill, Bill Nye was standing there laughing as he yelled, "Cut!" He said I looked petrified, and he thought we should re-do the shot.

Q: Some of your other films include *Too Young to Know* [1945], *Below the Deadline* [1946], *Philo Vance Returns* [1947] and *Green Dolphin Street* [1947] with Lana Turner. Does anything come to mind about these films?

AMES: On *Green Dolphin Street*, my scenes were quite brief, and I didn't actually work with Lana Turner at all, so my memories of this film are brief. Much of these times (doing these films) were quite pleasant.

Ramsay Ames also made a positive impression in the serial *G-Men Never Forget* (1948), one of the cleverest and most entertaining serials from the late forties. Roy Barcroft played an unusual double role as both the hero, police commissioner Cameron and the arch villain Vic Murkland. Clayton Moore

played the action hero, G-Man Ted O'Hara, and Ramsay played Sergeant Frances Blake. Barcroft was outstanding in this plot, not only as Cameron and Murkland, but as Murkland imitating Cameron. The part of Frances Blake was not a stand-by part either, as she was not only fully involved in the action, but one of the most intelligent heroines to appear in the serials.

After this period of her career, Ramsay moved to Spain for a period of 18 years. She appeared in a number of foreign films and international productions such as *Alexander the Great* (1956) with Richard Burton. Ramsay also had her own television show in Madrid which included interviews with celebrities.

Q: Which guest on your television program made the greatest impression on you?

AMES: Sophia Loren. I had hoped to have Sophia as an interviewed guest on my show, and I was very much looking forward to seeing her. Sophia and her husband Carlo (Ponti, the famous producer) were staying at a lovely duplex in Madrid to which I was invited. Suddenly, I heard a loud scream (after my arrival) and I said, "God, what happened?" People were rushing around, so my television crew and I rushed over to see what happened. Sophia had fallen down a flight of steps and had broken her shoulder. So I sent some flowers to the hospital, and called her a few days later to see how she was feeling. She told me, in all her pain and discomfort, that Carlo was rushing her back to Rome, but that I could come to Rome anytime and interview her there. I thought that

was just a wonderful thing to do. Well, I couldn't get away because I had eight shows a week that I was responsible for, but she said that I could send my questions, and she would tape her answers for me, which she did. Aside from this, Sophia had such charm and elegance about her that you couldn't help being touched. She's a wonderful person. She didn't have to do this for me, especially in her condition. That's truly the kind of person she is, very obliging even during a most trying time.

Q: What are some of your interests today?

AMES: You know, I love animals and work with them often nowadays. The work that I have done to help sick, wounded and homeless animals has given me such pleasure and happiness. This is something I cherish and want others to know.

Q: Any final thoughts about your show business career?

AMES: It is part of my life that I have left behind, and rarely reflect on since there are much more important things going on in my life now. It does feel good, however, to know that one's best efforts have been recognized and continue to be enjoyed by so many people so many years later. This is what we all strive for. I thank you yet again, and all of my admirers, for letting me know of this seemingly unending devotion.

Maybe there is some sense after all in the wacky timeline of the mummy films,

because these quickly done World War Two era films are still so remembered. They are also showcased on video. The image of the doomed Ananka reaches down the years to many viewers today. As John Carradine intoned as Yousef Bey in *The Mummy's Ghost,* she and Kharis have become immortal.

Ramsay Ames, a true talent and an eternal beauty, passed away on March 30, 1998.

2

Claudia Barrett

Ro-Man's Mate

One of the wackiest but most fondly remembered "Z" budget science fiction pictures of the Fifties is Phil Tucker's *Robot Monster* (1953). Fans particularly enjoy the escapades of Ro-man (obviously short for Robot Man), the emotionally confused alien invader in the film. Sent to our planet to kill and destroy, Ro-Man (actor/stuntman George Barrows wearing a gorilla suit and a diving helmet!) gets all fluttery with "human" feelings after meeting a pretty earthling girl named Alice, played by Claudia Barrett. Despite, or perhaps because of its impoverished budget, hollow production values and quirky visuals, *Robot Monster* stands alone as a mutant gem of sci-fi camp.

Claudia Barrett, however, still enjoys being remembered as Ro-Man's "femme fatale." In this interview, she recalls working on the film and her career in general.

Q: How did you begin your acting career?

BARRETT: As a child, I was very shy and my mother decided to give me acting lessons. A wonderful woman by the name of Harriet Hold was my teacher for twelve years. She had studied with a man who had worked with Konstantin Stanislavsky. We used his book, *An Actor Prepares*, as a text book. During these early years, I did many children's plays, monologues, pantomimes and musical readings for various clubs and programs. I studied

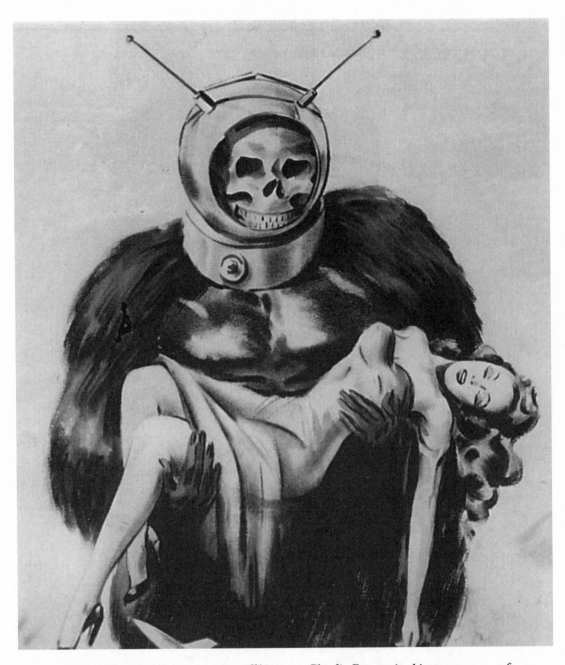

George "Ro-Man" Barrows carries off his mate, Claudia Barrett, in this rare poster art from 1953's *Robot Monster*.

acting at the Pasadena Playhouse School of Theater for one year before I had a screen test at Warner Brothers in 1949. I did a scene from *I Remember Mama*, and it turned out pretty well. The studio liked my test enough to give me a contract, and I had a fun year at Warner Brothers.

Q: Did you like being a contract player?

BARRETT: Yes. The publicity

department used contract players for promotional purposes, placing articles in movie magazines and newspapers. At the time, Harry Lewis (of Hamburger Hamlet restaurant fame) and Debbie Reynolds were at Warners. We all went on-call modeling bathing suits at the pool of the Beverly Wilshire Hotel. Contract players were also used during screen tests for actual motion pictures. I can't remember the name of the movie, but I played Bette Davis's role for a screen test opposite David Brian. They dubbed me "Test Pilot" because I made so many screen tests playing the starring role opposite various people up for roles in the movies.

Q: What was your own first part in a film?

BARRETT: My first role was a scene opposite Humphrey Bogart in *Chain Lightning* [1950]. I also made *The Great Jewel Robbery* [1950] with David Brian. He played a master jewel thief and I was his girlfriend.

Q: How did your career develop after you left Warners?

BARRETT: A large part of my career was acting in television, both filmed shows and live broadcasts. At CBS I played opposite Gil Stratton and Eddie Mayehoff on a show called *That's My Boy*, based on the 1951 Martin and Lewis comedy. I did several *Hallmark Hall of Fame* programs. On one, I played Mrs. John Wanamaker opposite Peter Graves. NBC gave me six-inch platform shoes so I didn't drop out of view when the camera was on Peter. Then I played Mrs. Oliver Wendell Holmes. I also played Mrs. Alexander Graham Bell with Peter Hanson. Mrs. Bell was deaf, so this role was a challenge for me.

Q: Did you ever have problems doing early television, either with cast members or the crew?

BARRETT: The people I worked with were interesting and fun. I had very few unpleasant experiences. On one program, though, I had a difficult time. The assistant directors seemed to rush me during wardrobe changes and makeup calls. I developed laryngitis and could hardly talk. On the last day of shooting, I was just whispering. When I saw the show, I was surprised at how sexy my voice sounded. I made a note of that for future use. On another television show, *Man with a Camera* [1958–1960] starring Charles Bronson, my voice didn't quite work out. The producer decided I should use a Southern accent. I never tried a Southern accent before, and it was pretty funny. I don't think I'd try that again unless I had a great deal of coaching.

Q: You also appeared in a number of Western films and television shows. Could you share some of your recollections about them?

BARRETT: I made several Westerns at the old Republic Studios. I loved horseback riding, and riding on stagecoaches and buckboards. Most of the costumes were rented from Western Costume, then fitted to the person wearing them at the moment. Adele

Claudia Barrett, ever the beauty, looks offstage in this publicity shot.

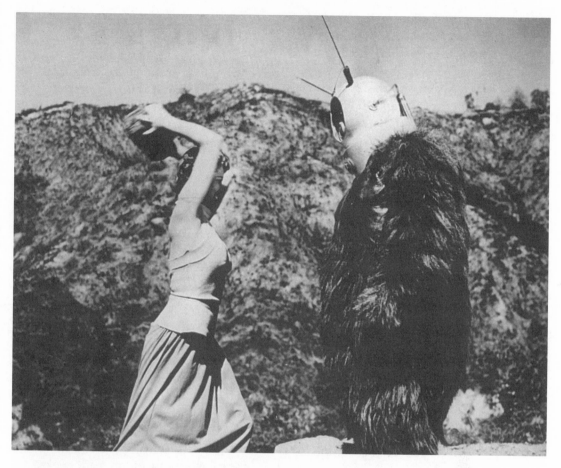

Claudia clobbers Ro-Man, the late George Barrows.

Palmer, the costume designer, said my figure was perfect for period clothes.

Q: Did you particularly enjoy Westerns?

BARRETT: Yes, Westerns are fun to make. When you're in costume, you feel like you're a child again, playing cowboys and Indians. A lot of Western movies and television shows were shot in Sonora, California, which is part of the mother lode country. It's a quaint little town with a country church and a few old buildings. They shot the series *Wells Fargo* [1957–62] there. I got to ride on a horse and in a stagecoach on that show, which was a lot of fun. It's a wonder to watch a good rider race across the hills. Dale Robertson was beautiful to watch. He and his horse blended into a single entity when he rode. I later worked together with Dale on an episode of *The Loretta Young Show* [1953–61] called "Flowers for Jenny." It was a story Dale had purchased some time before about a cowboy and a schoolteacher.

Q: Any feature film stand out in your mind?

BARRETT: *Rustlers On Horseback* [Republic 1950], starring Allan "Rocky" Lane, was one interesting Western. One of the co-stars was George Nader, who was a nice young man and easy to work with. We later co-starred in *Robot Monster* and he was still very easy and pleasant.

Q: Speaking of *Robot Monster*, how were you cast for the film?

BARRETT: I met director Phil Tucker at the first interview. Al Zimbalist was the producer. Mr. Zimbalist had me read for the part. I'm not sure, but I think Mr. Tucker read with me, playing the other parts. They both liked me and decided to use me as Alice. The picture was low-low-low budget and my agent at the time was not too pleased that I decided to take the part. But I was an actress and I just wanted to act.

Q: What do you recall about the others on the film?

BARRETT: Most of the cast was very good. Selena Royle played my mother. She was a dear and very fine actress. The wardrobe woman took Selena and me out shopping for our costumes. We went to Orbach's on the corner of Fairfax and Wilshire Boulevard, where we walked around looking at various clothes. Then we tried on gold felt vests to go over the nightgowns they had purchased for us to wear. I had a pair of gold high heels which I wore throughout the dream sequences. When the picture was first shot, there were no dream sequences. That came later.

Q: Where was *Robot Monster* filmed?

BARRETT: The family home scenes were shot near Dodger Stadium. There was an area that was being renovated for a low-cost housing project. Some walls or dividers remained and were used to separate our living quarters from the outside area. The ground was very rough and uneven. It was difficult to walk, especially in those gold high heels. The cave scenes were shot in Bronson Canyon, near the edge of the Hollywood Hills.

Q: What kind of director was Phil Tucker?

BARRETT: It was my understanding that Mr. Tucker was a first-time director. He was not familiar with camera techniques. However, since this was a 3-D picture, we had two cinematographers. They were both seasoned directors of photography and they helped direct. The scene where George Barrows [Ro-Man] is carrying me off to his cave was a case of too many cooks. Mr. Tucker gave me directions, then one cinematographer also gave me directions, and then the second cinematographer gave me conflicting directions. It really made things difficult. I was supposed to be screaming and beating on Ro-Man but after we took the long shot, Tucker got the idea I should try to seduce Ro-Man to find out his secrets. The finished scene is a bit confusing.

Q: What do you recall of Ro-Man?

BARRETT: George Barrows was a Hollywood stuntman who owned his own gorilla costume. I'm not sure

where they came up with the sea diver's helmet. It was quite a costume. George was big and strong. He made a good Ro-Man. He was easy-going, and I felt perfectly safe in his arms. Running up and down those hills, George could have dropped me several times. Fortunately, he didn't.

Q: Did you see the movie when it opened?

BARRETT: Yes. *Robot Monster* opened without fanfare at the Paramount Theater on Hollywood Boulevard. It was in 3-D, so everybody had to wear those funny glasses. My husband and I sat directly in front of Phil Tucker. When the love scene came on, Tucker teased my husband about the problem he had getting me to kiss George Nader. But both my husband and I enjoyed the film.

Q: The picture now has a reputation as one of the most entertaining "so-bad-it's-good" films. What do you think about that?

BARRETT: One Christmas my niece gave me a book that listed *Robot Monster* among the worst movies of all time. At first I wasn't too happy about that. Recently I saw it again on television. The film had a wrap-around skit which showed the outside of a movie theater, and a couple going to the movies. They had some funny lines about Ro-Man, the wedding scene and Ro-Man ripping my vest off. I laughed through the entire movie. It was tremendously funny. It's too bad the original producer and director didn't have a good sense of humor.

Q: Any final thoughts about the film?

BARRETT: When you decide to make a movie, the decision is made for various reasons: money, fame, or working with a particular star or director. I just wanted to act. I was a professional actress for 14 years, and I really loved the business. And *Robot Monster* was a movie I enjoyed making.

3

JEAN BYRON

The Byronic Heroine

The scientists in the hidden laboratory faced a dilemma at the climax of *Invisible Invaders* (1959). They had developed a weapon which could destroy the aliens, but their radio signal was jammed and they couldn't get the word out to the military. The hidden fortress was surrounded by the living dead, whose bodies were controlled by the invaders. "We'll crash our way through," suggests Major Jay, their military liaison. It would be up to Phyllis Penner to drive the truck through this horde of zombies, since both Dr. LaMont and Major Jay were needed to operate the sonic gun. At this moment, she becomes a key heroine in this battle to preserve humanity and overcome the invaders. This heroine is played by Jean Byron,

helping John Agar as Major Jay and Robert Hutton as Dr. LaMont. Saving the world was a unique highlight in the career of this actress.

Jean Byron (later billed as "Jeane" Byron) had a number of interesting moments before the camera. She braved the perils of the jungle with Johnny Weissmuller, was lady-in-waiting to Cleopatra and lent support to Richard Carlson as he battled the magnetic monster. On television, she taught Dobie Gillis, and helped raise Patty Duke. She was noted for her professional poise and demeanor, and had once delivered a live commercial moments after having her evening gown go up in flames. Jean was very happy to share her memories in the following interview.

Jean Byron in a somber publicity shot for *The Invisible Invaders.*

Q: Where were you born?

BYRON: I was born Jean Burkhart in Paducah, Kentucky. I left there when I was fairly young, and I went to Los Angeles when I was 19.

Q: How did you acquire the name Jean Byron? Was it inspired at all by Lord Byron?

BYRON: I was working as a singer with January Savitt's orchestra, and Jan asked me what name I wanted to use. I said, "Why not my own?" But he said, "You don't want to do that." So I said, "Well, anything starting with a 'B' then." The man looked across at the office and saw his friend Dave Shelley. That made him think of Lord Byron, so he said, "How about Jean Byron?"

Q: Why did you decide to keep the name when you started acting?

BYRON: I used it when I got my Screen Actor's Guild card because it was handy. I never intended to keep it, and I always thought I would change it. Much later I changed the spelling of my first name from "Jean" to "Jeane" because of a suggestion by a friend who was deep into numerology. I didn't believe in it, but I like the spelling. It was the same way Jeane Dixon spelled it.

Q: When did that come about?

BYRON: Sometime in the early seventies. Most of my film and television credits are as "Jean" Byron.

Q: How did you get started in show business?

BYRON: Like so many young girls, I started taking dancing lessons when I

was very young. I also fell in love with movies, particularly those starring Astaire and Rogers. So I wanted to become a dancer. I got a bird's eye view of professional theater when the Schuberts came to town to do some light opera. Freddie De Cordova was part of the staff. They chose me and some other kids from the dancing school for the chorus. I learned the life of a dancer was very hard. I saw it was preferable to be a singer. The principal players, of course, made the best money. John Schubert Jr. told the dance director Carl Randall, "Put her in the middle of the chorus line." He probably felt sorry for me because Randall was always on my case when the choreography called for ballet, especially point work. I had never been "on toe" before in my life. There was one time where we performed the cakewalk, and Freddie De Cordova said to me, "You were very good." It thrilled me, and I never forgot it. Years later, Freddie became the producer of *The Tonight Show* with Johnny Carson. That was my start.

Q: When did you first get to Hollywood?

BYRON: I almost got a contract when I was thirteen back in 1939. Jesse Lasky came to town with his radio show called *Gateway To Hollywood* and I won the local show. My mother and I went to California for the semifinals. I did a scene on the radio with Cary Grant. I was in shock. I just kept thinking how great he was in *Gunga Din* [1939].

Q: How did he treat you?

BYRON: It all went by too quickly. It was very professional. When Grant showed up at the radio show, he came directly from the studio. He was still in make-up. We had some conversation, but I was too much in shock to remember anything. I asked him for his autograph. There was no table, so he asked me to turn around, and he wrote it using my back. He was so charming.

Q: Did you win the contest?

BYRON: No, Gale Storm won, but I had made a good impression. There was some interest in me. They gave me a tour of the studios. I met Chester Morris and George Sanders there. I remember Sanders looking down at me with a dour expression. I even saw Lucille Ball at that time, and she looked gorgeous.

Q: Who impressed you most?

BYRON: I was on the RKO lot when we ran into this most attractive man. His eyes were just glowing. After he passed, I asked who he was. "That's Orson Welles," they told me. "He's shooting a picture here called *Citizen Kane* [1941]." He made such an impression on me. Seeing him was the highlight of my trip. Anyway, my mother and I talked it over, and we decided it was best for me to finish my education. Then I could pursue a career.

Q: How did World War Two affect your plans?

BYRON: After Pearl Harbor, my father was drafted. He was in his forties. Mother got a job, and I started

singing evenings in a nightclub while still going to school by day. It really was a high class bar. There was a platform behind the bar with three musicians and myself. It was good training. When my father got out of the army after the war, we moved to Los Angeles. The Ben Bard Players gave me a scholarship because they were looking for women performers. They had a lot of men studying there because of the G.I. bill. I just absolutely adored it. I couldn't get enough of it, but I worked like a dog.

Q: How did you get into motion pictures?

BYRON: I had a very good part at the "Player's Ring" and one of the guys in the show was Larry Stewart. His father was a casting director for Sam Katzman Productions, which was operating out of Columbia Studios. After his father came to the theater to see the play, he sent me a message to come and see him. He was casting a film called *Voodoo Tiger* and I was offered the female lead. It was one of the Jungle Jim series with Johnny Weissmuller. He was a darling man. The picture was simply hysterical.

Q: What stands out most in your mind about *Voodoo Tiger* [1952]?

BYRON: There was this seven year old chimp that I carried around on my hip. The chimp was very gentle, and she was called Tamba. I played an English lady with an accent who comes to the jungle in search of stolen art treasures. The Nazis stole some art treasures from France and hid them in the jungle. Some gangsters were also

after the treasure, and headhunters were also around. My next film was *Magnetic Monster* [1953].

Q: That was a most unusual film. It was evidently influenced by *Dragnet* [1952–1970] except with scientists instead of detectives. You really looked wonderful in that film.

BYRON: You know, I made that in one day. I played Richard Carlson's wife, so you got to see a little of his home life. He kept getting called off to deal with this threat, the element that became the magnetic monster. They used a lot of impressive old footage from a German film.

Q: That was *Gold* [1934], which starred Brigitte Helm. The effects were really quite good.

BYRON: Well they spliced it together and that became the climax.

Q: Your character was pregnant in the film, and Richard Carlson kept complaining you were too thin.

BYRON: He kept trying to feed me white bread and all these high fat foods. It's just the opposite of what you should eat. So the scientist pushing this diet seems rather funny today.

Q: What do you recall about *Serpent of the Nile* [1953]?

BYRON: That was also for Sam Katzman. He used all the old sets from the Rita Hayworth film *Salome* [1953]. Those sets were really beautiful. Rhonda Fleming played Cleopatra and Raymond Burr played Marc Antony. Rhonda was a very nice lady,

and the prettiest girl I had ever seen. I played Charmain, her handmaiden. I saw this film about three years ago, and the thing that impressed me most was my belly. [*laughs*] . I had a wonderful costume on, and they weren't supposed to photograph my naked belly. You were supposed to wear a belt or something. Leonard Katzman was the assistant director, and he was a very nice man. He was the nephew of Sam Katzman. The director was William Castle.

Q: What do you recall of William Castle?

BYRON: He was kind of hard to work with. He was so wired: he worked fast, he talked fast, he moved fast. Of course I didn't know anything about high blood pressure then, but there was something about him that made me uneasy. I felt subconsciously that he wasn't taking good care of himself. I prefer a calmer director like Arthur Hiller.

Q: When did you work with Hiller?

BYRON: It was on a very early NBC television series called *Matinee Theatre*, and it was wonderful. I had such fun doing it. It was at NBC in Burbank and was produced by Al McCleary. They did five of them a week, and they were individual dramas, one hour long. Arthur Hiller was calm, quiet and he knew exactly what he wanted. He never told you what to do. He took what you had and very gently focused it. It was such a joy to work with him. I'm sorry I never had a chance to work with him again after that program.

Q: Did you do a lot of television?

BYRON: Oh, yes, and many commercials too. I almost died doing one show. It was a quiz show called *Can Do* from CBS in New York, and the host was Robert Alda. It was a live show for Revlon, and opening night was November 26, 1956. Just before air time, my gown exploded. It was an expensive gown that was imported and not flame retardant. It was a strapless, beaded gown with a tight crepe skirt under a larger tulle skirt that went down to the floor. I am a very, very lucky lady, because I also had long hair. I was in the dressing room for a touch-up on my hair. There was very little space in there. The technical director came to the door and said, "One minute to airtime!" One of the account execs was with him. I put down my cigarette and started walking towards them. The technical director was going to usher me toward my marker where I was to open the show saying, "Good evening. I'm Jean Byron. Welcome to *Can Do*." The camera's first position was way back to see the gown. They wanted a shot of me sitting on a bench before they dollied in. Anyway, as I got to the door, the tulle skirt just exploded. I guess it was a spark from the cigarette. They grabbed me to pull it off. They tore this stinking black mess off me, just leaving the slip. Not a word was spoken, not from the hairdresser or the crew. I went over to the bench. The cameraman took one look at me, and dollied in for an above-the-waist shot. Just then the red light went on, and I said, "Good evening, I'm Jean Byron…"

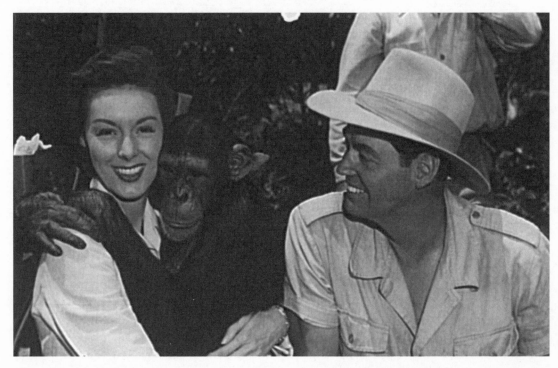

Jean Byron hugs Tamba as a smiling Johnny Weissmuller looks on behind the scenes on *Voodoo Tiger* **(1952).**

Q: You must have been on automatic pilot.

BYRON: I was. I had no idea how I got through it. The adrenaline was so strong, and I didn't have time for a delayed reaction. You know, the producers never so much as acknowledged what happened. Nowadays, everyone would be thinking lawsuit, but that thought never crossed my mind. It probably was against the law to import the fabric used in the gown. *Can Do* also turned out to be a bomb, and the program lasted six weeks.

Q: You also were the "Lux" girl in the late fifties.

BYRON: Yes, I hadn't had a vacation in a long time, and I was in New York just enjoying myself, going to the theater and seeing the sights. Then I got a call from J. W. Thompson who asked, "Would you be interested in doing some commercials for Lux soap?" So I made an appointment to do a test, and he gave me three scripts. There were a group of observers there, men in black suits to whom I was introduced, and that should have tipped me off that they were having difficulties finding someone. So I chatted with the director and then did two takes of each script, one in color and one in black and white. The director printed six consecutive commercials, each one on the first take. They were very impressed. By the time I got home, the phone was ringing with an offer for me to be the "Lux"

Magnetic attraction: Jean Byron and Richard Carlson in *The Magnetic Monster* **(1952).**

spokesperson. This was for the *Rose-mary Clooney Show* [1957–58] on NBC, and I also did *The Lux Play-house* [1958–59]. Years earlier, I did *Lux Video Theater* [1950–57]. That was in 1952 and 1953. I worked with Thomas Mitchell at that time, who was such an incredibly nice individual. I was having a little bit of trouble with one scene, and he helped me out. He just knew how to handle it.

Q: Did you work with any of the great TV comedians?

BYRON: In the real early days of

television, I worked with Ed Wynn. I remember we did one crazy sketch where I had to stand on my head. Of course, I could do it, but when I straightened up, I acted a little dizzy. "Oh no!" Ed exclaimed. "Don't do that! When you stand up, don't do anything!" So I said, "O.K." He seemed worried about anything that detracted the spotlight from him, but I also learned something about comedy timing from him.

Q: You appeared on a lot of television shows. Which ones come to mind?

BYRON: There were so many I couldn't keep track of them. There was *Cheyenne* [1955–63] with Clint Walker. I enjoyed working with him very much. There was *Laramie* [1959–63] and I was also on *Batman* [1966–68]. I was on a lot of anthology shows such as *Studio 57* [1954–55] and *Science Fiction Theater* [1955–57]. Then there was that series with Rod Serling.

Q: *The Twilight Zone?*

BYRON: Yes, and then I was in the original pilot for *Columbo* with Peter Falk in 1971.

Q: Tell us about your two famous television series. When did you sign for *The Many Loves of Dobie Gillis?*

BYRON: That was in 1959. I played Ruth Adams, the high school teacher. That show had a really good cast. Dwayne Hickman was wonderful. He was a real peach. The last time I saw him was shortly before I left Los Angeles, when he came to see a play I was doing. His brother Darryl was on the show for awhile too, and he was a nice guy. The careers of some of the people from the first season really took off. There was Ron Howard, for example. He was just a kid, but he was very poised and rather nice. Today he is one of our leading directors. Then there was Tuesday Weld as Thalia Menniger. Do you recall who played the rich kid that competed with Dobie for Thalia? It was Warren Beatty. I could really tell he was going places. He played Milton Armitage. His mother was played by Doris Packer. She was divine and a lot of fun. She did her

part very, very well. After Warren left the show, they introduced another rich kid, Chatsworth Osborne Jr. played by Steve Franken. But they kept Doris, however, and changed her from Clarice Armitage to Mrs. Chatsworth Osborne Sr.

Q: Didn't you play two different characters also?

BYRON: The second season, the boys went to college. The producer Rod Amateau liked me, however, so I became a college teacher in the next season. They used my real name, and I became Dr. Burkhart. They kept changing my specialty. One week I was an anthropologist, and the next I was a historian or something else. I worked on the show frequently. They had a great cast and I enjoyed the whole experience very much.

Q: Any recollections of Bob Denver?

BYRON: He was quite memorable as Maynard G. Krebs. He played the beatnik part so well. He was very nice and quite charming, but you know, we didn't work much together. The paths of our characters just didn't cross, and I don't think we ever had a scene with just the two of us. The cast of that show really worked well together. The show ran for four years, and the boys were starting to outgrow their parts.

Q: Your next series followed immediately. How did you become involved with *The Patty Duke Show?*

BYRON: Writer Max Schulman created *Dobie Gillis* and he wrote another pilot and created a role especially for me. I was the second lead. The leading

part was played by a beautiful girl named Mary LaRoche. Unfortunately, this pilot did not sell. But United Artists saw the pilot and liked it. They were casting *The Patty Duke Show*, which was written by Sidney Sheldon. The plot had Patty playing a dual role as two identical cousins. Well, United Artists called my agent and said, "We want to cast Jean Byron for this pilot." So I went down to pick up a script and sign a contract. As I was going out the door, Bill Asher said that if the show got picked up, it would be filmed in New York. After a long pause, I said, "Oh?" That was unexpected.

Q: Was the pilot set in New York?

BYRON: No, it was set in San Francisco. They did quite a bit of location work with Patty there. Mark Miller played the original father, Martin Lane. Mark later played the lead in the television series *Please Don't Eat The Daisies* [1965–67]. Later they couldn't come to terms with Mark and he was replaced by William Schallert. Ross Lane, the son, was played in the pilot by Charles Herbert. John McGiver was also in the pilot as Martin's boss, the head of the newspaper where Martin worked. Anyway, I recall watching the Oscar awards, and when they announced "Patty Duke" for an Oscar, I knew I had a job and that the series would be picked up.

Q: What were some of the changes made after the pilot?

BYRON: The European cousin, Cathy, became more elegant. The family became less affluent, and lived in a more middle class home in Brooklyn Heights. They also eliminated the large dog, a sheepdog, and perhaps that was for the best. My only disappointment on the show was that they changed my character somewhat from the pilot, but it still worked out fine.

Q: Was filming in New York a real hardship for you?

BYRON: It was a sacrifice. I missed my family. Eventually they did return to film in Hollywood by the show's last season.

Q: What do you recall about the program?

BYRON: It was a real heavy schedule. It was almost a seven day-a-week job. My day ran from 7 AM to 7 PM, and I came in even before Patty. It was a very heavy schedule for Patty Duke as well, because she played two roles. Of course, there was a double for Patty on the set at all times. Sometimes I felt sorry for her since she really didn't have that much to do. She was mostly photographed from behind in over-the-shoulder shots talking with Patty. They also relied on split screen effects quite often. Patty was marvelous. She was a real workhorse, like me. She and I would do pick-up shots every Friday. We worked together so well, and we would always get our things done in one take. She was simply marvelous and like quicksilver. She would change her clothes so quickly.

Q: How did you enjoy working with the rest of the cast?

BYRON: They were all fine. I knew William Schallert for a long time, and I worked with his wife Leah as well. He played Professor Leander Pomfritt on *Dobie Gillis* so we worked together on both these series. I was very fond of Paul O'Keefe, who played my son Ross Lane. When we took publicity shots, I would always reach down and put my arm on him. But between seasons he grew so quickly. When we started one season, I was surprised when he spoke to me. His voice had gotten so deep, I was startled. One of my all-time favorites was John McGiver. You could just eat him with a spoon he was so sweet and considerate. What a precious darling he was. I felt devastated when he died. He had such a delicious personality, and it came through in the parts he played. You know, we had a large number of guest stars on the show. I met very many interesting people.

Q: There were many popular recording stars.

BYRON: Yes, we had a big teenage audience, so a number of the guests reflected that. There was Paul Anka, Frankie Avalon, Bobby Vinton and Sammy Davis Jr. They all were wonderful, with perhaps one exception. There was one big guest star who was so rude that nobody could stand him.

Q: Did you do a third series?

BYRON: I was a semi-regular in another show in the seventies with Pat Paulsen. It was *Pat Paulsen's Half a Comedy Hour* [1970] and we did a number of skits. I would sometimes play a very grand lady. I would say

something, and then you would hear a toilet flush [*laughs*]. It was a lot of fun.

Q: Let's return to your film career. Did you do any other films for producer Sam Katzman?

BYRON: I did another jungle picture for him called *Jungle Moon Men* [1955]. This was also with Johnny Weissmuller. By this time, Sam Katzman lost the rights, I think, to the character of Jungle Jim, so Johnny Weissmuller simply used his own name for the new character who was just like Jungle Jim. Tamba the chimp became Kimba. The plot was a variation on H. Rider Haggard, and I played an anthropologist who was threatened by this powerful lost tribe headed by Helene Stanton.

Q: Do you have any recollections of *Johnny Concho* [1956]?

BYRON: It was a western, and it had a great cast with Frank Sinatra, Keenan Wynn, William Conrad, Phyllis Kirk, Wallace Ford and Claude Akins. The director was Don McGuire. He used to be an actor and writer. He was a damned good writer. He wrote the screenplay to *Johnny Concho* with David Harmon. Years ago, Don McGuire used to take me out. All we did was laugh. He was the funniest man I ever knew. Then we went our own ways. So I guess when he was casting this film, he saw my name as a possibility for a part, and he said, "God, yes, let's use her!" It was an interesting role. I was the town madame actually, but I didn't have a very heavy shooting schedule. I really

enjoyed working with Don. Wallace Ford was a darling also. He was great to be around. I really got a good impression of Frank Sinatra. He sent flowers to my dressing room on the first morning. With the flowers was a card that said, "Welcome to *Johnny Concho* and best wishes, Frank." I thought that was so nice. You know, sometimes you see people briefly over the years, and they would say, "Hi, how are you, darling," but they really don't remember your name. Sinatra was different. I ran into him over the years, and he always called me by name every time. He was a very kind man. He was number one in my book. He also did a lot of charity over the years, very quietly. The filming of *Johnny Concho* was very ordinary, very workaday, but it was a very pleasant set.

Q: You also did *There's Always Tomorrow* [1956] at the same time?

BYRON: It was shortly after, but it was just a one day role for me. It was a Barbara Stanwyck and Fred MacMurray picture. Joan Bennett was in it also. I played a saleslady. Douglas Sirk was the director. Everything went smoothly. The stars like it when there are no delays because they could get on with making the picture.

Q: You had the female lead in *Invisible Invaders* [1959]?

BYRON: It was another quick, low budget affair. Edward Cahn directed. John Agar, Robert Hutton and John Carradine rounded out the leads.

Q: Any recollections of Carradine?

BYRON: I don't believe we had any scenes together. Most of his work was voice-overs added later. A lot of the footage in *Invisible Invaders* was stock footage. Most of my scenes in the film were in this hidden laboratory bunker. John Agar was our military supervisor. Robert Hutton and I played scientists who were working on a counter-weapon to fight the invaders. We were also trying to make them visible. At first, only my father believed they existed. Then they began to take over the bodies of the dead. I forget the name of the actor who played my father, who was the senior scientist.

Q: That was Philip Tonge. In fact he died shortly after the film. Did he seem unwell on the set?

BYRON: Not that I remember. He had no difficulty in shooting his scenes. The picture was filmed rather quickly. I remember the director moving from one set-up to the next very rapidly.

Q: Some of it was shot in Bronson Canyon.

BYRON: Yes. That was when we were testing our sonic weapon. I guess you could say I was an action heroine. John Agar was on the roof of our truck, operating this sonic cannon. Robert Hutton was in the back of the truck, operating the equipment for the weapon. My father remained in the lab to contact all the other labs. That left me to operate the truck and drive through the zombies. The terrain was rather rough too.

Q: *Invisible Invaders* is sometimes

cited as an influential film, prefiguring such pictures as *Night of the Living Dead* [1968].

BYRON: Well, I'm sure they wish they had a bigger budget so they could have shown some bizarre or weird aliens. But special effects are costly. They spend a fortune today creating these creatures with costly masks and costumes. So it was far less expensive for them to show walking zombies in dress suits instead of strange alien invaders.

Q: Your hair was blonde in that film. Why did you change it?

BYRON: The film was shot while I was still doing Lux commercials. The only change Lux asked me was that I lighten my hair. So I had blonde hair for a time. Did you like it better?

Q: I think you looked more striking with darker hair.

BYRON: Yes, that is my natural color. I think it fits my face better.

Q: How did you enjoy working with John Agar?

BYRON: John was very sweet. It's the one quality that makes a man most memorable to me. When I work with rude people, I tend to forget them. John was memorable, professional and kind. He seemed easy-going and worked effortlessly in front of the camera.

Q: Your next film was *Wall of Noise* [1962]. What do you recall about this film?

BYRON: That was produced at Warners. There were a number of good people in it like Ralph Meeker and Suzanne Pleshette, Ty Hardin, Dorothy Provine and Simon Oakland. The picture was about horse racing, and breeders who loved thoroughbred horses. It was a bit of a soap opera about the people behind the scenes. My part wasn't very big. I played Mrs. Harrington. I believe the actor who played my husband was Gary Petrie.

Q: You later appeared in *Flareup* [1969].

BYRON: Now that was a day's work I remember! [*laughs*] My scene was shot on location in a real smelly bar. There was quite a bit of dialogue involved in the sequence. James Neilson was the director, and he was a darling man. He was having problems with last minute dialogue changes that Raquel Welch wanted to include. So the dialogue was all changed and everything was altered, and that caused a delay. I had no problem with the changes, but there were always additional ones. Anyway, the sequence was finally done late in the day. Now Raquel was polite and friendly. She thanked me as I was leaving. She was nice enough but she made the day so difficult. Then James Neilson took me aside, and thanked me for a tough day's work. It was unusual for me to remember a one day shoot, but this day I recall most clearly. You know, actor James Stacy was in this film, and it wasn't long afterwards that he had a horrible accident. He was on a motorcycle on Mulholland Drive, and he was sideswiped by a car. It was terrible, and he lost an arm and a leg.

Stacy was a very nice individual. It was such an unfortunate nightmare.

Q: Another of your credits was *Where Does It Hurt?* [1972]. Here you are billed as "Jeanne" Byron.

BYRON: That was a black comedy about the medical profession. I thought my performance was so terrible that I never saw it. It played in Los Angeles, and I wouldn't go to see it. I played Dr. Kincaid, and my character was altered from a male to a female doctor. That change didn't really work in the script, and it was awkward at times. The director was Rod Amateau, and we go way back to the *Dobie Gillis* series. Rod liked my work, but we just didn't have time to iron out these problems. Two other things stand out in my mind about that film. I simply adored Peter Sellers. I found him to be a most delightful person, even more delightful than he was on the screen. I was thrilled to work with him. Another was the opportunity to perform with Harold Gould, a marvelous actor. We were born on the same day in the same year. Harold's work was simply wonderful. I especially enjoyed him in *The Sting* [1973], where he played one of the scammers. He is the one who plays the phony Western Union guy. He also was a frequent guest star on *The Golden Girls* television series, and he also co-starred in a television film with Katharine Hepburn.

Q: When did you leave Hollywood?

BYRON: By the late eighties, I really didn't get enough work to justify remaining in Los Angeles. I did the-

ater and other things, but I wanted to live in a smaller town. Most of my neighbors are "non-combatants" so they enjoy hearing about my career.

Q: Non-combatants?

BYRON: Well, sometimes the industry seems like the front lines. A lot of people see only the glamour, but there is a lot of hard work in addition to the glamour.

Q: What are you most proud of in your career?

BYRON: Just making a living in Hollywood for so long, I guess. What I have enjoyed most about my work was meeting so many interesting people. Some of them were very nice people too. Now Cecil B. DeMille did not have a good reputation for sweetness and light, but he was very gracious with me. I auditioned for him for *The Greatest Show on Earth* [1952]. My credits were only television and plays at the time. I mentioned that I hadn't worked much, and he smiled, put me at my ease, and said, "That's no problem. I'm Cecil B. DeMille. Just relax and tell me about yourself." He treated me well, even though I didn't get the part.

Q: Who did you most enjoy as fellow performers?

BYRON: There were a number of them. I already mentioned Thomas Mitchell. There was also Louis Hayward, Ann Sothern and many more. Lucille Ball was also very special. Working with these individuals were probably the best moments of my career.

Q: Do you have any plans to return to acting?

BYRON: I have been approached for a project in the near future. CBS is planning a *Patty Duke* reunion show for autumn 1998 release. It will be done in Vancouver with the entire cast. Patty called me about it last week, and she thinks it will be a real hoot. I am eagerly looking forward to doing it, and seeing everyone after all these years. Of course, I'm happy with my television series *Patty Duke* and *Dobie Gillis* and I look forward whenever they are revived. And I am happy that so many people remember those small genre pictures like *Magnetic Monster* and *Invisible Invaders*. It is gratifying to be remembered.

4

LINDA CHRISTIAN

Mermaid Enchantress

Linda Christian has a well deserved reputation as an actress of international renown. She projects one of the most enchanting personalities on film, having played a memorable screen siren in *Tarzan and the Mermaids* (1947, an attractive witch in *The Devil's Hand* (1962), a charming au pair in *The Happy Time* (1952) and the prototype "Bond girl" in 1954 on live television's *Casino Royale*, the first Bond project ever produced. Linda is also remembered for her marriage to screen idol Tyrone Power in 1949. In this interview, Linda recalls both her on screen and off screen adventures.

Q: Where were you born?

CHRISTIAN: I was born in Tampico, Mexico. My father was Dutch, and he was in the oil business with Shell Oil. My mother was German, Spanish and French. The only Mexican blood I have is from a transfusion. I spent my youth all over the world, in Venezuela, in Europe, in the Middle East and South Africa. I got to know many languages: French, German, Dutch, Spanish, Italian as well as English. I even knew a smattering of Arabic and Russian.

Q: Where did you feel most at home?

CHRISTIAN: I guess wherever the family was. We were two boys and two girls. My original name was

cultures, and I wanted to help people. In Venezuela for example, there are many black people who are very poor, and they are incredibly happy people. They have so little, but they are filled with joy. It was meeting people like this that inspired me. I was also a film lover. My hero was Errol Flynn. My one and only Dutch cousin, Carla, who lived in Holland, liked Tyrone Power and had pictures of him in her bedroom. She would say to me, "He is much better looking than your Errol Flynn!" So you can imagine her surprise years later when I married Tyrone.

The bewitching beauty of Linda Christian manifests itself in this striking production pose from *The Devil's Hand* (1962).

Blanca Welter, and my sister, Ariadne Welter, is a well known actress in Mexico. One place I really loved was Italy, so I always felt very much at home in Rome. I also enjoy Spain and South America.

Q: When did you first get interested in becoming an actress?

CHRISTIAN: I never thought about being an actress. I wanted to be a doctor. Since I had seen so much of the world, I grew to appreciate all these

Q: Did you ever meet Errol Flynn?

CHRISTIAN: After I graduated from school, I was back in Mexico, and I met Errol Flynn. I told him about wanting to become a doctor, but he persuaded me to go to Hollywood and investigate an acting career. I had no dramatic experience except for school plays, but they always cast me in the leading part.

Q: How did you get started in show business?

CHRISTIAN: I was put under a seven year contract by MGM after I was in a

fashion show in Beverly Hills. Louis B. Mayer's secretary came to the show, and she took me to see her boss. After I signed, I was given all sorts of lessons, singing, dancing, acting and so on.

Q: What was your first film?

CHRISTIAN: *Up in Arms* [1944] with Danny Kaye. That was very short lived because I was having a bad problem with an impacted wisdom tooth. I was in a lot of pain. They weren't very understanding, so I just walked off the set to go to the dentist. I was in a production number on a ladder going up to the ship. It was Danny's first film as well, and he was fabulous. It was also Dinah Shore's first leading part. She was always knitting on the set. She was very friendly to everyone.

Q: Your next listing was *Holiday in Mexico* [1946]. What role did you play?

CHRISTIAN: I was the jealous girlfriend of Xavier Cugat, but I had no dialogue. I never opened my mouth. I was supposed to have a close-up, but I told the director, George Sidney, that perhaps I should hand Xavier his dog, a Chihuahua which I was carrying, from behind the camera. Sidney was amazed. "This is the first actress I ever met who didn't want a close-up!" Anyway, everyone was very nice to me since I was the newcomer.

Q: Any recollections of *Green Dolphin Street* [1947]?

CHRISTIAN: What a part! I had a

dark wig, tattoos and wore a rug around my body. I spoke broken English. Lana Turner was the star, and she and Tyrone Power were having a big romance. She went to visit him on location in Mexico while he was making *Captain from Castile* [1947]. Traveling connections weren't good, and we were stuck on location waiting for her to reappear. I thought Lana was excellent in her dramatic role. It wasn't a glamorous part, and she showed she could act. But when I tried to compliment her, she only said, "Oh, yeah?" After that, I crawled back into my shell.

Q: Your billing in *Tarzan and the Mermaids* [1948] was "Introducing Linda Christian."

CHRISTIAN: That was my first leading role, so that was an added boost for me. That picture was shot around Acapulco before all the resort hotels were built up. Robert Florey was the director and he was very accommodating.

Q: Any problems on the film?

CHRISTIAN: There was a hurricane, and it destroyed the big set on the rock in the bay. It is a very scenic rock in Acapulco. The whole film was centered on this temple. It took quite some time to reconstruct it for the film, and that was a major delay. In Mexico City, we did underwater scenes in this ice cold tank. So in the picture you see me diving into the warm, tropical waters of Acapulco, and then you see me underwater in the frigid waters of the studio tank. I had quite a few underwater scenes, and I

was frozen stiff. I also did the diving. They had a stuntwoman, but she was so unlike me, that they had to use my footage except for a real distant shot.

Q: What was your impression of Johnny Weissmuller?

CHRISTIAN: He couldn't have been nicer. I think he fell in love with Acapulco. They had a stuntman for Johnny, and he was also quite unlike him. Johnny had these long arms, and he was such a graceful swimmer. Well, the stuntman had these short, stubby arms. Many years later, Johnny was buried in Acapulco. I was the only actor there, I believe. When they lowered the casket, they played a tape of his famous Tarzan yell.

Q: George Zucco was the evil high priest in the picture. It was one of his last films. How was he to work with?

CHRISTIAN: He was very quiet and reserved. We didn't see much of him except on the set. He might not have been well.

Q: When did you first meet Tyrone Power?

CHRISTIAN: They wanted me to become involved with running the Churubusco Studio in Mexico. It would have been a wonderful opportunity. I was asked to take it over. Anyway, I was taking my sister to finishing school in Switzerland. We were in Rome. Our room wasn't ready at the Grand Hotel, and the MGM representative took us to dinner. He told us that Tyrone was staying at the same hotel. Well, Ariadne wanted his auto-graph. It was getting late, but Ariadne insisted that she really wanted his autograph that night. So we met him in the lobby of the hotel. So that's how I met Tyrone, and it was love at first sight. Tyrone proposed to me almost immediately. I decided to marry him. So I declined this magnificent offer to run Churubusco Studio. The president of Mexico, Miguel Alleman, told me, "But you would be much happier running the studio..."

Q: You must have met many interesting people while you were married to Tyrone. Does anyone stand out in particular?

CHRISTIAN: Howard Hughes was very strange. He would often invite Tyrone to go flying with him. He would show Tyrone these very risqué photos of these girls. It was like he was tempting him. Hughes was a nasty man as far as I am concerned. I actually met him before I knew Tyrone. He was very tall, and I felt he looked at me like I was a piece of meat. On this occasion, an associate, Johnny Meyers, questioned me about what type of house I liked best. Then he took me to this place to meet Hughes, and he was offering this home to me as a gift. Jane Russell was there too. Well, I just ran away. Howard had so many women in so many places, and I didn't want to be one of them.

Q: Was being married to Tyrone Power an asset to your film career?

CHRISTIAN: Not at all. We never wound up acting together. We were supposed to, but it never came about. We were supposed to do *Mississippi Gambler* [1953] together. But then Universal had their own agenda, and they wanted one of their contract players in the part, Piper Laurie. They gave me a quick test in modern clothes, but tested Laurie in the full regalia of the period. She is a very good actress, but there was little chemistry between Tyrone and her. This was a business decision for Tyrone, and he gave in to them. I think it could have been a better picture with both of us. It is one of my regrets. It would have been nice for our grandchildren to see. You see, I also became a mother. In fact, I was pregnant almost the whole time of our marriage. I lost two boys and a girl, and then I gave birth to two girls, Romina and Taryn. Romina was born in 1951, and Taryn was born in 1953. So looking after the children was important to me. Today one lives in Italy, and the other has a ranch in Wisconsin. Both have done some work in films. Taryn's first film was called *Maria* and it was filmed mostly in Columbia in 1971. It was in Spanish, and it was a beautiful love story. There later was an English dubbing. Romina was offered a seven year contract when she was only 14. She couldn't understand when I refused to consent. I knew how these long term contracts can make you a virtual prisoner to the studio. So she eventually did the film she was offered without a contract. She and her husband later performed as singers, first throughout Europe and then the rest of the world.

Q: Were there any other projects that you planned to do with Tyrone?

CHRISTIAN: There was an offer for us to do *From Here to Eternity* but Tyrone didn't want to do it. Tyrone was also offered *Solomon and Sheba* three years before he did it. We could have done it together.

Q: Did you and Tyrone socialize with the studio heads?

CHRISTIAN: We went to a dinner party with Bill Getz, who ran Universal, and he got a little fresh with me. I wouldn't put up with it, so maybe that had something to do with not being chosen for *Mississippi Gambler*. Some of the Hollywood moguls could be nasty. However, I was really surprised by how nice Darryl F. Zanuck was. Harry Cohn also impressed me as another fine individual.

Q: Any other interesting experiences?

CHRISTIAN: While he was shooting *The Black Rose* [1950] in Morocco, Tyrone and I were supposed to go over the Atlas mountains to the desert on the other side. There was going to be a scene shot in the desert. So Jack Hawkins, Bill Gallager, Tyrone and I got into this car and left from Marrakech. It was a beautiful day and we were all in our summer clothes. Well it got colder and colder. It got dark and it started to snow and rain. It was a terrible storm. When we finally got through the mountains on the other side, the bridge had washed out. So it was already dark, and we tried to find a place to stay. We saw this mysterious

wall, and behind it was this shabby hotel filled with foreign legion–type characters. We spent the night there, and the mattress was alive with lice. It was terrible. The next day, we were going back to Marrakech, and the bridge was out on the other side as well. We were stranded in the Atlas Mountains. We finally came across this big home owned by an eccentric Russian, and he put us up. I remember he was called Sacha the Pasha. He was a fabulous chef who fixed us these rare, delicious meals. So that was quite an adventure. There were many newspaper headlines about us saying "Lost in the Atlas Mountains!"

Q: You were on location with Tyrone for many of his films?

CHRISTIAN: Yes. When he was in the Philippines shooting *An American Guerrilla in the Philippines* [1950] with Fritz Lang, they sent me to Hong Kong for a month because I was pregnant. I wanted to be with Tyrone on his birthday, and when I got to the set, everyone was very concentrated. There was an intense scene with all sorts of big explosions going on. That night, I lost the baby in the quonset hut. It was the third child we lost.

Q: *Battle Zone* [1952] with John Hodiac and Stephen McNally was your next film. How did you enjoy that picture?

CHRISTIAN: I was under contract, but I wasn't too comfortable on that film. It was about the Korean War, and I didn't feel like doing the picture. On the other hand, I really enjoyed

doing *Happy Time* [1952]. This was a warm, nostalgic comedy set in Canada in the twenties. It wasn't a glamorous part, but it was one of my favorite pictures. I played an au pair who came into this family, and everyone took a liking to me, especially the boys. Charles Boyer was the lead in the film, and making that picture was a happy time.

Q: You had the female lead in *Slaves of Babylon* [1953] with Richard Conte.

CHRISTIAN: I had a little trouble with Richard. He had some amorous ideas. So I brought Tyrone to the set one day, and after that Richard settled down. The film was a Biblical epic about Nebuchadnezzar.

Q: What do you remember about William Castle?

CHRISTIAN: I thought he was very nice. He was pretty easy-going with me. I also recall Julie Newmar on the film. She did this wild sabre dance. She was so striking, tall and beautiful. Even today, she is stunning.

Q: *Athena* [1954] was a musical with Jane Powell, Vic Damone, Edmund Purdom and Debbie Reynolds. What part did you play?

CHRISTIAN: I played Edmund Purdom's fiancée. At that time, I was a vegetarian, but my character in the film was a meat lover who made fun of vegetarians. So that was acting against the grain. But this film had a "health consciousness" that was ahead of its time. Now, everyone is health conscious, and thinking about diet and exercise.

Q: Did you work with Steve Reeves in *Athena*?

CHRISTIAN: No, we were in different parts. He was used as an example of the ideal, healthy man. Later, he played Hercules, and he still looks great today. Last year, we met in Palm Springs, and he said it was a shame we didn't get a chance to work together on that film.

Q: You later married Purdom in 1962?

CHRISTIAN: That's when I first met Edmund, and later we became romantically involved. Eventually, I married Edmund in 1962, but it wasn't much of a marriage. Edmund was so frustrated that I waited so long to marry him that he hit me. So our actual time together didn't even last 24 hours.

Q: Yet you worked a lot with Purdom after that?

CHRISTIAN: We've worked with each other and it was all very friendly. He has apologized for what happened quite sincerely and I forgave him.

Q: You starred in *Thunderstorm* [1956] which was filmed in Spain. How did this picture come about?

CHRISTIAN: I liked the idea of going to Spain so I agreed to do the film. It was shot in Northern Spain in the Basque country. One problem with that picture was that they did not know how to end it. The film was produced by Mike Frankovich, and his wife, actress Binnie Barnes, even showed up on the set trying to help with ideas to wrap it up. Carlos Thompson was the leading man. He was very much in love with Lilli Palmer whom he was about to marry. She had just divorced Rex Harrison. He was very talented, very passionate. He had just played composer Franz Liszt in *Magic Fire* [1956]. He later went into writing and producing.

Q: After Lilli Palmer's death in 1986, Carlos Thompson killed himself. He was very devoted to her.

CHRISTIAN: He was a very nice man. I did a German language film with him in Vienna in 1965. Then there was another called *The Great Concert in Munich*, I believe. Carlos played a classical conductor and Edmund Purdom played another conductor who specialized in contemporary music. In life, Carlos was not a great classical music buff, and he asked Edmund for pointers to appear like a conductor. Edmund was totally involved with classical music. He could identify almost any symphony after hearing only a few notes.

Q: *The Devil's Hand* [1962] was an interesting little genre film that many fans remember. You really looked great in the film.

CHRISTIAN: The film was actually shot in 1959. I liked the original title *Witchcraft* much better. The script wasn't bad. It touched on clairvoyance and astrologers and numerologists. In real life I had some interest in these things, not as a sideshow, but there are people who are top-of-the-line and have been remarkably accurate. I liked my part and it was rather glamorous,

but I was disappointed when the script was made into a film because it was so superficial. They changed the emphasis from magic and witchcraft to devil worship.

Q: They were just trying to make a horror film.

CHRISTIAN: My daughter Romina just saw it on television in Germany, and she said it gave her the shivers, so the film can have some effect. Romina thought it was spooky. You provided me with a recent screening, and it reminded me how they kept changing it willy-nilly. The producers were not very honest, and that is why I have regrets about having done the film.

Q: Were they dishonest?

CHRISTIAN: They just disappeared with the footage. I don't think everyone got paid. They owed us quite a bit of money. My sister, Ariadne, was also in the film. She was visiting me at the time. Unfortunately, Ariadne and I didn't have any scenes together. She later said, "Never again!" to doing a film in America. Ariadne did many films in Mexico, including *El Vampiro* [1957] with German Robles. She also did a magnificent film with Ricardo Montalban called *Green Mansions*.

Q: Did you enjoy shooting the film?

CHRISTIAN: Yes. Robert Alda was very nice but rather private. I don't recall too much about Neil Hamilton, who was the evil sorcerer in the film. We shot the picture at a small, independent studio. The picture was shot really quickly. They were having financial problems and wanted to get it in the can. It was okay making the film, but what happened later left a bad taste in everyone's mouth.

Q: Did you yourself ever have any clairvoyant experiences?

CHRISTIAN: When I was married to Tyrone, I got a terrible feeling. I didn't want to disturb him on the set, but I kept getting this feeling that I had to call him. When I got him on the phone, he was upset and he told me that one of the huge studio lamps had just come crashing down on the chair where he had been sitting studying his script. It happened just after he got up to come to the phone. That was a real premonition. I had one other, and it was the last time I saw Tyrone before he left to do *Solomon and Sheba* in 1958, and I asked him if he had had a checkup. I was worried about his heart. He told me he had just had an EKG, and they made him wait about twenty minutes. That made him nervous, but it turned out that the machine wasn't working right. I told him I had a bad feeling, and he should have it checked. He looked at me gravely and said, "If that is the case, I don't want to know." I then asked him what his favorite flowers were, and he said carnations. Well, he died of a heart attack while doing *Solomon and Sheba*.

Q: Where were you when he died?

CHRISTIAN: I was in Holland staying with an old friend from my school days. It was my birthday, November 13, and I hadn't heard from Tyrone.

He never forgot my birthday, and I said to my friend, "He is either dead or about to die." My feeling was that strong, so I headed off to Paris, and when I got there I heard from reporters that he had died on the set in Madrid. He had just finished shooting the sword fight with George Sanders, went to his dressing room, and passed away. He was only 44. I was told by his third wife that neither I nor the children were welcome at the funeral, and she later auctioned off all the private photos and films Tyrone had of ourselves and the children. I was never told about the auction, or I would have acquired some of them. Tyrone loved to shoot films, and there were many of them, particularly of our travels and the babies.

Q: *The V.I.P.s* [1963] was your next project. What do you recall?

CHRISTIAN: I had a number of scenes cut from the film. Allegedly, Elizabeth Taylor refused to finish the picture unless these scenes were cut. She didn't look too well in this film, and I'm not sure what problem she might have been having, but she wasn't nice about my scenes. I know one of my scenes turned out very well. Rod Taylor had called me from the airport, and I had a scene with a puppy. They wanted me to do it on the bed, but I suggested doing it on the floor. The puppy got hold of the telephone cord and was pulling on it while I was talking on the phone. It really turned out to be an adorable scene. I thought the scene added to the film. If anything, the dog stole the scene from me. So I felt very disappointed that a lot of my footage was removed from the film.

Q: Didn't you say that Elizabeth Taylor rented your house?

CHRISTIAN: Yes, she had rented my house, and left it in shambles. Subsequently, I had to sell it at a low price. Before, I had rented it to many celebrities, like Henry Fonda and Polly Bergen. There never was a problem.

Q: Although you didn't have any scenes together, did you meet and talk with either Richard Burton or Orson Welles?

CHRISTIAN: I never met Burton, but I knew Orson going back to *Prince of Foxes* [1949] which he made in Italy with Tyrone. We shot the film all throughout Italy, and it was a wonderful way to see the country. You know, it was amazing how much Orson and Tyrone were adored in Italy. We had to sneak out of hotels in the middle of the night to avoid crowds. I liked Orson tremendously. He was very, very nice, and we were friends for a long time. He tried so hard to keep to a diet and keep trim. This was difficult in Italy, where the food is so appealing. Years later, he gave up and no longer tried. He enjoyed living well. The last time I saw him was at a restaurant here in Los Angeles. I told him he should see the pictures of my grandchildren, and he joked, "I would never expect such a beautiful woman to be talking about grandchildren."

Q: Any reflections on the British picture *The Beauty Contest* [1964]?

CHRISTIAN: It wasn't a large part. I was on the judge's panel at a beauty contest. I also didn't care much for *The Moment of Truth* [1964], which was a Spanish film I did about bullfights. Because I did that film, everyone subsequently thought I was crazy about bullfighters. [*laughs*] They are probably near the bottom of the ladder as far as I am concerned. In that film, they used a real bullfighter, and I thought the torrid love scene was just so phony.

Q: Were you living in Spain at the time?

CHRISTIAN: Yes, I went for a short visit and wound up staying seven years.

Q: How would you compare European films with American?

CHRISTIAN: In England, the technique is very similar to American films. As for American films, I like the older ones like those shown on AMC. Those films had real heart. In Italy and Spain, they prefer to use natural light as much as possible and not rely on direct sound. But if it comes to dubbing, I think the Italians are the best in the world at doing it. The story lines of Italian films are much more natural, it seems to me. I also enjoyed the German films I did in Berlin. Most of my filmographies miss those titles completely.

Q: Which of these films stand out in your mind?

CHRISTIAN: There were a number during the mid-sixties. At that time, O. W. Fischer was a huge favorite film star in Germany, and I did two pictures with him, *Peter Voss, the Million Dollar Thief* and *Good-bye to the Clouds*. Another popular one was called *Full Hearts and Empty Pockets*. *Peter Voss, the Million Dollar Thief* was an adventure film about a latter day Robin Hood stealing from the rich to give to the poor. We also shot some scenes in Morocco for that picture. In *Good-bye to the Clouds*, I played a hysterical German countess in an airplane that was having trouble. Eventually the plane crashed. It is a frightening picture for those who hate to fly. *Full Hearts and Empty Pockets* was a romantic picture about these poor people who at least found happiness through love.

Q: Which actor most impressed you in your career?

CHRISTIAN: Robert Taylor. I did a mystery film with him called *House of the Seven Hawks* [1959]. He was so natural whenever he spoke his lines, he never seemed to be acting. He impressed me so much with his talent. He also made all the other actors feel comfortable, which is also important.

Q: Did you do television also?

CHRISTIAN: Off and on I did quite a bit, especially in Europe. I did a wonderful program in Italy two years ago. In the United States, I was the first Bond girl ever. It was an hour long version of *Casino Royale* for *Climax* [1954–58] on live television. Barry

Nelson played James Bond, and Peter Lorre was the villain, Le Chiffre. They made Bond an American for the show. I was a French agent named Valerie Mathis, and Bond and Valerie had an affair. I called him "Jimmy," and that sure was different. No one else ever called James Bond "Jimmy." It was done live, so that anything could happen. It wasn't a happy time for me because I was getting a divorce from Ty.

Q: What were your impressions of Peter Lorre?

CHRISTIAN: Peter was so modest and sweet, and I never realized what a big star he had been in Germany before the Nazi era.

Q: Did you ever do any talk shows?

CHRISTIAN: I did the Johnny Carson show in New York, for example. This was right after I was robbed of my jewels at the Plaza Hotel in New York. Johnny asked if I had insurance. Well, the company wouldn't pay because they said I should have deposited them in the hotel vault. Later, when I was staying at the Mayfair Hotel, I heard the hotel vault was robbed and I felt glad I had nothing in the vault.

Q: Are there any particular moments in your career of which you are most proud?

CHRISTIAN: You may think it unusual, but I am particularly proud of my swimming sequences in *Tarzan and the Mermaids* especially with the difficult conditions. The straps of my sandals were coming off, and I had to do a lot of kicking while swimming. I am also proud of the book I wrote in 1962. It is called *Linda: My Own Story,* and I put a lot of effort into it, and I think it turned out very well.

Q: If you had your life to do over again, what would you do differently?

CHRISTIAN: That offer to run the Churubusco studio was such an opportunity. At the time I didn't feel I was business-minded enough to do it. It is a very materialistic world. If I had the right people to help me, it might have been a wonderful experience. I had Hollywood contacts and could have brought some Hollywood directors and stars to Mexico for some projects. It could have opened up the process for both Spanish-speaking and English-speaking audiences. But I am glad for the opportunities I did have, and I am grateful for the many people who remember me, and the films I have done.

5

SANDY DESCHER

Child Star and Space Child

Sandy Descher was one of the most popular and talented child performers of the fifties. She is particularly remembered for her roles in two science fiction classics of the era: *Them* (1954) and *Space Children* (1958). In *Them* she is memorable as a catatonic little girl who survived one of the first attacks by the giant ants. She sets the plot of the picture in motion when the police find her wandering in the desert. She later gives the film its title when she screams, "Them! Them!" as scientists test her reaction to a scent left by the ants. In *Space Children* she is one of a group of children possessed by a weird space alien who tries to stop a rocket launch. She and the other children sabotage the project, and they are later released from the alien's control when it reveals its peaceful intentions and returns to space. In between, Sandy played many other roles, from a Babylonian child priestess in *The Prodigal* (1955), to a young cripple whom Jerry Lewis tries to entertain in *Three Ring Circus* (1954). In this interview, Sandy reflects on her varied experiences as a child performer.

Q: When and where were you born?

DESCHER: I was born in Burbank, California on November 30, 1945, at St. Joseph's Hospital.

Q: How did you get started as a child actress?

DESCHER: I was about five and was traveling with my parents to New

Sandy Descher (third from left) and the other children await their orders from the glowing alien brain in *The Space Children* (1958). Michel Ray, center; Johnny Crawford, far right.

York, and I saw the ballet of *The Red Shoes* on Broadway. For some reason, I really identified with it. I loved to dance. As we left the theater I said that I wanted to become an actress and a dancer.

Q: From there, how did you get started?

DESCHER: We came back across the country. We stopped at Jackson Hole, Wyoming, and a crew was shooting a film there. Gordon Douglas was directing. My parents and I were having dinner at the lodge, and Mr. Douglas was observing me in the dining room. He came over and introduced himself and asked my parents if he could use me in the film he was shooting in Jackson Hole, and how long would we be there. They replied that they were traveling and would not be able to stay. Of course, I was ecstatic. He left his card and said to contact him when we got back to Los Angeles. He told them to call him at the studio because he felt he could definitely use me in the future. Anyway, I didn't shut up the rest of the trip, and when we got back, Mother called him, and about six months later I appeared in *It Grows on Trees* [1952].

Q: Wasn't that the fantasy film about money growing on trees in a family's backyard?

DESCHER: Yes, that was with Irene Dunn and Dean Jagger. It was Irene's last film. Richard Crenna was also in the picture, and it was his first film as well as mine. He was about 15 at the time and a lot of fun. I have great memories of that film. It was rather different, a really innocent fantasy, something we could use more of today in pictures ... good, enjoyable films for the whole family.

Q: What did you do next?

DESCHER: I don't remember the exact order. I did another family film with Richard Widmark called *My Pal Gus*, and I did a small film for Disney, which was a Christmas program. Gordon Douglas then went over to Warner Brothers, and that was when I did *Them* [1954].

Q: That has become a classic film, one of the first of the "giant mutant" science fiction films of the fifties and, of course, the title comes from your only line in the picture. You were quite impressive as the catatonic survivor. What can you recall about working on that film?

DESCHER: Well, it was a very difficult shoot, particularly for a child so young. I had a double and stand-in. Her name was Luz Potter, and she was a midget. As a matter of fact, she doubled for me for years until I outgrew her. Anyway, the shoot was difficult because of the weather. It was very hot in the desert, and we had a lot of sand that was supposed to be blowing. In particular it was difficult for me to maintain that catatonic state. I had to keep my eyes open, and sand was always blowing in them. I remember Mr. Douglas was directing me from under the camera. Suddenly he fell into a cactus bush, but he kept going. I didn't ruin the scene, and he didn't

Center of attraction: Sandy Descher as the catatonic girl of *Them* (1954), being interviewed by Edmund Gwenn. Far left: James Whitmore, Jr. Far right (with back to us): James Arness.

cry out until the shot was over. It was quite amusing. He wound up with a number of stickers in his rump, and he had to have them pulled out with tweezers by the make-up man. So that was a memorable moment. James Arness and James Whitmore were quite delightful to me on the set. So was Christian Drake, the other patrolman. I used to ride around a lot on their shoulders on location. I have some home movies showing that. James Whitmore was very natural.

Q: He shows the same qualities in his recent commercials for Miracle-Gro, don't you think?

DESCHER: Yes, absolutely. He's a wonderful actor and a very nice person.

Q: Any other memories from *Them*?

DESCHER: Yes. I remember specifically the giant ants. Of course, they really mesmerized me. They were loaded onto trucks. They didn't have electronics in them. They had people in them, working the legs, you know, much like a float in the New Year's Day parade. They were quite something. They were aluminum with netting over them, and the hairs were

glued on. They were actually quite life-like in appearance. They were remarkable, and I was fascinated by them. They were something else. It was a wonderful experience for a child.

Q: Do you have any recollections of Edmund Gwenn?

DESCHER: He was delightful. I worked with him later too. He always had a twinkle in his eye, just like when he played Santa Claus in the original *Miracle on 34th Street* [1947]. He was a class act. These people are few and far between. I remember the scene we had in *Them* where I was in the hospital, and I remember they presented me with a serum with a scent, and I started screaming. They used something that did smell quite strange. It wasn't ammonia. It was something else that smelled really strange. They tried to create something different, and it helped me a lot with that particular scene.

Q: You spoke about some home movies on location?

DESCHER: I haven't seen them in years, but I do have them in storage. Whether they are watchable or deteriorated, I'm not sure. My son is involved with a film production company that he makes training films for, and he is going to take them to the lab and see if something can be done with them.

Q: At least some frames might be salvaged in case there had been damage.

DESCHER: Hopefully, that can be done. Mom made quite a production

out of it, with me waving, going into Warner Brothers. This was a big deal because we were going on location to the Mojave Desert. She made her own little travel film out of it. There was quite a bit of the behind-the-scenes look to it.

Q: Did your mother accompany you on all your films?

DESCHER: Yes. All children have to have an adult with them while they are at the studio. My mother was even paid a salary as a chaperone by MGM.

Q: What other films were you involved with after *Them*?

DESCHER: It wasn't too long after *Them* that I went under contract to Metro-Goldwyn-Mayer. I did five films for them, including *The Last Time I Saw Paris* [1954], *The Cobweb* [1955], *Interrupted Melody* [1955], and *The Opposite Sex* [1956]. The most lavish was a Biblical epic with Lana Turner, *The Prodigal* [1955].

Q: How was it working on an epic?

DESCHER: Fabulous. In fact, I had a $35,000 wardrobe for that film, with real expensive jewelry and everything. There was some friction on that shoot between Edmund Purdom and Lana Turner. She wound up slapping him at one point when she thought his performance was too amorous, and he kicked in her dressing room door another time. There was a lot of yelling between them. I think Metro dropped him after this film. But there also were a lot of film veterans like Cecil Kellaway on that one, particularly

in this grand gambling chamber sequence, and it was great working with them, they had such vibrancy and were such pros. They just oozed personality.

Q: Why did you leave Metro?

DESCHER: My agent at the time was Paul Small. Paul passed away, and his wife, who was a dynamic agent in her own right, took over. She broke my contract with Metro, because they were loaning me out to other studios too often. I was lent out to do *The Bottom of the Bottle* [1956] with Van Johnson at his request. I did *The Man in the Gray Flannel Suit* [1956] on loan also. I played Gregory Peck's daughter in that major production. The studio was reaping the financial benefit of all these pictures on loan, but I wasn't because I was a contract player. They shuffled me around. I might as well have been out there on my own. Television was also beginning to enter the picture, and I began to do a lot of early live television, such as *Playhouse 90* [1956–61], *20th Century–Fox Hour* [1955–57], *Kraft Playhouse* [1947–58] and the original *Day in Court* [1958–59]. I did a lot of live television. Some of my best work on television was *Miracle on 34th Street* and *How Green Was My Valley*. I also did a few live plays as well.

Q: What among your films was your favorite?

DESCHER: My favorite was *The Last Time I Saw Paris* [1954]. I got to speak French in it, and I got to dance, but they made me dance badly on purpose. It was Richard Brooks' first big film as director. We all kind of bonded on the film, and there was quite a cast, with Elizabeth Taylor, Van Johnson, Donna Reed, and Walter Pidgeon. It was all first class, and Brooks got a hell of a performance out of Elizabeth Taylor. It was also one of Roger Moore's first films. He was wonderful and gave a solid performance. It was a pretty close unit, very special, and a lot of fun. We became a family. I also enjoyed *Three Ring Circus* [1954].

Q: Tell us about your experience with *Three Ring Circus*.

DESCHER: It was a very special film, with Dean Martin, Jerry Lewis and the Clyde Beatty circus. Of course, Jerry Lewis played the circus clown, and in our big scene, he tries to make me laugh. He was a lot of fun. Dean Martin was pleasant, but he wasn't around as much as Jerry, who was always "on" and entertaining. Mr. Lewis and I went to do a benefit together during the time we were making the picture. During *Three Ring Circus*, I had to wear braces, and they were very archaic. They left them on all the time, which seemed to be hours at a stretch. It made me feel very sympathetic for children who had to wear them. It personalized it for me, even today when I think back, or when I see children with braces. Anyway, Jerry Lewis was a great prankster. Mr. Lewis was very visible and very nice. Years later he did a scene in a picture in a shop that my parents ran in a luxury hotel, and we reminisced

about our earlier film. He was very considerate. Elsa Lanchester was real natural and very nice. Dean Martin was a wonderful entertainer, and he will be missed. I was also touched by the recent passing of Tommy Rettig who had many great parts in the fifties. Tommy and I were in *The Cobweb* together. He was a dear person, and a great father to his children.

Q: How did you originally get involved with *Space Children*?

DESCHER: You know, it was very strange. I'd been in the business quite awhile, and I usually had scripts sent to me. I didn't do much interviewing as a child. Producers basically looked at my past films and knew my work. But on *Space Children* they did have an interview, and it was almost a "cattle call." Looking back, I believe it was for publicity. It was the only time I was in a "cattle call," and they must have had a couple of hundred kids there.

Q: How was it working for Jack Arnold? He had quite a good track record, and he considered *Space Children* one of his favorite projects.

DESCHER: He was wonderful. He had just the right touch with all of the kids in the film.

Q: What are your recollections of the other people in the film? Jackie Coogan played your father.

DESCHER: Well, Jackie Coogan was great. He was the first actor who was a star as a child, back in the silents with Charlie Chaplin. The children, of course, were all in school together. I do remember being terribly embarrassed because I was very young, and I felt I looked terrible in the bathing suit I had to wear. I had knocky knees, and I had a little crush on Michel Ray, and I thought it was cruel of them to make me wear that bathing suit at this age. Johnny Washburn and I went back to *My Friend Flicka* days, and our parents were great friends. Our mothers formed a bowling league for all of us kids in the business.

Q: What memories do you have of the shoot?

DESCHER: I remember the glowing space brain in the film. It was really weird. It was rubbery, and it had lights under it, and some sort of hydraulic system that made it pulse and hum. Some of my other recollections are vague. I remember particularly the beach scenes. All the cave scenes were done in the studio on a set. The cave was fabricated. You know, there are certain times of your life when things are not as clear as other times. I was uncomfortable at that age in the bathing suit. It was a time I don't remember too much about. I have much more vivid memories about earlier films. I saw the film recently, and it was a real hoot, just an entertaining picture. Even the errors, like the scene where there was a bright flash, and you saw people's shadows on the painted backdrop of the sky behind them, had a charm that made the film fun. It was so tacky, it was cute.

Q: What was you last feature film?

DESCHER: Well, actually *Space Children* was the last feature film I was involved with. I went very heavily into television work. I was in a lot of programs like *The Loretta Young Show*, which was an anthology. That lead to the series, *The New Loretta Young Show* where Loretta played a writer who was a widow with seven children. Beverly Washburn and I got a chance to play sisters. I was a regular in 1964 on *The New Phil Silvers Show*. I was in practically every show at the time, but I was sorry that I never got to do *Dr. Kildare* [1961–66] because I had a terrible crush on Richard Chamberlain. I was going to do *Heidi* as a series with Four Star, which was Dick Powell's production company, and it was going to be a big production. However, there were delays and other problems after Dick Powell passed away. By the time the project came back on track, I had outgrown the part for a television series.

Q: Was *A Gift for Heidi* the result of that project?

DESCHER: Those were three half-hour pilots that were blended together as a television film. *A Gift for Heidi* was the title they used for the television release.

Q: How were you treated as a child actress?

DESCHER: I never had any problems working with anyone in the industry, except there was one person that I didn't like working with. I did a pilot with him, and he was a heavy drinker.

It might have been a major mistake in my career, where you wish you had done something but didn't. It became a very famous film project, but I just didn't like working with the man. I told my parents at the time that I'd rather go under contract to Metro. I don't want to say the man's name, but I found working close to him very repulsive. He was a very funny man. I never did run into anyone else I felt uncomfortable with or didn't get respect from. I know that some people I worked with would talk about me at home. I know I was mentioned in the book by Lana Turner's daughter, Cheryl. It appears she was a little bit jealous of me because she heard about me at home. Some of the people who were particularly nice to me in my career included Vincente Minnelli at Metro, June Allyson, Dick Powell, Elizabeth Taylor and some of the others I've mentioned like Edmund Gwenn. It was a different era. I think people still treat children well, but not quite the same. I never really had trouble with any of the directors.

Q: How about the other child performers?

DESCHER: No, we got along quite well. You see, we were a group somewhat apart. We were like small adults, and children not in the business sometimes saw us as being very different. So, we pulled together.

Q: Are there any other pros and cons to being a child star that you haven't mentioned?

DESCHER: There certainly were

far more pros. The only serious con is the danger that can come from publicity. I was threatened with kidnapping a number of times. There was one woman in particular who was stalking me. There was one time when she almost got me. She was deluded and thought that I was really her long-lost daughter. It was very bad and frightening. Things like that are hard to deal with. Even today, I remember talking to the FBI. You never know, when you are a face on the screen, when you might become somebody's obsession. But acting was a tremendous experience. I still love movies. *Babe* [1995] in particular is my new favorite. I think it is a great film. I don't think I have any bad memories at all about the films I made. I was lucky in particular with the two science fiction films I did, which were two of the classics. I have no regrets about any of the projects.

Q: Would you have any interest in becoming involved with films again?

DESCHER: I don't know about films, but I might like to get involved with some stage work. I might be interested in directing. Back in the Fifties, Ida Lupino was the only active woman director. Perhaps if I were more aggressive, or if there were other role models, I might have pursued directing as an adult. Unfortunately, I never explored my interest. But, if women were as active in directing then as they are today, I might have taken that path.

6

FAITH DOMERGUE

This Island Faith

For many years, it was assumed that the sensual, on-screen beauty of actress Faith Domergue could be traced to the French Quarter of New Orleans. Instead, Faith Domergue is actually of Irish-English origin. This charming actress is best known for a series of classic science fiction films from the fifties, including *This Island Earth* (1955) and *It Came from Beneath the Sea* (1955). She also maintains a thriving admiration among critics and film buffs for a memorable *film noir*, *Where Danger Lives* (1950), in which she played a "femme fatale" with murderous charms who bewitches Robert Mitchum. She also coiled her way into the hearts of many movie fans with *Cult of the Cobra* (1955), in which she played a supernatural,

avenging reptile who was able to transform herself at will into an alluringly beautiful woman. This film showcased both her sultry beauty and talent. Once billed as "one of the most exciting personalities to reach the screen," Faith Domergue was launched in motion pictures as a protégé of millionaire Howard Hughes in the late forties. Hughes, the famous industrialist-aviator-producer, spared no expense in promoting her talent during his term as boss of RKO Pictures. Domergue's career prospered with a memorable soft and fragile elegance all her own, and she appeared in numerous productions, including *Vendetta* (1950), *Duel at Silver Creek* 1952), *The Great Sioux Uprising* (1953), *This Is My Love* (1954), *The Atomic Man* (1955),

1761-22A0

A classic pairing: Hero Rex Reason and heroine Faith Domergue prepare to battle the Met-alunans in *This Island Earth* **(1955).**

Escort West (1959), *California* (1964), *Voyage to the Prehistoric Planet* (1965), *Track of Thunder* (1967), *The Gamblers* (1970), *Legacy of Blood* (1970) and *House of the Seven Corpses* (1974). She also appeared in a number of foreign films, such as *L'Amore Breve* (Italian 1969) and *Una Sull' Altra* (*One on Top of Another*, 1970).

Long before Faith blossomed into womanhood, the adopted daughter of Annabelle Quimet and Leo Domergue moved West to California in the early thirties. This fit in perfectly with her plans to become an actress. Being in the movie capital helped a great deal. Before she began pursuing her acting career, she finished her schooling at Beverly Hills Catholic School and St. Monica's Convent School. Upon completing her education in 1942, Faith started down the challenging road towards auditions, singing and playing piano. When a near-fatal automobile crash occurred, Faith's plans for a show business career came to a sudden stop. Eventually, she would pull through this ordeal. Her lucky break came while she was recuperating from the accident. While attending a party aboard the yacht of Howard Hughes, her unusual beauty captivated the elusive mogul, and she was signed to a long-term contract. Faith's three years of studying voice, diction and drama paid off when she was cast as the female lead in *Vendetta* (1950). This classic tale of Corsican murder and intrigue provided the perfect vehicle for Miss Domergue's introduction to motion pictures.

After completing *Vendetta*, Faith and her husband, Hugo Fregonese, whom she married in 1947, left for South America. Fregonese was himself a director, known for his films *Decameron Nights* (1953), *The Raid* (1954) and *Black Tuesday* (1955). Fregonese was born in Argentina, and he had previously directed a number of films there as well, including *Donde Mueren las Palabras* (*Where Words Die*, 1946), *Apenas Un Delincuente* (*Hardly Criminals*, 1947) and *De Hombre A Hombre* (1949). Faith and her husband traveled to Trinidad, Brazil and Argentina, before returning to the United States a year later. Faith gave birth to her daughter Diana in Buenos Aires in 1950. Faith's next memorable starring role was opposite Robert Mitchum in *Where Danger Lives* (1950), alternately titled *A White Rose for Julie*.

At one point in her career, Faith became unhappy with the lack of work in Hollywood and left the United States once again for London and Spain. Upon returning, she became a free-lance actress after her contract ended at Universal Pictures. After divorcing Fregonese, Faith returned to Europe and married a well-known international talent agent named Paola Cossa in 1966.

Until her death on April 4, 1999, Faith Domergue remained a very private person. It was only after her close friend Noreen Nash introduced her to Paul and Donna Parla that Faith felt comfortable enough with anyone to grant them an extensive, in-person interview about her career, sharing many stories and anecdotes never revealed before. In fact, she began the interview with the news that she only recently learned that she had been adopted.

DOMERGUE: Much to my surprise, and just recently in my life, I discovered that I was an adopted child. I've also just discovered my family and my true ethnic roots, which I'd always thought to be Spanish and French. I was adopted when I was six weeks old. My foster mother was a lovely woman, and she was married to Frank Monteleone, a very wealthy man who owned the Monteleone Hotel. After they were divorced, she married a wonderful man named Leo Domergue. When they learned that there was a baby girl they could adopt, they adopted me, as they did not want me to be placed through the usual channels for adopting children at that time. They were very loving, wonderful parents to me. She never told me that I was adopted. This was all meant to be, I guess. We came to California in the early thirties, and that is where I was raised. I came to consciousness in California. So it was only recently I found out that I am actually of Irish-English descent … brunette Irish. Or Black Irish, as we sometimes call it, and my English roots go back to Revolutionary War times. My ancestors settled in Virginia. Domergue was my adopted name. So I was surprised to learn that I do not have any French or Spanish roots.

Q: How did you begin your performing career?

DOMERGUE: I was just a child when my foster mother put me into a speech program at the Beverly Vista grammar school. This was a program for children who had speech defects, and I lisped very badly. When my speech teacher finally realized that I could recite, she realized that I could

act as well, and so did my foster mother, so I did all kinds of children's theatrical productions.

For a while I was with the Bliss-Hayden Theater and later went under contract with them. Then my mother joined a club in Santa Monica called The Delmar Club, and someone there who was an agent said to me that I was a beautiful child, that I had a lovely voice, and asked if I ever considered being an actress. Well, my mother wouldn't hear of it so I was sent, by myself, to talk to Henry Wilson at the Zeppo Marx Agency. Henry took me over to Warner Brothers to meet a man named Solly Biano, who was their head talent scout. He liked my appearance and introduced me to Sophie Rosenstein, head of the drama department. Then Sophie brought me in to meet with the head of casting. They gave me a test and signed me.

I immediately had to go back to high school because I was well under 18 years old. So I was enrolled in a little school at Warner Brothers. I didn't get to do anything really at this time except meet twice a week. This was when I first met Lance Fuller, with whom I later starred in *This Island Earth*. Around this time, Howard Hughes bought my contract from Warner Brothers and the Zeppo Marx Agency. Howard stopped all production on my career and made me finish my high school education with a private tutor. Although I never did theater, I did do a lot of dramatic preparation at this time and afterwards did *Vendetta*, released in 1950, which made me hate motion pictures.

Q: What made you feel that way?

DOMERGUE: There are a lot of unfortunate situations and sad memories connected with that film. I don't talk much about Howard Hughes. I think it is quite sad that it is the negative side of someone's life that is interesting to the public, and not the fact that he was one of the great contributors to aeronautics in this country since the beginning of this century.

Q: The recent film *The Rocketeer* [1991] featured Terry O'Quinn in a positive light as Hughes. What are your recollections of Howard Hughes?

DOMERGUE: All my memories of Howard are good ones. He was a nice man and made great contributions to his country. His life has been so maligned, and that's sad to me.

Q: What was your very first screen appearance?

DOMERGUE: I do want to mention one scene I did in a film for producer Hunt Stromberg, *Young Widow* [1946]. Mr. Hughes wanted me to get familiar with the camera and performing this way and this was mainly for the experience. It was one day's work.

Q: *Vendetta* had a very troubled road from script to final film. What was your part in the making of this film?

DOMERGUE: Howard wanted to make a film with me after I graduated from high school. *Vendetta* would turn out to be a tortured, horrible experience for me. Howard had formed a company with Preston Sturges which was called "California Pictures." Preston

was quite brilliant, and he had an idea to make a picture called *Colomba*. Preston Sturges was half-French, and he was very well-versed in French literature. Prosper Mérimée was a famous nineteenth century French writer who wrote *Carmen*, upon which the opera was based. Mérimée also wrote the original short story *Colomba*, which eventually became the film *Vendetta*. Preston approached Howard wanting to do *Colomba* and told Howard that he first wanted to do a film with Frances Ramsden, his girlfriend, and Harold Lloyd called *The Sin of Harold Diddlebock* [1947]. This picture was later cut to 79 minutes and reissued as *Mad Wednesday* [1950]. If Howard would allow Preston to produce and direct *The Sin of Harold Diddlebock*, then Preston would undertake *Colomba* with me. He told Howard, "I will make a star of her." Well, this is what one likes to hear, of course.

Q: Who was to originally direct *Vendetta*?

DOMERGUE: Preston originally chose a German director Max Ophuls *Letter from an Unknown Woman* [1948] to direct *Colomba*, and he started to work with Max on the script. It was a beautifully written script, heavy with dialogue. I worked with Max a great deal on the script before shooting started. Just before we were all ready to get to work, Howard was piloting his private plane and crashed into a house in Whittier and remained between life and death for weeks. Production on *Sin of Harold Diddlebock* was finished, and we had started

shooting *Colomba* way out in the valley. We all thought Howard was going to die. There was no doubt in anyone's mind, and now Preston had total control of the whole company. At this point something happened to Preston. He lost his bearing. So much hubris came into his actions, this arrogant pride. He and Frances Ramsden would go off on horseback for hours, and the whole company would just have to sit around. We would get only one shot in before the sun went down and then call it a day! Now, I had not made a picture before, so I was beginning to think that this is the way it's done.

Q: How did Max Ophuls cope with these developments?

DOMERGUE: Preston wouldn't allow Max to direct any scenes, but would give him director credit. Max would only be allowed to yell "action" and that was it! He never allowed him to say "cut" or instruct any of the actors. Max was suffering terribly over this. This situation kept getting worse and worse. People wanted to leave and the technicians didn't want to work anymore. Max had been a Jewish refugee from Germany. He would have been killed if he remained there. He needed this credit to work in America and here he is getting this awful treatment. He was such a wonderful director and I felt so badly for him. Co-star Nigel Bruce (known for playing Dr. Watson with Basil Rathbone as Sherlock Holmes) was getting short-tempered with it all. He and actor George Dolenz wanted to leave. This whole picture was supposed to be for my

benefit and here it was all going down the drain. We had been out there shooting for six weeks and we didn't have one completed scene. I once made 95 takes of one little short scene. Finally, one Friday when we were closing up shop, Max came into my dressing room and asked me if I could get a message to Howard to inform him as to what was going on. But I couldn't. I truly lost the "sacred fire" making this picture, my first film, so I wrote a letter about all this to Howard's secretary, Toni Guest. When I came to work Monday morning, all of Preston's people were packing up and leaving. The entire company had been dissolved and, alas, Max was with Preston's company. He was fired, too. There remained George Dolenz, myself, Howard's people, and the money they had put up for the film.

Q: How did things proceed? Did they hire another director?

DOMERGUE: Yes, they hired a nice gentleman named Stuart Heisler, who directed *The Monster and the Girl* [1941], *The Glass Key* [1942] and *Along Came Jones* [1945]. But Stuart never really got started. We laid off ... then we went back and shot some close-ups. Then we laid off again and came back two years later and shot some nice stuff with Mel Ferrer as director. He took credit now and shot six weeks of retakes. By this time, I was married in 1947 and totally lost the enthusiasm of being a star and I never got it back. I wanted to bail out totally from the industry. I did all that I could do and left for South America with my husband, Hugo Fregonese.

Q: Was Hugo ever considered to take on *Vendetta*?

DOMERGUE: No. Hugo was a director under contract to MGM. He originally came to the United States in the late forties, when we met and got married. Hugo was the only one in his family born in Argentina. He was actually of Northern Italian descent. He was in the Joe Pasternak unit of MGM, and he was very unhappy there. When he turned down a picture called *The Kissing Bandit* [1948] with Frank Sinatra, the studio got so angry at him that they dropped him. He wanted me to go back with him to Argentina. I was very pissed off about *Vendetta*. I was doing one of a series of many retakes when I told Howard's company that I was leaving after six weeks of retakes. They didn't believe me, but I had a plane ticket to leave after the six weeks were finished—not knowing I was also pregnant. Not feeling well at all, I arrived in Buenos Aires, and soon after Hugo started work on a film called *Apenas Un Delincuente* [1947] or *Hardly a Criminal*. Hugo wanted me to do a little part in the film. Suddenly, I started looking very pregnant, and there is a scene where I'm seated at a gambling table and the table came up to my waist so my pregnancy wouldn't show. A famous Argentinian producer who had been there rushed over to my husband and said, "I want to star that girl in my next film!" When I stood up, he saw my condition and yelled, "No, no, no, I won't!" [*laughs*] I had wonderful times there, but I just wanted to stay away from motion pictures and be with my husband.

Q: Any other thoughts on *Vendetta*?

DOMERGUE: The *Vendetta* experience was still fresh on my mind. All that time and money wasted. By the time this was all over, I had no drive left and to be perfectly frank, I lost my first child because of *Vendetta*. I had a miscarriage and this was very heartbreaking. *Vendetta* is not a good film but we were all quite good. Unfortunately, all of the performances that Max Ophuls and I worked on went out the window. What you see in the final version is bits and pieces of everything, but nothing of what Preston shot at all, except a couple of long shots.

Q: It was actually your husband who brought you back to Hollywood?

DOMERGUE: Hugo went under contract to Universal after our daughter was born in 1950. *One-Way Street* [1950] with James Mason, Dan Duryea and Marta Toren was the first film Hugo directed in America. He then did *Saddle Tramp* [1950] with Joel MacRae, and *My Six Convicts* [1952] with Gilbert Roland and John Beal. Hugo directed Gary Cooper and Barbara Stanwyck in *Blowing Wild* [1953], as well as numerous others. When I returned from South America, I reconsidered my decision and returned to films. I went under contract to Howard Hughes and RKO, and he gave me *Where Danger Lives* [1950].

Q: That picture, co-starring Robert Mitchum, is something of a *film noir* classic.

DOMERGUE: *Where Danger Lives* was an interesting film. I felt I was much better in it than in *Vendetta*. I played a psychopath, and I loved the role. It expanded my range. The director, John Farrow, was a very impressive fellow. He did many films, such as *The Big Clock* [1948] and *Night Has a Thousand Eyes* [1948]. John also had a great personality. He was a very attractive man who was beautifully educated and beautifully spoken. He carried a swagger stick, and we became good friends. After we finished the picture, John and Robert Mitchum sent me a little gold medal, and on the back was written, "from the other men in your life." My romantic rival in the film was played by Maureen O'Sullivan, who was John's wife.

Q: Things worked out well with Robert Mitchum too?

DOMERGUE: Robert Mitchum was wonderful, and we had a marvelous time making *Where Danger Lives*. He was my best friend on the set.

Q: The other star was Claude Rains. How did you enjoy working with him?

DOMERGUE: Claude Rains played my husband in the film, and we had some difficult scenes together. I remember clearly there was one scene where I attempt to smother him in one take. There was one insert, a close-up, that was added later, but the sequence ran about 12 minutes, and we did it in just one take. It was quite a lesson in histrionics. Mr. Rains was a very formal man, indeed. You didn't call him Claude! He was always prepared and he learned his lines right down to the last apostrophe! [*laughs*] Sometimes we ran through scenes on the set at night with new lines added. We would have a fresh scene written every night and we would rush to our dressing rooms to re-learn the newly added lines, because we were to film the scenes in the morning. Claude Rains found this difficult. He was never bad-tempered, but was very structured. He was a splendid actor. Just prior to the scene where I am supposed to smother Claude, there was a dramatic moment where I pull an earring out of my ear and declare, "He's done it!" There was supposed to have been violence between us both before. It was high hysteria. Well, Mr. Rains brought nuances to his role of the husband that were just incredible. But I didn't know how to approach it exactly. After we shot the scene, Robert said to me, "I like you. You don't know what you're doing, but you're in there doing it with all your heart!" [*laughs*] Robert threw every scene he could my way. He watched out for me. He watched the camera. He watched the shadows. It was fantastic.

What was not so fantastic was the fight I had with RKO. There was an enormous publicity campaign afterwards, and millions of dollars were spent. I was on practically every magazine cover there was at the time ... 15 pages in *Pageant* magazine, four pages in *Life*, the cover of *Look* ... you name it. Howard Hughes wanted to do a

Faith Domergue in *Where Danger Lives* **(1950).**

five million dollar publicity campaign once he knew *Vendetta* and *Where Danger Lives* were in the can. Perry Leiber was in charge of this campaign. I also worked on this the year prior to the release of the film, and I came to dislike it intensely. It was very consuming. I started to become difficult. I had given a lot of thought to having another child, a brother or sister for my little daughter. I thought this was the time to do it. But I was traveling all over the country, presenting myself in a manner that wasn't the real me. David Selznick, at one point, wanted to sign me. I thought it might have been better for me since Selznick managed actresses who were more my type. Howard Hughes had types like Harlow and Jane Russell, and I felt I didn't fit into that frame of actress.

Q: Did any particular event bring these problems to a head?

DOMERGUE: Yes. By the end of 1950, I was being very difficult. RKO had scheduled the New York openings of *Vendetta* and *Where Danger Lives* at the same time. I'd just come off a ten-city tour and I was tired, angry and pregnant. I told the studio I wouldn't go to New York. Then Howard phoned me and said that there was a lot of money tied up in this campaign. When I told him I was going to have a baby he said, "OK, good-bye, Faith," and that was the last time I ever heard his voice. Both films came out and were not successful. I had my baby, and Howard loaned me out to do *Duel at Silver Creek* [1952]. Then I asked to be let out of my contract. I still had

five years to go on it, but they obliged me. My husband was going to Rome to do a film production with producer Mike Frankovich, and we left for Europe. When I came back to the U.S., I signed a two-picture-per-year contract with Universal, a contract that allowed me to do independent work as well.

Q: You have developed a vast following of devoted fans due to the three films you made in 1955. *This Island Earth* was the first one. How did you feel about it?

DOMERGUE: *This Island Earth* seems to have attained more popularity than anything else I have done, despite the fact that this was not a showcase film for an actress. It is a film for the technicians. It is the special effects and the photographic tricks that take center stage. It is still a beautifully-done film, and was amazing for the time it was made. It had been done on the biggest set in the world, the old *Phantom of the Opera* set. They built the whole surface of Metaluna on it. They didn't shoot it in matte or with tricks, they shot it right on this huge set. It was extraordinary and quite dangerous at times. All of the lightning, explosions and fire that you saw were, of course, under control, but were actually happening right there on this enormous set.

Q: How did you become involved with this production?

DOMERGUE: *This Island Earth* was part of my two-picture-per-year deal with Universal, and I wasn't too

pleased about it. I had left RKO in a rather abrupt way and Robert Goldstein, a good friend of mine and twin brother of producer Leonard Goldstein, were both at Universal. Robert often tried to get me on loan from RKO for other films but they wouldn't let me go. The first picture I did at Universal was *The Great Sioux Uprising* [1953] with Jeff Chandler. I didn't like doing this film. So my agent came to me and told me that there was one other film they would give me and then I could get out of my contract with them if I wanted. So I asked, "What is it called?" and they replied, "*This Island Earth.*" I was surprised and told them that this was not what I had in mind! Well, I signed and did the picture. My agent told me that it had a lot of money behind it and an interesting director, Joseph Newman, who was very bright and very keen on the script, and I wouldn't be sorry, and that I had no choice anyway! [*laughs*]

Q: What was the shooting schedule on that production?

DOMERGUE: I was on the set every day with the exception of one short portion at the beginning. After that, I worked every single day that the film was shooting. I was never so weary in all my life. We worked six days a week. I'd go in at six in the morning and get out at six at night, so they wouldn't go overtime with me ... but they did once in a while. When we shot the exterior scenes on the back lot in the lake, I'd work 13 or 14 hours. It was the coldest lake in the world as far as I'm concerned, because we shot when the sun went down. Knowing

that I had to get into the water, I spent a lot of time trying to keep the technicians from spitting in the lake! [*laughs*] No mishaps or accidents, thankfully, and no, I never sprained my foot as it's been rumored. I was very agile. *This Island Earth* took about two months to film in 1954, I believe and I missed the first 15 days or so, but it wasn't the length so much, it was the way it was scheduled. The amazing thing about the popularity of this film is that in the 30 years I lived in Europe, I paid no attention to being an actress. But every place in Europe where there was a science fiction festival, this film was at the top of the roster. It's been dubbed into many languages.

Q: How did you like working with the director?

DOMERGUE: Well, Joseph Newman was an excellent director, very tough and demanding. He knew what he wanted and he articulated it well. I had no problems with him. He did, however, have some difficulty with Jeff Morrow because Jeff's part was pivotal to the story. Jeff had his own ideas about how to play his character, the head alien Exeter, and Joe had his own ideas. They clashed a number of times.

Q: What did you think of Jeff Morrow as the alien?

DOMERGUE: I thought Jeff was splendid. Jeff was a very good actor and took his work very seriously. Joe Newman knew what he wanted and wouldn't tolerate any discussions about

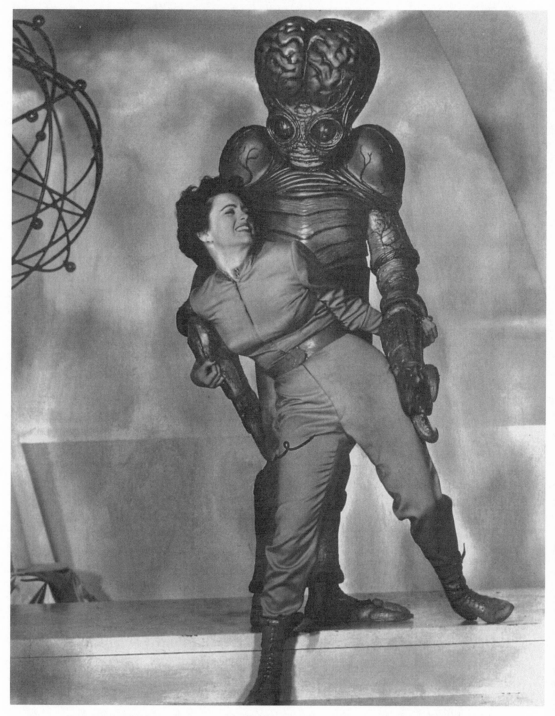

"Regis Parton (the mutant) was an adorable guy. He would walk around the set in his monster costume holding my children in his arms." Faith Domergue and Regis Parton in *This Island Earth*. Regis Parton died in California in 1996.

it being done differently. I feel this is why the picture is most unusual and was so successful, partly due to the effects but also due to Newman's handling of it. But Jeff and Joe clashed a number of times. I remember them clashing during the scenes when we were going from one part of Metaluna to another in the tram vehicle. Jeff wanted to make it clear at this point that he was not going to kill us and wanted to save us. He wanted Exeter to be much more tender and caring about our safety. But Joseph wanted this shown later, when we met the "monitor." Jeff wanted to introduce more emotion into Exeter and really lost his temper at times. But they were professionals, and got over it.

Q: Any memories about your other co-workers?

DOMERGUE: My character was a very simple black and white, in color, character. I was the romantic interest and tried to give her as much color as possible. I had my own little feud with the production manager one day because I thought he was pressing us a bit hard. On the day that we shot the scenes with Rex Reason and me in the lake, we finished these shots around 5:30 in the evening. It was starting to get dark, windy and cold. I was covered in mud from the water and when I went under the water, I came up with mud and silt all over me … just filthy. We did our work for the day and we just wanted to go home. The production manager thought we had more time to shoot and instructed us to go back to the make-up department, get cleaned up and have fresh

make-up applied. I was just not going to do this! I was so tired and thought about calling my agent, but I agreed to go into make-up. The wardrobe girl literally had to peel my clothes off me, put me in the shower stark naked, and start scrubbing me down with these huge sponges. After I was dressed, make-up artist Bud Westmore put the finishing touches on me. At this point I was so tired I could barely stand up. Then the production manager walks in and calls a break! I thought I'd hit him, but I didn't, of course. He was making time with the front office and I thought that was pretty greedy on his part. I was pissed off for at least a week.

Q: The mutant monster in *This Island Earth* is one of the most memorable creations from any fifties science fiction film. What do you recall about this actor?

DOMERGUE: Regis Parton played the monster. Reggie was an adorable guy. I would often bring my husband and children to the set. Reggie would pick up my children in his arms and walk around with them in his monster costume. My children were quite young at this time and when we all went to see the film in Rome, my children just could not connect the monster with the man who was playing with them on the set. They got hysterical when they saw their mother being attacked by the mutant. The sequence that stands out in my memory is when the mutant chases me around the platform of the spaceship. Doing this scene with Reggie was much more violent than what appeared in the final

version. I was thrown around that set and I was black and blue from head to toe. My body looked like someone had gone over me with a rubber hose. By this time, we were well into the film and I was excited about it all, the adrenaline was flowing with Reggie and me. He was a big guy to begin with and in the costume, he became even larger. I was given some nasty bruises when it was all over. It was even more exciting the way we originally shot it, but they wanted to get on with the rest of the spaceship sequences and not dwell so much on the struggle between the monster and me. That monster costume was superb. I remember it was green and the exposed brain area was green and red.

Q: That outfit you wore in the later scenes was rather stunning. Did it cause you much difficulty?

DOMERGUE: Oh, those outfits we wore were skin tight! We changed to them before we landed on Metaluna. I had problems getting into mine, and wearing panties under them would not work because they would show, as was the case with anything I attempted to wear under it. So I told the girl who was dressing me that I had an idea, and simply removed all of my clothes and put the skin-tight silver costume back on over my bare skin. I jokingly told her that if she caught me in the zipper I was going to replace her. [*laughs*] so she zipped me up and not a line showed. Then I went stark nude into my suit and it became difficult to sit down. At this point, I asked them to build special leaning slant boards to

rest on for the scenes that had Rex, Jeff and me seated in our chairs aboard the spacecraft. Later I asked them to put armrests on my chair, so they added armrests onto all of them. It was quite painful to sit down while dressed in this costume because the zippers could jab into my flesh, so in order for me to sit down after our scenes were done, I'd have to strip down and wrap a blanket around me so my hairdresser could do my hair and get me ready for another scene.

Q: Was there much of a grand opening for the picture?

DOMERGUE: I wasn't able to attend the premiere of *This Island Earth* because by the time the picture was ready, it was June of 1955 and I had already left for Europe. I spent two and a half years in Rome and London. It was in Italy that I saw the completed film of *This Island Earth*.

Q: Your next science fiction film is one of the most memorable, concerning a giant octopus. Your performance as the scientist was a rather strong role. What do you recall about the making of *It Came from Beneath the Sea* [1955]?

DOMERGUE: I did *It Came from Beneath the Sea* just before *Santa Fe Passage* [1955] and then *Cult of the Cobra* [1955]. I don't think I had one week off during the whole first half of 1955. We went up to San Francisco and they wouldn't let us shoot on the Golden Gate Bridge because the giant octopus in the film partially destroys a model of the bridge. City officials became insulted about it, so we went and shot on some minor bridge. Ken

Tobey was very nice to work with and so was Donald Curtis, who was a preacher of Religious Science at that time. I was also interested in Religious Science and was the first one to speak to Donald about it.

Q: What did you think of the picture?

DOMERGUE: *It Came from Beneath the Sea* was a good little film. I enjoyed making it because I really like doing all of those scenes in the briefing rooms, and all that wonderful dialogue I had that sounded so scientific. I got a chance to travel in a submarine for the first and last time in my life. It was terrifying.

Q: What are your recollections of the other individuals who made the film?

DOMERGUE: Robert Gordon was the director. He was older, but very nice and somewhat old-fashioned. The producer, Charles Schneer, was an interesting sort of guy. He went on to do some films in England. I had a beautiful yellow chiffon dress to wear in this film which had been photographed for *Life* magazine. Schneer wanted me to wear a necklace and I thought the look of the dress, which was strapless, and my hair didn't call for a necklace. The director was on my side in all this. He was sort of a fan, and he told the producer that I should look free and flowing. So I got my way.

Q: Did you ever get to meet Ray Harryhausen, who did the special effects for the film?

DOMERGUE: No, I never did, but I thought the special effects were wonderful for the time, though primitive by today's standards. I don't think they were anything to compare with *This Island Earth*.

Q: You then went straight to work on *Santa Fe Passage* [1955]?

DOMERGUE: Yes. We shot most of that film in Utah. We had returned to Los Angeles to shoot some interior scenes at Republic when my agent approached me and told me that Universal was unhappy with the lead for a film called *Cult of the Cobra* [1955].

Q: *Cult of the Cobra* is now one of your best remembered films.

DOMERGUE: That picture is not a fond memory for me. My marriage to Hugo was starting to break up. He was in Europe and I was here. I told my agent (Ed Henry at MCA) that I had to keep busy. I had just completed *Santa Fe Passage* [1955], with a wonderful director named William Witney, who was the best director I've ever worked with. Mari Blanchard, from *Abbott and Costello Go to Mars* [1953], was originally in that role. She had begun shooting *Cult of the Cobra* and I replaced her while I was still working on *Santa Fe Passage*.

Q: Did that present much of a problem?

DOMERGUE: Since Universal and Republic were close to one another, I did my preparation for *Cult of the Cobra* on my lunch hour, going back and forth for about two weeks. One day, I got confused and was supposed

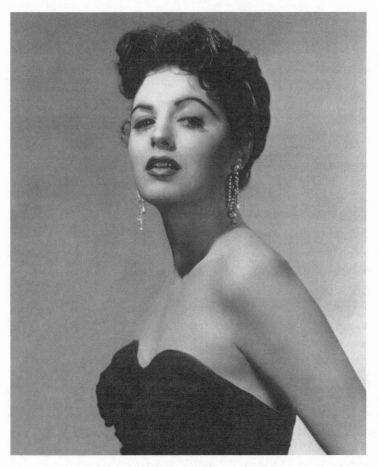

A role which had originally gone to the late Mari Blanchard in *Cult of the Cobra* (1955) was given to Faith Domergue. Although the film was not a pleasant memory for her, Miss Domergue made a most seductive villainess.

this happen right in the middle of production was awful. They couldn't do many close-ups because I looked so weary from it all. My marriage had gone to hell.

Q: Another one of your science fiction credits is *The Atomic Man* [1956]. This is an unusual story of a scientist who has an accident, and when he recovers, his mind has slipped five seconds into the future. So when he talks, he gives an answer to a question before it is asked. It had an alternate title of *Timeslip*. What do you recall about it?

DOMERGUE: I went to England to make that film. It had a very good director (Ken Hughes) and I thought it was a good film, though the pace was slow, actually very slow. I recall it was freezing cold, but it was done very quick, so there's not much to mention about it.

to show up at Universal but wound up at the Republic gate! [*laughs*] Talk about keeping busy! At this point it seemed as though I was trying to be the richest woman in the graveyard. [*laughs*] Then during the middle of filming *Cult of the Cobra*, my husband returned from Europe and we divorced. This became quite disturbing for me and by the end of shooting, I wasn't sleeping very well. Joanne, my hairdresser, God love her, was doing her best to pull me together. Having

Q: Did you do any other pictures in England?

DOMERGUE: Right around the same time I made *The Atomic Man,* I also did a film in England called *Spin a Dark Web* [1956]. I played the queen of a group of racketeers with Lee Paterson. It was sort of a *film noir* and we

shot it at a studio outside of London at Walton on Thames. I used to take my children out to the banks of the river Thames and picnic. Richard Greene was working at the same studio at the same time filming *Robin Hood*. Another film I did in England in 1957 was with Zachary Scott called *Man in the Shadow*.

Q: The title of that film was changed in the United States to *Violent Stranger* because there was another film called *Man in the Shadow* starring Orson Welles. Your film was also a *film noir* where you played a woman whose husband was unjustly convicted of a crime. She locates the evidence to clear him, but finds herself blackmailed by the man who has the evidence.

DOMERGUE: It was pleasant working with Zachary Scott, but nothing memorable happened while shooting the film. This period in my life became an active time because I was a single mother with children to support. I also did a lot of television work, particularly a large number of Westerns.

Q: Do any of these television appearances stand out in your mind?

DOMERGUE: Only one, but not due to the show. I was filming an episode of *Bonanza* [1959–73] when the news came that President Kennedy was assassinated. The episode was called "The Lonely House," and everyone involved in that episode will never forget that awful day. We laid off for three days, but no one could really function well after we resumed shooting.

Q: Let us turn to the numerous Western films you have done in your career. Do you have any specific memories of them?

DOMERGUE: I enjoyed making Westerns. I'd been riding horses since I was six or seven years old. My father would take me riding way out in the San Fernando Valley. He had me jumping little single-saddle jumps, and on *Vendetta* I learned side-saddle. I am a good horse-woman. I did all of my own riding whenever I could, to the dire fear of the production people. They knew I could ride quite well, so they let me get away with murder at times. My first Western was *Duel at Silver Creek* [1952], and it was a fun film. Leonard Goldstein produced it. Leonard had been producing a lot of the films that Hugo was directing. And Don Siegel was a great director and a man with a lot of patience. Don later made the classic *Invasion of the Body Snatchers* [1956].

Q: What most impressed you about this film?

DOMERGUE: I thought I wore the most beautiful clothes for *Duel at Silver Creek*, the best wardrobe since *Gone with the Wind* [1939]. One day, I was wearing a gorgeous gown for a scene. My character's name was "Opal" and I was wearing huge opal earrings which practically went down to my shoulders. We did the long shots in the morning and I went to lunch, removed my earrings, came back later and started shooting my close-ups. After two hours of shooting, I realized that I didn't have my earrings on. It wasn't going to match the morning

shots we had done. The continuity would be all wrong. Well, this was not my problem, really. It was the responsibility of the script girl and wardrobe. Most directors would have made an awful time for those girls, but Siegel was quite reserved about it and asked me to get the earrings back on so we could move ahead to correct it.

I did have one dreadful experience on this picture. I did a lot of riding on this one, and we were shooting out at Vazquez Rocks (outside of Los Angeles). There was a posse following us in one scene, and my horse slipped at full gallop. If I had fallen, I would have been killed. When the insurance company found out I was riding, they would no longer let me do scenes like that.

Q: do you have any other anecdotes from your Western films?

DOMERGUE: We shot *The Great Sioux Uprising* [1953] in Pendleton, Oregon, and my fondest memory of this film is that they used fishermen from the Umatilla Indian tribe. They never rode horses, they fished, and here they were playing Sioux Indians, who were the greatest horsemen of all! When we would have a run-through for the camera, we had more Indians hurt because they were flying off the horses and were scattered around the field. They were excited about doing it and wanted to work but did have their problems riding horseback. Victor Mature also had a problem riding in a later film called *Escort West* [1959]. Now, I would have thought Victor Mature would have been a great rider,

but he was terrified of horses! [*laughs*] He couldn't ride. I laughed about it and thought he and I wouldn't hit it off. But he had a good sense of humor and laughed about it himself. He would get up on the horse, but not before two people held him on both sides. [*laughs*] Victor had such a winning personality.

Q: Which was your favorite Western?

DOMERGUE: My memories of *Sante Fe Passage* [1955] are just great. It was a lovely experience and among my best films. We were filming out in Mormon country in St. George, Utah, with Rod Cameron and John Payne. I also worked in that film with a most wonderful director named William Witney, who was the best director I've ever worked with. The plot was about a group of men trying to run horses through a passage to Sante Fe to make money. I recall the actor who played the Apache chief was of Greek descent. He played him wonderfully, but he had a very hairy chest. Since Indians don't have hairy chests, and he wasn't going to part with his hair, they made him a beaded vest to cover it up. It worked, since the vest fit the time period as well.

Q: You were one of the stars of *Voyage to the Prehistoric Planet* [1965], a low-budget science fiction film that incorporated footage from a Russian movie called *Planeta Burg* [*Planet of Storms*].

DOMERGUE: The company that made *Voyage to the Prehistoric Planet* had purchased the Russian film and combined scenes from that with our footage, which we shot in Los Angeles.

Basil Rathbone was also in it. There really isn't too much to tell about it because it was one of those fly-by pictures that we just wanted to get behind us.

Q: After this film, you married for a second time.

DOMERGUE: In 1966, I married a beautiful man named Paolo Cossa, and we had 30 wonderful and cherished years together. He passed away recently, and I miss him dearly. I only worked sporadically after our marriage.

Q: What are your memories of some of your later, lesser-known films? Which one stands out, in your opinion?

DOMERGUE: *L'Amore Breve* [1968], the first film I made in Italy, was a hell of a movie and turned out to be my favorite film experience. We filmed it in Trieste and my scenes were done at the Cinecitta Studios, where Federico Fellini did many of his films, and in a place called Gorizia, in the house where Ernest Hemingway wrote *A Farewell to Arms*. This was a beautifully sensitive story. I played a Trieste socialite, a beautiful and desirable woman of good family, and Joan Collins played my best friend. My son in the film was played by Mateo Carre. He is a boy of 18 who realizes that he is in love with his mother. The boy later meets the mother's best friend and becomes attracted to her. The mother, being quite decadent, becomes jealous. Her friend falls in love with the boy and has a passionate affair with him. At the end of the film, he reviews his life and decides to leave.

Q: This picture was also known as *State of Siege*?

DOMERGUE: Yes, but it was eventually released in America under the disgracefully embarrassing title of *Too Hot to Trot*. The original title, *L'Amore Breve*, literally means *The Short Love*, and it told the story of a boy in a state of siege over this relationship. He is a lovely boy with a brilliant and bright future but realizes that he could never remain in that kind of decadent and suffocating atmosphere. The film was also built around the social collapse of Trieste, which had a Communist director. We shot it in half-Italian and half-English. Aside from the film being very "in" for the time and quite odd, it was not successful, which broke my heart because I had such high hopes for it.

Q: How did you get along with Joan Collins?

DOMERGUE: Just fine. I thought Joan was sensational. Joan and I had some semi-nude scenes and we agonized over just how we were going to do them. Joan helped me a great deal with my performance. She was much more experienced than I, and very generous. There is a scene with Joan where I tell her about my son's affair knowing he is involved with someone else, but not realizing it is Joan. We are dressed very beautifully, and I am showing her a section of my mansion, while talking to her about this affair.

My character was a shallow woman, very proud of her wealth. I was also jealous of this secret affair. It was quite difficult to convey all of this all at the same time. I did not want to play her pleasantly. Joan helped me to create a balance between these various aspects.

Q: Frank Wolff was also in this film. He was a remarkable actor who also did a number of films for Roger Corman.

DOMERGUE: He was a wonderful actor who later tragically committed suicide. My husband, Paola Cossa, was handling an actor in a film called *The Story of Giuliano*. Frank was also in this picture, and he played magnificently in that film as well.

Q: How long did you work on this film?

DOMERGUE: We lived in Trieste for two months and we really got to enjoy the location. Trieste is a great city. It was one of the centers of the world and had enormous money and great palaces. We shot in one of the aristocratic palaces, which added to the beauty of the film. I would love to see it again. I haven't seen *L'Amore Breve* since I finished making it.

Q: What were some of your other foreign films?

DOMERGUE: I did *The Gamblers* [1970] in Yugoslavia and that was a fun experience. *Una Sull' Altra* or *One on Top of the Other* [1971] was another Italian production in which I appeared. It was actually shot mostly in San Francisco. Elsa Martinelli and John Ireland were also in it. We shot scenes at San Quentin prison, in the death chamber. I don't know how the Italian film company got in there to shoot, but we did, and out of curiosity I sat in the gas chamber seat. The chair was apple green, as was the rest of the room. Afterwards, John and I had to do a scene in the teaching mortuary! When John realized that there were dead bodies in the room with us, he left. [*laughs*]

Q: What can you tell us about *The Man with the Icy Eyes* [1971]?

DOMERGUE: We went out to Albuquerque, New Mexico for that film. We worked out in the desert. Barbara Bouchet, from *Casino Royale*, had a scene where she was dressed in a summer top and shorts, and this was on a cold December day! Birds were literally dropping from the cold and we thought she would as well, due to these terrible conditions.

Q: Some of your other genre film titles include two low-budget shockers, *Legacy of Blood* [1971], and *House of Seven Corpses* [1974]. Any reflections on them?

DOMERGUE: I had the pleasure of working with John Carradine in both of those films. At that time, he was very arthritic and handicapped and looked almost skeletal. We wondered how he would do the scene where he opens the film in a monologue while coming down a touring staircase. But he was such a trouper and did it with grace and style. There was another scene in which he had a bookcase fall

over on him. We thought he would really get hurt, but he did splendidly.

Q: Did you ever turn down any film roles which you later regretted?

DOMERGUE: No, but I missed out landing the lead role in *The Egyptian* [1954] opposite Edmund Purdom. Of course, Jean Simmons did it. But there was a moment when Jean was not going to do it. Ed Henry, my agent, took me out to see the director, Michael Curtiz. Curtiz wanted me for the part, and thought I would be better suited for it because I was darker. I thought I had the part, but I never got it and I was heartbroken. I loved the character and I loved the costumes, but it was not meant to be.

Q: Looking back on your career, is there anything you would have done differently?

DOMERGUE: Well, I would not have gone back with RKO when I returned from South America. Instead, I would have gone to New York to do

theater. Although I'd done a number of live television performances, I did not do any theater. My whole career got off to a peculiar, difficult start with *Vendetta* and having lost my first unborn child while making that picture, I really soured on wanting to become a really good actress. The inner drive was gone.

Q: How do you feel about being remembered primarily for your science fiction films?

DOMERGUE: I'd have to say that it's fine with me. Doing those pictures was never a black spot on my career. They simply became work. Gosh, if I'd had any idea at the time that these kinds of films would be so popular and so remembered, I would have tried to go on and make bigger and better ones. But it is always nice to be remembered for your efforts. The thought of making appearances at shows and film conventions does not interest me at this point in time, but I do appreciate the interest so many seem to have in my career.

7

AMANDA DUFF

Karloff's Screen Daughter

The young woman is sitting at a table in a laboratory where a number of corpses are attached to some strange equipment. Her father, Dr. Julian Blair, warns her that he will need to use increased amplification in this experiment. But he assures her that he will succeed, and that they will hear the voice of her dead mother. Dr. Blair then places her head in a strange helmet, the same type of helmet worn by the dead figures at the table. They are like a series of tubes in a bizarre circuit board. Dr. Blair turns on the equipment, and an other-worldly whirlpool forms at the center of the table. Dr. Blair straps himself in near the control panel and calls out again and again, "Helen! Helen!" Then we hear the voice, scratchy at first but increasingly clearer, "Julian! Julian!" Below, on the grounds, an angry mob has formed and plans to break in and discover what strange and unnatural experiments are being conducted. Dr. Blair continues to raise the amplitude when suddenly one of his electrical devices explodes ... and then another and another.

This is the climax of *The Devil Commands* (1941), an unusual and somewhat bittersweet horror story about a man pushed to the brink to communicate with his dead wife. The scientist, Dr. Julian Blair, is played by Boris Karloff, and his daughter, Ann Blair, is played most effectively by Amanda Duff. The scene combines many of the standard elements of the early horror film: an isolated gothic house on a cliff overlooking

Karloff commands, Amanda Duff obeys in *The Devil Commands* **(1941).**

the sea, an angry mob threatening to storm the grounds, and a crazed scientist risking everything to complete a desperate experiment to contact his dead wife. But there are different elements. Karloff's Dr. Blair is more heartfelt, more gentle and more sympathetic than his usual mad scientist turn. Amanda Duff is also a stronger character than the usual passive daughter. In many ways, she is the key to the story. The film is presented through her eyes. In fact, she narrates the film, perhaps a deliberate parallel to Hitchcock's *Rebecca* (1941), which was a tremendous hit. This film remains one of

the most remembered in the career of Amanda Duff. She prides herself on not only appearing with Karloff in *The Devil Commands* (1941), but has the fondest memories of Karloff the individual, whom she got to know away from the hot and hectic soundstages of Hollywood.

Q: When and where were you born?

DUFF: I was born in Fresno, California, in 1914.

Q: How did you get started in films? Was a screen career one of your main ambitions?

DUFF: No, I really never took my acting career as seriously as I should have, I guess. Got into films because in 1930 I had been appearing in a stage play in New York called *Tovarich*. A man named Al Melnick, who later became my agent, made the offer to me. He said that 20th Century–Fox had been short on actors at the time, and they needed to develop talent, so I went.

Q: What was your first film?

DUFF: I made my screen debut in *It's a Deal* [1930].

Q: What were some of your other films?

DUFF: I starred with Shirley Temple in *Just Around the Corner* [1938]. It was one of the last of the Depression-era comedies, as Shirley tries to get a rich tycoon to start a job creations program. Irving Cummings was the director, and many well-known performers were in it, like Joan Davis, Charles Farrell and Bert Lahr. Bill "Bojangles" Robinson was in it too, and that was one of the films where Bill and Shirley danced together. The picture had another title when filming started. It was *Lucky Penny*. I also enjoyed doing *Hotel for Women* [1939].

Q: That picture also had a different title while being filmed.

DUFF: Yes, it was called *Elsa Maxwell's Hotel for Women*. Elsa was a well-known columnist and socialite at the time. She played herself in the picture. Ann Sothern and Lynn Bari were also in it. It was Linda Darnell's screen debut. One thing about Linda Darnell I can recollect was that she was very nervous and somewhat scared when the talent scout brought her in for *Hotel for Women*. She was very pretty and charming, but she was just so nervous about the whole thing. You know, I have never felt comfortable acting in pictures myself. On the stage I felt fine, but with pictures I was uncomfortable.

Q: Another of your titles is *Escape* [1939].

DUFF: That was a smaller role in a Norma Shearer film. It was about Robert Taylor trying to get his mother out of a concentration camp before the war. Norma played a countess who had influence over a Nazi general played by Conrad Veidt. Then I was in another film called *City of Chance* [1940].

Q: Are you surprised that two of your most remembered films are *Danger Island* [1939] and *The Devil Commands* [1941]?

DUFF: Yes, indeed. At the time, I would never have picked these two as ones that I would be asked about in a interview over 50 years later.

Q: Let us consider *Danger Island* for a moment. That was one of Peter Lorre's series as the Japanese detective Mr. Moto. What part did you play in the film?

DUFF: I played Joan Castle, the heroine of the mystery, which was set in Puerto Rico. Mr. Moto came there to track down a syndicate of diamond smugglers.

Q: What was your impression of Peter Lorre.

DUFF: Now, Peter Lorre was quite nice, but quite sly in a very funny manner! He would always be poking fun at things, in a harmless way of course. He loved to conduct practical jokes, like putting something in a small box that would fly out when you opened it and give you a jolt! Those sorts of things. He was also very nice to work with. His disposition, from what I can remember, was always pleasant. I never saw temper bouts or anything like that. There was something about Peter Lorre though that I remember to be a bit strange.

Q: What was that?

DUFF: He could never understand why I had taken an apartment so close to the studios at that time. [*laughs*] It was mainly for convenience, of course, but he always said that he wanted to live as far away as possible from all the studios. Back then, I may not have been as observing of why he may have felt this way, but possibly it could have been due to the demanding nature of his work. After his work was finished for the day, he enjoyed keeping his distance from the chaos of the industry.

Q: The plot of *The Devil Commands* concerns a kindly old scientist, Dr. Blair, who has been trying to measure and record brain waves. After the death of his wife, the doctor is amazed to discover that he still can record his dead wife's brain waves.

DUFF: That is because I was in the next room. I play his daughter. In the film, Boris goes into seclusion to pursue this experiment. Anne Revere plays Mrs. Walters, a medium, who Boris uses in his experiment. It isn't until the end of the film that Boris realizes that it is my presence that is essential to his efforts.

Q: You also did the narration throughout the picture. It works quite well, and makes the core of the film your concern for your father.

DUFF: Doing the narration was the simplest part.

Q: How did you get the part?

DUFF: At the time I did *The Devil Commands* [1941], it was simply a contract assignment to do one picture, so I was put into that film. You must remember that this was a tough time too for many people, not only actors but everyone. Back then, people appreciated having the work ever so much, so you basically did what was available. There wasn't anything scientific about the process, just because Boris Karloff was appearing in the film. It was just a job and a most welcome one at that for the times we were in. When I did *The Devil Commands*, it was not the first time I had met Boris Karloff.

Q: How did you come to know Boris?

DUFF: It's kind of ironic that I should wind up in a film with Boris playing his daughter. Boris and my husband, Philip, knew one another fairly well and played cricket often together around Los Angeles. My

Conflict of interest: Amanda Duff and Boris Karloff during a tense moment.

husband thought it was very funny that I was being considered for the part with Karloff, because I myself had no idea that I was being considered.

Q: Your husband knew this through Boris, and you knew nothing about it?

DUFF: At this time I was going from studio to studio when we knew they were about to cast a picture. I remember meeting director Edward Dmytryk, a very nice man. He actually wanted someone more "exotic-looking" for *The Devil Commands*, so I suggested my friend Mary Taylor for the part. Mary went to see Edward,

but as it turned out, Edward chose me instead.

Q: Boris Karloff, like Peter Lorre, is among the most popular of screen personalities. What was it like to really know him?

DUFF: He was simply charming, very elegant and such a sweet, sweet man. Another person who I remember to be very nice on that film was Ann Revere.

Q: Ann played the psychic, Mrs. Walters. How did you get to know Ann?

DUFF: She and I would go to lunch

practically every day when we worked on the picture, and I do wish that I had stayed in touch with her more over the years.

Q: How did Boris enjoy doing this film? You know, he took a break from films after *The Devil Commands* and went to do *Arsenic and Old Lace* on Broadway.

DUFF: Karloff never gave the impression that he had been dissatisfied with doing this type of film, and this goes back to what I said earlier. Back then many valued having jobs, and Boris, aside from being an absolute gentleman and professional, valued not only having the work but having the chance to perform and develop into the fine actor that he was. I thought his most outstanding feature was his genuineness as a person.

Q: Can you give us an example of this aspect of Boris?

DUFF: One time he had been visiting us at our home and when he learned that our daughter, Philippa, who was just a small child at the time, was sick, he asked me if he could go upstairs and read to her. So he did. It was these things which made Boris so dear to me. Both Peter Lorre and Boris Karloff were superb actors and professionals in every sense of the work, and no matter what they

appeared in, they always made it look polished. I actually did not enjoy making these kinds of movies and felt quite foolish doing some of them, but I never got that impression from either Peter or Boris.

Q: What later changed your mind about these films?

DUFF: It was right around the time I did *The Devil Commands* that I believed they were putting me in just about anything they could find because they had basically given up on me! [*laughs*] One must feel comfortable doing this sort of thing, and I didn't. Also, I did not have the drive or the coaching needed to pursue it properly. In those days, they frowned on those who considered taking acting lessons. At the time I made these pictures, I guess I hadn't realized the opportunities that were being given to me, as well as the exposure. With the horror films, I just felt silly doing them. The trouble with me, I feel, was that I didn't realize that whether it was a horror film or not, it was exposure which I could have grown with. Look how these films are often the ones that are remembered. I may have been kind of spoiled at the time, and instead of exploring it more, finding out how I might have done better, I just thought that this or that wasn't for me. I didn't take it as seriously as I should have.

8

EVANGELINA ELIZONDO

Cinderella of Mexico

The classic Disney animated features are beloved worldwide in numerous languages. Disney took scrupulous care casting each of these films for foreign editions, particularly in the musical numbers. Ilene Woods was the voice of Cinderella in English. In choosing Evangelina Elizondo as the Hispanic Cinderella, Disney also launched the performer into an extraordinary career in films and show business in Mexico as well as the United States. She has even appeared in the recent Keanu Reeves film *A Walk in the Clouds* (1994). She is also remembered by lovers of genre films, particularly for the horror/comedy *El Castillo de los Monstrous (Castle of the Monsters*, (1957). In that picture, Evangelina encounters all the great classic monsters, including the Frankenstein monster, the mummy, the Gill Man, the wolfman, and even German Robles in the role of the elegant vampire. This wild monster extravaganza has found new life on video, and even without English translations, the plot is clear as master comic Clavillazo and Evangelina Elizondo explore the bizarre and colorful castle of monsters. Evangelina spoke with us recently about her career in genre films.

Q: When and where were you born?

ELIZONDO: I was born April 28, 1929 in Mexico City.

Q: When did you get interested in acting?

Evangelina Elizondo: Walt Disney's choice for the voice of *Cinderella* in the Spanish-speaking world.

me to it, and I was selected as the voice of Cinderella. I did the dialogue as well as the singing for the Spanish version of this picture.

Q: That film is a classic, and each new generation of children see it on video as well.

ELIZONDO: It was a very important role, and it opened a lot of doors for me. Shortly after this, I was offered a role in musical theater. So I sang on stage before the public, and then I got an offer to go into the movies.

Q: What was your first film after *Cinderella*?

ELIZONDO: It was a real crazy comedy with Tin Tan [German Valdes] called *Las Locuras de Tin Tan* [*The Folly of Tin Tan*, 1951]. It was not a very large part, but it wasn't a short part either. It was a good role for a newcomer to get noticed in. A number of films followed one after another, like *Frontera Norte* [*The Northern Frontier*, 1953] and *Educando a Papa* [*Teaching my Father*, 1954]. One of my favorite ones was *Pueblo de Proscritos* [*Fugitives*, 1955]. The director was Fernando Mendez, and he was an excellent director. I worked with him a

ELIZONDO: I was very interested in music and singing. I really didn't think much about acting. In college, I took my degree in theology. I went to the Universidad La Salle. Walt Disney was running a contest to select the voice of Cinderella for the Spanish language version of his new cartoon film of *Cinderella* [1950]. My brother told me about this contest, and took

lot. I think I am the actress that he used most often. There were a number of first rate Mexican directors. One of them, Alejandro Galindo, is a real genius.

Q: How many films have you done?

ELIZONDO: Over 75 movies, counting films for television as well. I am doing a television film this week.

Q: Which films do you enjoy most?

ELIZONDO: I love doing musicals. I love to sing in these films. I also enjoy comedies very much. In one film, *El Superflaco* [*Super-Skinny*, 1957] I played a dual role. One was this exuberant, voluptuous lady, and the other was the plain-looking teacher of this skinny fellow who had to appear in a fight. Well, he trained and he became known as *Super-Skinny* and it was a very funny picture. I especially loved my next film after *El Superflaco* which was the horror comedy called *El Castillo de los Monstrous* [*Castle of the Monsters*, 1957]. That was directed by Julien Soler. He was a good director, but a little bit neurotic.

Q: That picture is highly regarded as the finest Mexican horror/comedy. It is inspired by the approach taken by Universal for *Abbott and Costello Meet Frankenstein* [1948] in that the monsters are played straight, and the comedian is blended into the plot.

ELIZONDO: Exactly. It was a classic of its kind because it used all the famous monsters. They were all living in this castle. There was a mad doctor who was searching for the secret of eternal life. He had brought together all these monsters. They included the Frankenstein monster, the vampire, the wolfman, the mummy, and so on. They had every one, even the Fish Man ... how do you call him?

Q: Either the Gill Man or the Creature from the Black Lagoon. Your co-star in this was Antonio Espino Clavillazo. How was it working with him?

ELIZONDO: He was an extraordinary comedian with a unique personality. His trademark was the silly hats he wore. He had a special way of talking that was very amusing. This was the only film we did together, but I worked with him in the theater. Without his silly hat, he was rather good-looking. Working with him was the most pleasant thing I ever did in my acting career. Between scenes, he was as naturally likable as he was on camera. He was always telling jokes and always in the mood to be a good companion. Many of the other comedians were also great to be around. I loved working with them.

Q: What other comedians have you worked with?

ELIZONDO: I performed with Tin Tan. I worked with another eccentric comedian called Resortes. His real name was Alberto Martinez, and he was a fantastic dancer as well, but very eccentric. One excellent picture I did with him was *Los Platillos Voladdres* [*Flying Saucers*, 1955] in which we pretended to be Martians in order to swindle some people.

Q: German Robles played the vampire in *El Castillos los Monstruos*. Do you

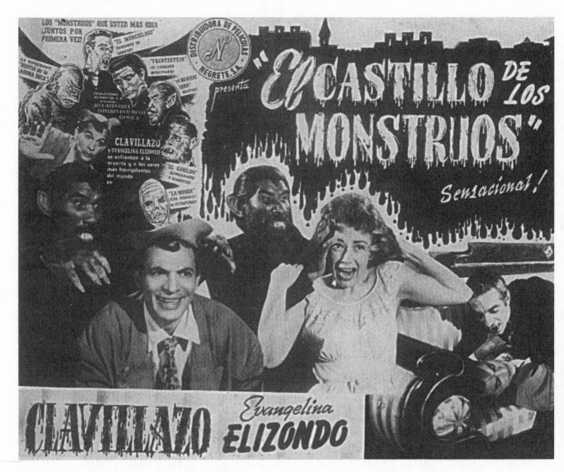

Mexican poster ad art for *Castle of the Monsters* (1958) starring Evangelina Elizondo.

have any memories of working with him?

ELIZONDO: German is an excellent actor and a gentleman. I saw him doing *The Lady in Black* on stage quite recently, and he was so good. It is a phenomenal success and he has been doing it for quite awhile. He originally came from Spain. He has a particularly beautiful voice, and he knows how to use it well. He can sound very profound when he speaks. He was a tremendous horror star in Mexico because of *El Vampiro* [1957]. He was making a sequel to *El Vampiro* when

Clavillazo approached him to be in our film. We didn't have a vampire, so when we added German, we had them all.

Q: Christopher Lee, the British star, says he based a large part of his performance on the work of German Robles in *El Vampiro*.

ELIZONDO: That's fantastic. It is a fine tribute to German.

Q: What scene most stands out in your mind from *El Castillo de los Monstruos*?

ELIZONDO: The Gill Man almost

Mexico's answer to *Abbott and Costello Meet Frankenstein* was the 1958 south of the border horror spoof *Castle of the Monsters (El Castillo de los Monstruos)*. Evangelina Elizondo and Clavillazo are confronted by a Mexican version of the Black Lagoon Gill Man.

died during the filming of the picture. It was the scene where he was shot and his costume began to smoke. It was horrible. Remember, we did not have any special effects available then to do these scenes. They just did the best they could with a small budget. I guess his costume was made of plastic, and it began to smoke from the inside. He was making movements to show he was in trouble. It was almost a tragedy, and he was rushed to the hospital, but he was all right. Everyone was so upset.

Q: In the film, his costume is smoking as he falls to the ground and writhes on the floor. Then he is transformed into a fish.

ELIZONDO: Well, everyone rushed to help him, so of course they cut that out. I guess they put that in later to try to disguise the real danger the man was in.

Q: That was a genuinely scary moment.

ELIZONDO: Yes, but it turned out

O.K. You know, it was creepy having all these monsters around.

Q: They were all stuntmen.

ELIZONDO: Yes, but they enjoyed hamming it up on the set. There wasn't much money for expensive make-up, and everyone worked on their own characterizations. The guy who played the wolfman was a pretty scary man himself. That is why they contracted him. The mummy was an Egyptian mummy, different from the Aztec mummy from other films.

Q: *El Castillo de los Monstruos* and other Mexican films of this era have become quite popular on video in the United States. Some are dubbed into English, but many are just shown in Spanish.

ELIZONDO: It is great to know they are still enjoyed. They were a lot of fun to make.

Q: Abel Salazar is well known from these pictures. Did you ever work with him?

ELIZONDO: Yes, I worked with him in *Tropicana* [1956] which we made right before *El Castillo de los Monstruos*. It was a very good musical, and the director was Juan Ortega.

Q: Did you do any other horror films?

ELIZONDO: The most frightening one I did was called *El Mistero de los Hongos Alucinantes* [*Mystery of the Magic Mushrooms*, 1967]. It was in color, and I think it was also dubbed into English. It was a color film, and it won a film festival award in Acapulco. I had a good part as a nurse in a hospital where they were conducting illegal

experiments on human subjects. They wound up turning them into monsters.

Q: Did you get killed in the film?

ELIZONDO: No, I have never died on screen, after so many films. That one was real scary, I'll tell you. Then there was also *Noche de Terror* [*Night of Terror*, 1987].

Q: Did you ever make any films in English?

ELIZONDO: Yes, just a few years ago in America I made *A Walk in the Clouds* [1994] with Keanu Reeves and Anthony Quinn. I also did *Romero* in English, which was with Raul Julia, who played Archbishop Romero from El Salvador.

Q: And you have also done a lot of television?

ELIZONDO: Yes, I have even done commercials for American television. In 1996 I did a commercial for the California Milk Commission.

Q: Are there any parts you haven't enjoyed?

ELIZONDO: I have never cared much for straight drama. I prefer musicals and comedies. I usually decline straight dramatic parts.

Q: You have done a lot of stage work.

ELIZONDO: Yes, I have done shows like *Mame* and *Me and My Girl* on the stage. I have even done *The Merry Widow* by Franz Lehar on stage with Placido Domingo. It was still early in his career, and he came to the casting. He didn't get the principal part, but he was so dedicated. He always came

Evangelina Elizondo is menaced by a Mexican version of the Frankenstein monster in *Castle of the Monsters* (*El Castillo de los Monstruos*), beautifully photographed by Victor Herrera.

early to rehearsals. He was such a nice person. He has written some books, and he included photos of me in one of them. Whenever there is any trouble, Placido is always there to help. When there was the terrible earthquake in Mexico City, Placido Domingo was there doing his best to help people in trouble.

Q: Do you have any other strong interests besides acting?

ELIZONDO: I love art, and I have done painting, including works of surrealism and fantastic art. I have had exhibitions of my work in Paris, in New York, in Texas, and so on. It is a very rewarding activity. I have also done a number of musical recordings for RCA, Peerless and Columbia.

Q: Looking back, what have you enjoyed most in your career?

ELIZONDO: I have met such wonderful people and have made such wonderful friends in my career. I have three daughters, and now I am a grandmother as well. I am 68, and I am still working and enjoying myself. I am still Cinderella at the ball.

9

MARGARET FIELD

Meeting the Man from Planet X

The science fiction "B" classic, *The Man from Planet X* (1951) is the type of genre masterpiece which seems better each time it is viewed. The film is a unique blend of mood and menace and stands alone as an example of the quintessential "visitor from outer space" scenario of the fifties. This picture combines a pulpish, comic book flavor with subtle eeriness and decent photographic effects. It is an unforgettable example of how artistic brilliance can transform a low budget film into a distinguished-looking upscale production.

Much of the credit goes to the director, Edgar G. Ulmer, a former Hollywood set-designer known for his avant garde concepts as far back as *The Black Cat* (1934). Ulmer took advantage of the left-over sets from the Victor Fleming RKO-PATHE version of *Joan of Arc* (1948) starring Ingrid Bergman. Ulmer is known for his expertise in turning a small budgeted picture into an expensive-looking production, and his creativity gave *The Man from Planet X* the look of an "A" picture using a budget of less than $50,000. He used the existing painted backdrops as a Scottish village, and incorporated other *Joan of Arc* landscapes to the best of his ability. *The Man from Planet X* is set in Scotland where a mysterious spacecraft lands way out in the desolate, mist-laden moors, where a superbly constructed miniature was used for longshots showing the spacecraft sitting eerily in the night out on the marshy heath.

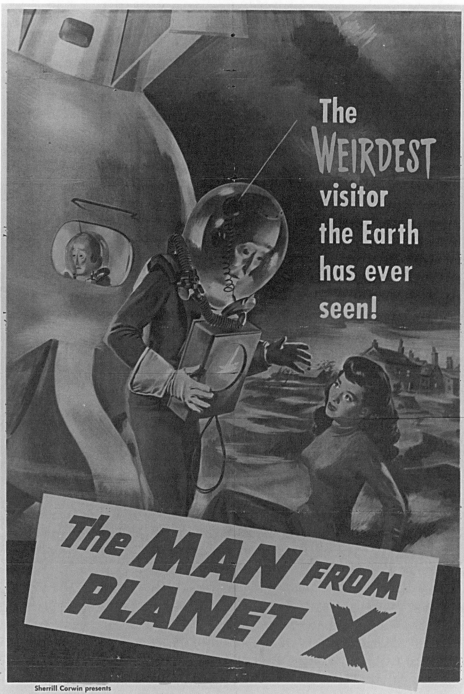

Ulmer's genius in saving a buck and not having it show on screen was also evident in the close-up sequences involving the actors when they appeared with the little man from Planet X and his diving-bell shaped spacecraft. This was effectively done by building the spacecraft out of cost-cutting material and propping it up onto a plywood landing base which looked quite convincing on film. We never actually see the inside of the spacecraft, except for a brief interior matte painting. Blinking lights served as the menacing alien gadgetry, and a simple magnetic audio tape "drone" works well as the voice of *The Man from Planet X*. Ulmer painted the castle exteriors himself and designed the spacecraft as well. The film has lots of creative ingenuity, and to this day, some think the film is a foreign production filmed in Scotland, due to the realistic ambiance.

Not much has been revealed about just who was inside *The Man from Planet X* spacesuit. It has been said that the man who played the visitor from space was very disappointed that he was not credited in the cast and often complained of his meager pay and extreme discomfort in the costume. *The Man from Planet X* costume featured a sort of alien power-pack which was fitted onto the actor's chest. It was brightly lit from inside the unit, which made it hot and almost unbearable to work in for long periods of time. It has also been rumored that the little *Man from Planet X* was a vaudeville acrobat hired for the role because of his small size.

Actress Margaret Field, mother of Academy Award winner Sally Field, starred as the attractive young heroine in this classic film. Margaret Field was born in Houston, Texas, and was discovered by a Paramount Pictures talent scout while she was in the audience watching a stage play at the Pasadena Playhouse in Pasadena, California in the late forties. She was offered a screen test and showed significant promise. This landed her an 18-month stock contract signed by Paramount. By the end of the forties, she moved to Pasadena with her mother and brother Jack. She attended Pasadena Junior College and went on to appear in numerous television films, such as *Solitaire* and *The Faith That Moves Mountains* as well as local stage plays.

In 1947, Margaret gave birth to her daughter, Sally, her lucky star who went on to become the much loved, and admired actress. She was the ever-popular *Gidget* (1965–66) during the sixties. When Sally was born, Margaret considered her to be a lucky omen in her life. Soon after Sally's birth, Margaret returned to work at the studio in *Blaze of Noon* (1947). From that point on, she prospered in motion pictures which include *Welcome Stranger* (1948) with Bing Crosby, *Beyond Glory* (1948) with Alan Ladd, *The Big Clock* (1948) with Ray Milland, *Chicago Deadline* (1949), *My Friend Irma* (1949), *Samson and Delilah* (1950), *Paid in Full* (1951), *Chain of Circumstance* (1951), *Yukon Manhunt* (1951), *For Men Only* (1952) and *Story of*

(*Opposite*): Margaret Field was featured on this poster advertising the arrival of a most unique extraterrestrial, *The Man from Planet X* (1951).

Will Rogers (1952). One of the first films that brought her to the public's attention was a small, but important role in *Night Has a Thousand Eyes* (1948). In this production, Edward G. Robinson plays a stage mentalist who suddenly receives a genuine precognition for Margaret, a member of the audience. Another odd film among her credits is the post-nuclear disaster oddity *Captive Women* (1953). This low budget movie is also known as *3,000 AD* and was released in 1957 as *1,000 Years from Now.*

Margaret had the great pleasure of starring with fifties veteran actor Robert Clarke in both *The Man from Planet X* and *Captive Women.* Bob Clarke is often remembered for playing the title role as *The Hideous Sun Demon* (1959), which is regarded as another "B" classic among genre fans.

This is Margaret Field's first interview.

Q: Was it your ambition to become a film actress?

FIELD: I never really thought of being in motion pictures until Milton Lewis, a talent scout from Paramount Studios, approached me one day in the audience of the Pasadena Playhouse. Afterwards, I auditioned and was signed by Paramount and was there for four-and-a-half years. At Paramount, I studied voice training and acting. They would put me mainly in the background of a number of Bing Crosby and Alan Ladd pictures. When I left Paramount, I worked at Columbia for awhile and had some leads.

Q: Did you do any work in early television?

FIELD: Yes, around this time I started doing a lot of live television, which I found very interesting. I did the *Lux Video Theater* production which was taken from a Faulkner story. The title of it escapes me. This was an active period for me in television, and I went on to do most of the television anthologies at the time. I would go from one to the other, so to speak. I also did a good amount of television Westerns like *Wagon Train* [1957–65], *The Virginian* [1962–71] and so on. There was one television Western called *The Range Rider* [1951–52] during the fifties, and it was on one of these episodes that I met Jocko [Jock Mahoney], whom I later married. Jock passed away in 1989.

Q: Were you ever cast as a regular in a show?

FIELD: Although I never had a television series, I spent a lot of time doing many shows for television. It was a lot of fun and a learning experience as well, because I got to play a whole lot of different parts.

Q: How did you land the role in *Man from Planet X* [1951]?

FIELD: My agent at that time was Walter Herzbrun, and he and his wife, Hilda, were looking for a film to put me in. I had been under contract to Paramount for four years. That's when Jack Pollexfen and his partner called me into their office to read for the part in *The Man from Planet X.* I do remember quite well that Pollexfen had an office that opened up into another office which had a lot of people walking around in it. One thing they

wanted to be sure of was that I was able to scream adequately! [*laughs*] There I was screaming in their office, and they liked it!

Q: What do you recall about the locales for the picture?

FIELD: The sets for *Man from Planet X* were quite small, but they were very impressive to work on. In the scenes which had us walking out to the spaceship on the moors, they had built large rocks and put them around to disguise the smoke or mist machines they were using. They laid in a lot of this mist. I remember clearly that it was difficult to work because it would get into our throats and irritate us all. It was hard to see when you were walking and we would have to stop at times and all go outside to take deep breaths. We really suffered in this respect while filming, but other than this I love the film. I just adore it.

Q: What do you recall about the man who played the spaceman?

FIELD: You know, the little man who played the alien in *Man from Planet X* and I never really talked with one another during filming. That fellow really had a hard time on the picture because if it wasn't the smoke that got to him, it was having to get in and out of that costume so he could breathe properly. It would take him a long time to put on and remove the costume, which he would occasionally have to do to get some air. It's a shame that he was not credited, because he worked so hard and went through all of this with us, but was left out. The unit that he wore on his chest was

illuminated from the inside with a bulb or something, and he was always very hot and perspiring. It was a hard project for him. My only conversations with him were between takes or before we started shooting, and were mainly related to how he was feeling. He usually would reply that he was quite uncomfortable but that he would get through it okay. We never really talked further about anything other than the tough time he had playing *The Man from Planet X*.

Q: How was it working with the renowned Edgar G. Ulmer?

FIELD: He was fine, and I can't remember anything negative about working with him on this film. I just seem to get the impression that he *could* have been difficult to work with, but I did not have a problem with him. There may have been one impasse between him and the crew, because Ulmer was under a lot of pressure due to the short shooting schedule. The picture was done in a very short time, and this may have been why I remember him being a bit temperamental with the other crew members.

Q: Did you have any regrets about doing a science fiction film?

FIELD: None whatsoever. I loved doing this picture, and I think Bob Clarke did too. You know, Jocko and I were always believers in UFOs and extraterrestrial life.

Q: Today's science fiction is often tomorrow's science. Astronomers are learning more and more about the

An entranced Margaret Field becomes an earthbound slave of *The Man from Planet X* (1951), played by Patrick Goldin (1902–1997). Says Margaret: "If the answer to a better world is somewhere 'out there,' then that's fine with me."

existence of planets around distant stars. With countless planets, the odds of life and intelligent life increases.

FIELD: As we learn more, we see these things are not inconceivable. You know, long after this film, Jocko and I would go out to the desert and hope that we would see an unidentified flying object. We would meet with groups of people who shared in this belief. Being a part of it was quite interesting. In a way, I guess we both hoped that we would have a close encounter of some kind because our belief and open-mindedness in the

subject is genuine. *The Man from Planet X* may seem a bit corny to some today, but it was more inspiring to me years later when I became more enthused with this subject. It's that kind of movie. It makes you wonder.

Q: What can you tell us about the spaceship in the film?

FIELD: The spaceship was one complete structure, and was closed all around. It was not just a façade. I remember the scenes where I am lured out onto the moors, and I walk completely around it. It was an interesting

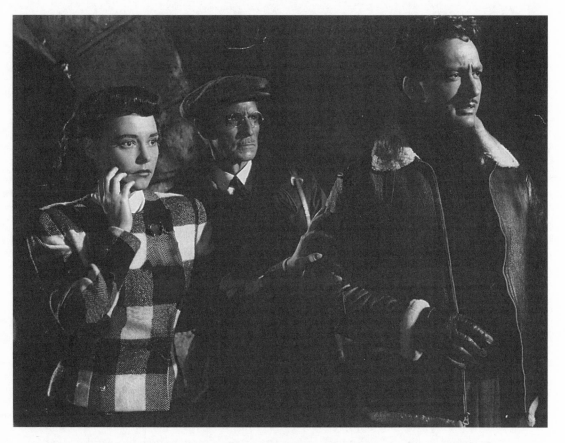

Left to right: **Margaret Field, Raymond Bond and Robert Clarke face an alien (off-screen) in**
The Man from Planet X.

prop and unique among other space-
ship-styled flying saucers that came
later in other science fiction films. The
scene where *The Man from Planet X*
appears suddenly in the window in
front of me was frightening, because
the set and surroundings were quite
realistic and made it easy to be fright-
ened. Looking back on my perfor-
mance, I must say that I seemed a bit
"green" at the time and became a bet-
ter actress later on. There is a special
place in my heart for *The Man from
Planet X* regardless of how I felt about
my performance in it. I'm proud of
having done the picture.

Q: Have you re-watched the film
often?

FIELD: I didn't have a chance to see
it again for many years. It wasn't
shown often on television. Then one
day actor Burt Reynolds contacted me
and told me he had located it for me. I
was very pleased, to say the least.

Q: What about *Captive Women*
[1953]? Have you watched that one as
well?

FIELD: No, I haven't seen it since its
debut.

Q: How would you compare the two
films?

FIELD: *Captive Women* was done a few years later, and it was another quick picture. Robert Clarke and Ron Randall were both very nice. Gosh, if my grandchildren saw that one they would probably laugh at me! Bob Clarke and I worked very well together. There was never a mean or unkind word between us, and we just had a great time doing these pictures. Bob Clarke and I would talk often about how hard we would have to work doing *The Man from Planet X* and *Captive Women* because they were very long days. We started early in the morning and finished late at night. We wondered how we got through those work schedules in such a short period of time. But neither of us was ever sorry that we did these pictures.

Q: You then decided to concentrate on raising your family?

FIELD: By the sixties, my children were growing up and Sally had become a teenager. I had always felt that I was going against the grain, against the way women were supposed to be. During this period it became hard for me to continue acting. Women were supposed to stay at home and take care of their children, and I was a renegade for my time. I decided to stay at home and be with my children and just quit acting. Sally was about 13, and she was having a tough time, as most teenagers do during this time, with normal teenage situations. I had always felt guilty about having worked steadily for nearly 20 years and also felt that I was neglecting my home matters. I had to take care of these things now to the fullest.

Q: What was it like for you when your daughter Sally became an actress?

FIELD: Sally just went right into it. She got her television series, *Gidget*, and that lasted for a couple of years. Then she was married around the time she did *The Flying Nun* [1967–70] and had her baby while she was working on this show. I helped her out a lot with the baby during this period, because it was tough working the hours and having to care for her child. Sally had always wanted to be an actress from the time she was six or seven years old, but I would never let her at this age. I don't think it is right for children that young to be in this business. Sally was 17 when she entered film, and to me that is still a child. She had just graduated from high school and was on her way to college, but she wanted so much to do this. She had such determination and drive. I knew that she was old enough, of course, to pursue what she wanted in life, but I would never have allowed her to go into the business as a small child. It's just not healthy for a small child to have to function in this kind of atmosphere. I've heard so many unpleasant stories about other child actors through the years, and I think it's a shame, just horrible, what they have been exposed to. Sally had already gone through high school, and she had gone to Birmingham and had her four years of drama in high school. When children enter college, you just have to let them go, and so I did with Sally. Jocko and I always helped her when she was young. We did not always stand over her with advice, but

instead told her what to expect. Sally was always a fighter, and she wasn't going to let anyone walk over her. I was just overwhelmed with pride when she won both of her Academy Awards for *Norma Rae* [1974] and *Places in the Heart* [1984] and of course her Emmy for *Sybil* [1976].

Q: Were you able to assist her at all when Sally was getting started?

FIELD: For a time, I helped her choose her projects, and I'd read her scripts with her. Later on, she had another child, and I was there helping her, traveling all over the country with her, just as she did with me when she was just a baby. *Gidget* was a very smooth project to have been a part of with my daughter. Sally was a real trouper, and she was actually playing herself in *Gidget* because it was so much like her in real life. Sally hated *The Flying Nun* the whole time. The entire experience was bad for her, because she felt that there was no reality in it at all. She couldn't connect with any of it.

Q: Do you have any comments or thoughts about the other films you were in in your career?

FIELD: Looking back now, I was in a number of musicals during the late forties and fifties. Again, I was mostly in the background with the other girls, but I can remember just how long it took to dress us in our gowns. We were dressed like showgirls, and it would take a couple of hours by the time we got into these things. On *The Big Clock* [1948], Ray Milland was genuinely sweet to me. This was actu-

ally my first real part where I was more visible than in some of the films I'd done earlier. I play a secretary in the film, and I did have some lines to speak. I think *The Big Clock* is still a great picture. It was directed by John Farrow, father of Mia Farrow.

Q: Charles Laughton was also in *The Big Clock*. What do you recall about him?

FIELD: I studied with Charles Laughton's Shakespeare group after I graduated from Pasadena College. Charles Laughton was obviously a truly gifted actor, but a strange and moody man. He was sweet and gentle and very interesting to be around. I played Juliet in *Romeo and Juliet*, one of the plays he directed on stage in Hollywood, and I was also chosen for another role which he directed in Chekov's *The Cherry Orchard*. It was also on stage in Hollywood, and I worked with Eugenie Leontovich. At the time she was quite old, and years earlier was well-known in the theater. It was an odd experience working with her because she would do mean things, little tricks to make you look bad on stage. Things like holding your hand and not letting go when you were supposed to exit! I got the impression that Laughton was not a happy man. There was a strangeness in him which I encountered every so often. In *Samson and Delilah* [1949], I actually read for the part of Delilah in front of Cecil B. DeMille, but I was not at all ready for that role. I don't think I had much of a chance of getting that part, anyway.

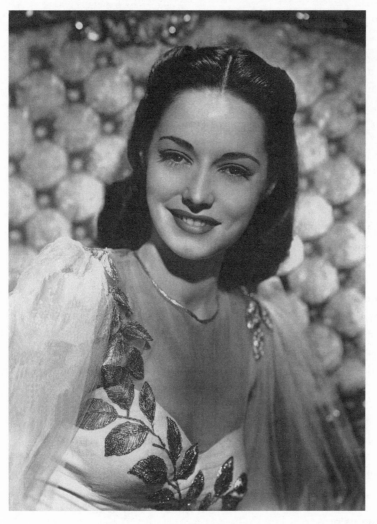

Margaret Field.

FIELD: I had a very small part in *The Raiders* [1952], a Richard Conte film about the Gold Rush days in California. I was in a square dancing scene. Funny enough, I got some fan mail about this soon after. In the early sixties, I had been doing television roles under the name of Maggie Mahoney, but I stopped my acting career around the time Sally got *Gidget*.

Q: So if *The Man from Planet X* is the film that most people remember you for, is that fine with you?

FIELD: Certainly, and with pride.

Q: You also worked with Paul Henried, another talented individual. Could you tell us about that?

FIELD: I played Paul Henried's wife in a film which he also directed called *For Men Only* [1952]. I enjoyed working with him very much. I remember that I almost tripped down the stairs on that picture ... a close call!

Q: Any other parts of interest?

Q: One of the unusual aspects of *The Man from Planet X* is the ambiguity of the original motivations of the title character. Is he a cunning, evil entity or a docile invader who is forced to defend himself after being attacked? The key moment in the picture is the attack on the alien by Dr. Mears [William Schallert]. After this, the alien displays a more aggressive and cold-hearted strategy. In the conclusion of the picture, the diminutive alien is destroyed, but mankind is also the loser because

it was a lost opportunity for mankind. Does this variety of interpretations benefit the film?

FIELD: That's one reason the picture is remembered. At the time we did the film, flying saucers or outer space beings were thought to be the enemy. Many of the science fiction films which came out well after *The Man from Planet X* usually projected this negative image. It was implanted that there was an enemy out there, especially if it came from outer space. I always hated that way of thinking in these films. Jocko hated that idea as well, and we never believed that this was true. There is good and evil here on earth, so there must be the same scenario "out there" as well. Here again, in 1951, I was so young to the motion picture business that I would never have thought of asking them or suggesting that they change anything for the end of the picture.

Q: If you could, how would you have changed the ending?

FIELD: I would have rather filmed it differently and made the invader a "good guy" who came to help and encountered some evil ones on our planet. Maybe I could have given my life for him or perished with him to make some kind of statement. That would have been too different I guess for the period! We should have shown a more positive side to his coming, and at least had him give us something which could have added to the quality of our lives instead of that tired, worn out finale. I mean, we feel sympathy for the creature, and I know the audience did as well even in 1951. I guess in order to sell a picture, being different was not their main concern. We are all products of our time and back then I would not have looked at it this way. If the answer to a better world is somewhere "out there," then that's fine with me.

10

MIMI GIBSON

Unleashing the Monster That Challenged the World

A young girl sneaks into a laboratory to visit her friends, a group of bunny rabbits, test animals in cages. They seem to be shivering. She looks around and says, "Maybe I can think of something." She spots what she thinks is a thermostat, and turns it up.

This scene is a key moment in *The Monster That Challenged the World* (1957), a well done, modest science fiction film that has developed a popular following. In the film, the thermostat the young girl has adjusted is actually raising the water temperature that will allow a giant egg to hatch. She has unleashed *The Monster That Challenged the World* for the exciting last sequence of the film. The young girl is Mimi Gibson, already a veteran of over a dozen films. The

scene is one of the most memorable in a unique film career.

Mimi Gibson was born in Renton, Washington. She became a "calendar girl" when she was just 18 months old. Her mother took her around to photographers who found her captivating. She made her first film at the age of two and a half in *Corky of Gasoline Alley* (1950). Pictures that followed included *I'll See You in My Dreams* (1951), *My Pal Gus* (1952), *A Slight Case of Larceny* (1953), *The Egyptian* (1954), *Strange Intruder* (1956), *The Ten Commandments* (1956) and many others, culminating with *The Monster That Challenged the World* (1957) and *Houseboat* (1958) with Cary Grant and Sophia Loren. She continued with memorable films, like *The*

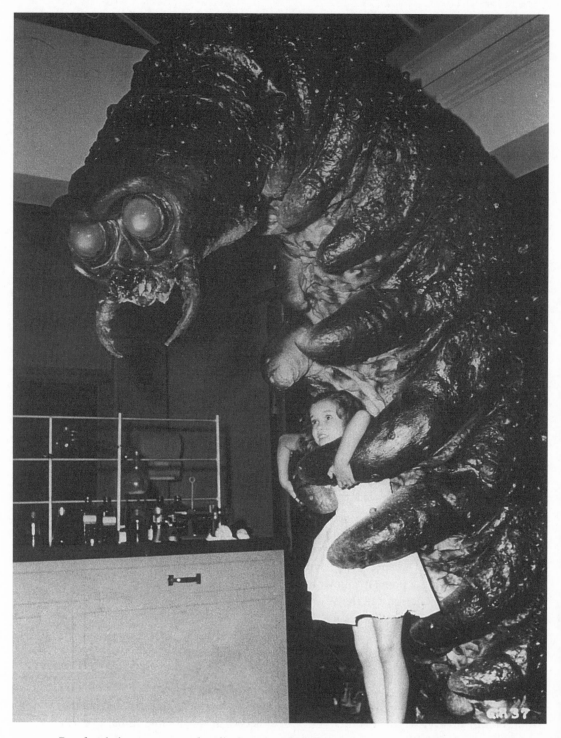

Posed with the giant mutated mollusk is a petrified Mimi Gibson, from *The Monster That Challenged the World* (1957).

Children's Hour [1961], until her last feature film, *If He Hollers Let Him Go* [1968]. Today, Mimi remains a vivacious personality, and her infectious humor makes any conversation a pleasurable experience.

Q: Tell us about your career as a calendar model.

GIBSON: Marilyn Monroe was not the biggest calendar girl ... it was me! Of course, I was always posed with chickies and duckies, and puppies and kittens. I can't even tell you the number of calendars I did. Those were the days when they loved kids and animals on calendars.

Q: What was your role in *Corky of Gasoline Alley* [1950]?

GIBSON: I played Clovia. If you read the old comic strips, she was the girl in the family. I then went on to work more and more. I worked with director Michael Curtiz in *I'll See You in My Dreams* [1951]. He was very sweet to me. He gave me a lot of presents. All the people I remember from this time were either nice or horrible. If they gave me presents, they were very nice. Michael Curtiz was very, very nice! I remember Doris Day came up to me, looked me over, and said to my mother, "She should do this for a living." I don't remember much about Danny Thomas. I remember what people said about Frank Lovejoy ... that he was a very hard drinker. I noticed the blood-shot eyes. When you're a child, you really notice people's faces when you're working close to them.

Q: *The Egyptian* [1954] was quite a memorable epic, again directed by

Michael Curtiz. What memories do you have of it?

GIBSON: It was a wonderful costume piece. We got to wear these gorgeous costumes that were handmade. They had jeweled belts that hung down and gold slippers. I was a little princess who got to carry a monkey. They hired me because I worked well with animals. The trainer handed me the monkey and told me not to move too fast, but I was petrified by the thing. Then the monkey pooped down my gorgeous jeweled belt! The trainer took his knife out and he scraped the poop off! I thought, "Oh my gosh, I am not having fun with this monkey!"

I also remember that Victor Mature was very nice. I remember Debra Paget was in the film too and I thought she was so beautiful. I followed her around and she used to let me sit in her dressing room while she changed her wardrobe.

Q: You were very busy making so many films at a young age. What memories from any of them stand out for you?

GIBSON: I remember that *Strange Intruder* [1956] had a creepy atmosphere. I particularly remember this moss-covered swimming pool in one scene that impressed me as real creepy. In *There's No Business Like Show Business* [1954], I played Mitzi Gaynor as a little girl. What most impressed me in this film were the costumes by Edith Head. The were gorgeous! I worked a lot on *The Ten Commandments* [1956].

Q: That must have been a fascinating

film behind the scenes. Can you describe your impressions of this experience and C. B. DeMille?

GIBSON: Even when you didn't work, they hired you and you'd be there hanging out. It was like being in a foreign country. They had animals all over the place. Sound stages were set up to house all these animals. You could walk around and it was like being in a zoo. You could see the camels and elephants, and you could go up to the trainer and talk about the animals.

They had a huge rear projection screen. They were parting the Red Sea, and we were all supposed to sit around these rocks. There was water down below, and the prop men were throwing pieces of debris. Cecil B. DeMille just loved such dramatics. He not only made dramatic films, he was dramatic himself. He loved sitting high up on top of one of those booms with the camera and he would shout. He would pick out some obscure person in a corner and shout at them. You would think, "How could he see that?" My mom would say, "My God, he saw me!" He was always very nice to me. I was always thankful for that. It was a lot of fun watching all the technical stuff that went on while shooting the Red Sea sequence.

The Monster That Challenged the World [1957] is one of the best, low-budget science fiction films of the fifties. It had an unusual setting, the Salton Sea, a body of water in the desert of Southern California near the Mexican border. An undersea earthquake allowed a group of prehistoric giant sea mollusks to hatch.

They attack and kill military personnel and civilians. The sheriff and the military combine forces to track down and kill the creatures before they can escape through the All American Canal to open waters. One egg is captured and studied in the lab. Leading man Tim Holt, who plays Twillinger, had a career both as a western star and a straight actor. He was best remembered for his outstanding performance in Orson Welles' production of *The Magnificent Ambersons* [1942]. Holt's character is brash and stiff, but he begins to mellow after he meets Dr. Rogers (Hans Conreid) and his assistant Gail MacKenzie (Audrey Dalton). It is Gail's daughter Sandy (Mimi Gibson) who really breaks the ice with Twillinger when she befriends him by letting him hold her ladybug. Holt delivers an interesting performance, particularly as his cold character becomes warmer. He also adds a realistic touch in the climax when he allows the hero to show fear as he confronts and destroys the monster. Other figures in the story are Dr. Tad Johns (Casey Adams), Sheriff Peters (Gordon Jones—best remembered as "Mike the Cop" from the *Abbott and Costello Show*, 1951–53) and Jody Sims (Barbara Darrow) who is one of the first victims of the monster.

The monster in this film is most unusual, and among the most elaborate to appear during the fifties. It is over ten feet high and looks like a giant caterpillar with many legs and large pincers. The eyes are huge and milky, and it drools a radioactive slime. This creature was developed by special effects wizard Augie Lohman, who was responsible for the Triceratops in *The Lost Continent* [1951] as well as the mechanical whale

model used in *Moby Dick* [1956]. Lohman used fiberglass to construct the Monster which when completed stood eleven feet high, weighed 1,500 pounds and required three miles of wiring to operate. Many of its movements were controlled by air pressure and tubing. The monster could sway, bob up and down, and extend vertically. It had special pincers. Much of the monster rested on a platform which could be moved when necessary. The creature was painted and highlighted with glycerin. The sounds of the creature were created by mixer Charles Althouse and recorded by B. F. Remington who combined the growl of a puma with the sound of a bittern booming. The total impression was very life-like on screen.

Q: About *The Monster That Challenged the World*, what did the film mean to you personally?

GIBSON: I loved it. I especially loved the monster, watching how it worked. But when you saw how it operated, with men pumping it up with bicycle pumps, it wasn't very scary, it was almost laughable. I know I looked terrified in the film and publicity shots. That was acting. They told me to look scared. I thought it was really fun.

Q: Were there any difficulties in shooting your scenes with the monster?

GIBSON: When I did the scene in the closet with Audrey Dalton, the crewmen were punching holes through my hand. Then they showed the monster. Audrey was cut with a jagged piece of wood. (You can see her get hit in the face during the sequence.) She got hurt and they were concerned about her, but she was okay.

Q: What impressed you most about the film?

GIBSON: It was so much fun watching the technical aspects of the film. I remember the slime of the monster. I loved it when they put the slime around. It was made out of flakes, something like Ivory Snow flakes. They used a little bit of water and a large amount of flakes. Then they stirred it and made this goop. I loved it. One weekend, I made my mother buy some flakes and we made our own slime at home. It was really cool. My mom just put up with me, but that was no big deal. So we mixed it up and slimed a few things outside. Making this film was great. I just loved it. There was all this slime on the bunny cages, and I wanted to make sure the bunnies were okay. But I was the little girl who unleashed the monster. During the action shots, you had to be careful where you were standing. They directed these scenes very carefully. I wanted to make sure I was in the right place doing the right thing. When the director tells you to be scared, then I was scared. I had to remember when to scream and say my lines. I would have loved to do more movies like that.

Q: You had a key part in *The Three Faces of Eve* [1957], the multiple personality story for which Joanne Woodward won the Best Actress Oscar for her portrayal of Eve. You were actually the fourth face of Eve, because you played the part of Joanne

as a little girl in a memorable flashback scene when Eve was forced to kiss the body of her grandmother. What stands out in your mind about this film?

GIBSON: I got to scream my head off. Except when they first hired me, I said I wouldn't do it. Not with somebody dead or playing dead in the coffin. I wouldn't do it! So the coffin was empty when I went into hysterics. I stuck my head down and screamed. Martin Ritt was the director. He gave me fifty cents because I screamed so well.

Q: In *Houseboat* [1958], you were one of three children, with Paul Petersen and Charles Herbert, who matched up your father, Cary Grant, and his housekeeper, Sophia Loren. Was this your favorite film?

GIBSON: Without question! *Houseboat* was fun, wonderful and I loved it. The director was Melville Shavelson, and he was wonderful. He liked kids, which was rare. I remember it was a long interview process, and it was down to me and this one other girl, and I felt so lucky to get the part. Then I found out how neat it was going to be. We shot for a month on location in Washington, D.C. and were treated like royalty. We had a chauffeur driven limousine. The chauffeur's name was Sugar. He was a darling. Paul's mom still writes to him. The first time I was ever on a roller coaster was with Paul and Sugar. It was the tallest roller coaster in the country at that time, and I felt myself getting scared, and they put me in the middle. When I came out, everyone said I was actually as green as the grass.

Q: How was it working with such major stars as Grant and Loren? There were reports that Cary Grant and Sophia Loren became rather close to each other while making *The Pride and the Passion* [1957], but things became strained on *Houseboat*. Did you notice this?

GIBSON: Sophia was very wonderful and very sexy. I'd never seen anyone like her. But she and Cary were kind of cold to each other. We just thought some people don't mesh. Well, Sophia married Carlo Ponti while she was doing the movie. It was when we were back in Los Angeles. She was just away for the weekend, and when she got back she said she was married. It was really weird, like Sophia was showing off in Cary's face. She would say to Paul and Charlie, "Pinch me. I'm Italian. I like it." The boys would say to me, "Pinch Sophia, she likes it," and I would say, "I don't think so." Sophia was very warm and sweet to us. She had the first birthday party she ever had while on the set. It was rather sad. She was so grateful for this dopey little party. We gave her gag gifts. I always felt bad that I didn't get her something nice. At the end of the movie, she gave all of us these gold medallions with the houseboat on the front of it and on the back it was etched, "To Mimi from Sophia" and "To Paul" and "To Charlie." It is something that I treasured all these years.

Q: Any special memories of Cary Grant?

GIBSON: He was nice to us also, but he was different. He gave us all 50 dollar savings bonds at the end of the production. He gave me all these little

One happy family: Mimi Gibson appears with Sophia Loren, Cary Grant, Charles Herbert (left) and Paul Petersen (right) in 1958's *Houseboat*, one of the happiest memories of Mimi's career in motion pictures.

lectures about what to do when I'm an adult … to eat well, not to get fat, and not to let my husband get fat. Cary and I had these pillow fights. I loved doing the scenes when I was falling in bed with Cary. There also was another scene I remember where I was supposed to be reading this comic strip, and Cary was doing lines with the other kids. Well, everyone kept flubbing their lines. Cary would flub a line, then Paul would flub a line. We kept doing the scene over. It was about the 23rd take, and I was getting interested in what I was reading. It came to my line, and I was reading the newspaper. They said, "Excuse us, but we're acting now!" You get weary when you have to do take after take.

Q: You also had a part in *The Buccaneer* [1958]. It was Cecil B. DeMille's last film, which he produced but did not direct, depicting the Battle of New Orleans and the end of the War of 1812. Did you enjoy working in this film?

GIBSON: Anthony Quinn was absolutely marvelous as the director. He was so demonstrative and so sweet. He loved everybody. He was so passionate. If you did a scene well, he'd hug you and kiss you. My scenes were with Jerry Hartleben and Yul Brynner. When Jerry did a scene well, Anthony would hug him. My scenes were all on a set. I only had a small part, and we did no location shooting. He'd smoke cigarettes, he smoked a cigar, he smoked a pipe. Even though I was only a kid, I remember thinking if anyone is going to get lung cancer, he is.

Q: *The Remarkable Mr. Pennypacker* [1959] starred Clifton Webb, and was a period piece of a man who leads a dual life with two families. Did you find this film a less pleasant one to complete?

GIBSON: Yes. There were a lot of kids in that film. Between them and the adults, we'd do up to 40 takes on some scenes. It was very difficult. There were also a lot of strange things happening on the set of that picture. The director was Henry Levin, but I have no memory of him. Mr. Webb was difficult and it wasn't a pleasant set.

Q: *The Children's Hour* [1961] was a very memorable film. It was based on a controversial play by Lillian Helman and featured Shirley MacLaine, Audrey Hepburn, Miriam Hopkins and James Garner. What are your reflections about this film?

GIBSON: William Wyler was the director. He was a nice man. I was the third lead. It was set in a girl's school.

MacLaine and Hepburn were these two teachers. The film suggests that they might be lesbians. It was a very odd movie. I particularly remember one incident on the set. Veronica Cartwright had to get hysterical and cry. A bunch of us were watching, and she wasn't getting hysterical enough. Miriam Hopkins was an old time actress who was playing Shirley MacLaine's aunt. She said to Wyler, "Do you want her to cry harder?" Wyler said, "Yeah," so Miriam Hopkins walked over to Veronica and slapped her in the face. Veronica was so shocked, her face turned red. All of us were shocked. Her mother didn't say one thing, and they went on with the scene. Of course she was hysterical enough then. That couldn't happen today.

Q: What do you recall about the other performers?

GIBSON: Audrey Hepburn was wonderful, but Shirley MacLaine hated kids. She didn't want to hang around us or talk to us. She wanted to stand off and tell jokes to the grips. They were also shooting *Sergeants Three* [1962] on the same lot. Frank Sinatra, Peter Lawford and Dean Martin would come over and get in line to kiss Shirley. They were really silly. They would run around the sound stage and pretend to shoot each other and fall down like kids. On the other side of us they were shooting *Follow That Dream* [1962] with Elvis Presley. He would always show up with an entourage. They would drive up with two Cadillac convertibles and an entourage of guys. I met Elvis, but he didn't impress me. He was just a

simple country boy. He would say things like "ain't" and he was just a down home boy. But I'll tell you who did impress me: Burt Lancaster. We went to school on the sound stage, and there was this trapeze equipment on part of the stage. I think Burt started as a trapeze artist. When Burt would show up he would say, "Good morning ladies" to us and start to work out. He did this at least twice a week. We were all 12 and 13 or so, and we were all in love with him. He was such a charming guy, and he was great looking. When he would leave, he would come over to us and say, "Good day, ladies!" While he was there, there wasn't much schooling going on. It was a very interesting studio to be with at the time.

Q: You also did a lot of voice-over work as well, particularly for Disney studios.

GIBSON: It was fun, but there wasn't a big deal made over it. I did it, and that was that. I did some voice-overs on *Toby Tyler* [1960]. There was one picture where they couldn't understand the actress at all, and I re-dubbed all her lines. I also did some lines for *Pollyanna* [1960]. What happened was sometimes there would be a noise or something and they couldn't hear the actress. I'd step in and re-dub her lines. The actress would get the credit, but I wouldn't. I did a lot of that. I really couldn't keep track of them. Voice-over work is a big industry now, but there wasn't much money in it back then.

Q: What did you do in *One Hundred and One Dalmatians* [1961]?

GIBSON: I was one of four kids who played the puppies. Ricky Sorenson was the lead puppy. We did the voices for all the puppies. We used English accents, too, and it was fun.

Q: Your first television show was with Jack Benny when you were three-and-a-half years old. What other shows did you do, and how did you enjoy it?

GIBSON: I loved doing television. It was my favorite medium, and it was the golden age of television. The favorite work I did was *Playhouse 90* and I did eight of them. They were always exciting to do, and it was live TV. I was in the original *Days of Wine and Roses* with Cliff Robertson and Piper Laurie. Most of *Playhouse 90* was done back east, but they did a few out west every year. They were exciting. Of course, you can't make mistakes. If they are taped, you can do it over, but not on live TV. I did a lot of programs of *The Red Skelton Show* [1951–71] as well … maybe six or eight. The one thing about Red Skelton was he loved to break people up. The reason I did so many shows is that he couldn't break me up. I would stay in character. If you did break up, they wouldn't hire you anymore. They would never let us watch his rehearsals. Usually you could wander in and out and watch, but they always kept us out. I wondered just what was going on. So one day I sneaked into his rehearsal. Well, it was very, very funny, but it was blue! They used dirty language. Well, I left really quick. But Red was a wonderful man. He had a great personality. He had a son with leukemia, and I sent him pictures and

wrote to him. He died and it was very sad. Out of all the people I worked with on TV, I liked Red Skelton the best. He was really fun and was a really neat person.

Q: What was your favorite show?

GIBSON: I liked doing *Whirlybirds* [1956–59] because I always got a helicopter ride afterwards. I really liked doing it. I also liked doing *The Jimmy Durante Show* [1954–57]. I can particularly remember one with Eartha Kitt. I loved her. She had this voice and this look. I thought she was the neatest thing I ever saw. I was fascinated with her. I would sit on her lap, and I would sit on her so long that her legs went to sleep! Jimmy Durante was also a real cute and friendly guy.

Q: Did you have any unhappy experiences while acting?

GIBSON: A few. My worst experience was on *The Loretta Young Show*. It was a show about child abuse, and Loretta really abused me on the show. I was never known for acting like a brat, but on that program I locked myself in the dressing room and wouldn't come out. On the show, I played a girl who had one of her fingers broken by her mother, and I wore a fake finger for the effect. I was doing this scene in the doctor's office,

and Loretta wanted me to cry harder. Well, she took my fingers and actually bent them backwards! I just didn't want to take that. The show was about child abuse and she was really doing it! They lured me out with a doll and an ice cream cone. After that show I was banned from the studio. They filed a complaint against me. That's the power a star had.

Q: Didn't Loretta have a breakdown after this incident?

GIBSON: My mother tried to explain that's why Loretta was acting so strangely, but I was not convinced.

Q: Any final thoughts about the career of a child actor?

GIBSON: It is a hard industry. I would urge all child performers not to neglect their education. Education is the most important way to develop yourself and take on the future. As for myself, I'd like to be remembered for *Houseboat* but I'm glad to be remembered for *The Monster That Challenged the World* as well. It's fun to be remembered for that. I wish I had done more horror and monster films. The monsters had all these neat things about them, and it was fun to watch them work. They were good entertainment for the audience too, and that is what really counts.

11

MARILYN HARRIS

Flower Girl from Frankenstein

The monster comes stumbling out of the woods. The little girl by the lake is initially startled, but then comes up to the giant and says, "Who are you? I'm Maria. Will you play with me?" This is the start of one of the most famous and controversial encounters in film history, from the original 1931 version of *Frankenstein* with Boris Karloff. The young girl is played by Marilyn Harris. Maria and the monster sit by the lake. She hands him some daisies and shows him how she makes them float in the water. Overjoyed, the monster throws all his flowers into the water. He then reaches down to Maria. At this point, the scene is cut (and remained unseen for years), and the dead body of Maria is later shown carried into the village by her father.

The origin of this scene has been argued. Some critics cite the murder of a crippled girl by drowning in the 1927 *Frankenstein* play by Peggy Webling. Webling is cited in many credits as a source. But there also is a scene in the original novel by Mary Shelley (Volume 2, Chapter 8) of significance. It reads as follows, with narration by the monster.

A young girl came running toward the spot where I was concealed, laughing as if she ran from someone in sport ... suddenly her foot slipped and she fell into the rapid stream. I rushed from my hiding place, and, with extreme labor from the force of the current, saved her and dragged her to shore. She was senseless; and I endeavored with every means in my power, to restore animation, when I was suddenly interrupted by the approach of

115

The little flower girl, Marilyn Harris, and Karloff share a serene moment before terror strikes.

a rustic…. On seeing me, he darted towards me, and tearing the girl from my arms, hastened toward the deeper parts of the woods.

When the monster tries to follow the pair, he is shot, and it is this incident that turns him against mankind. In a sense, this passage from the novel also inspired the scene with the shepherdess in *Bride of Frankenstein* [1935]. So the drowning scene can by traced back to Mary Shelley herself.

When Marilyn Harris awoke on the morning this scene was to be shot, she had no idea what film she was going to be in or what scene would be done.

Instead of being just a footnote in film history, her performance that day won her lasting fame. Harris looks back at her entire childhood with unhappiness today. It was an extremely difficult period for her. She had been an abused child, and physical abuse was the motivating factor behind many of her performances. Harris decided to grant this exclusive interview to share her recollections and put her impressions on record.

Q: What do you recall about getting started in films?

HARRIS: This is difficult for me

because for years I have tried to repress everything, not just *Franken-stein* but everything about this period in my life. I tried not to think about it, but of course it is still there. You see, I was adopted when I was about one month old. About one month after that, I started in movies. My first one was as a baby in a *Rin Tin Tin* film. This was in 1924. I was one of two babies used in the part. I hear that when my mother came to pick me up, Rin Tin Tin would growl at her. There was something about her that the dog didn't like.

Q: So you were in films as far back as you can remember?

HARRIS: Yes, I was in many, many films. When I was not working, I was taking lessons. I took ballet lessons, I took singing lessons and much more … tap lessons, piano lessons, diction lessons, horseback lessons. I didn't want to take them, I had to take them, and if I didn't do what I was told, I was hit.

Q: What do you remember about *Frankenstein?*

HARRIS: I don't recall auditioning for it. I was taken to talk to a lot of people many times, so I suppose I was cast from one of those sessions. I got up in the morning and I was taken to the studio. I didn't know for what part. My first clear memory was meeting Boris Karloff. He was in full make-up and costume. I was immediately drawn to him. There was just something about him. He was very special, a very nice man, very kind.

Even to this day, when I see him on television, I feel very drawn towards him.

Q: Did you keep in touch with him?

HARRIS: No, I wrote him towards the end of his life. I don't think he got the letter because it was about a week before he died. I remember reading interviews with him, and how kindly he was treated by some people. He talked about how children were drawn towards the monster.

Q: Well, you were the first one.

HARRIS: I was. I recall when we were preparing to go to the lake, to be driven to the location. Nobody wanted to ride with Karloff. I went up to him and took him by the hand and said, "I'll ride with you," and he said, "Will you, darling?"

Q: That is almost like your meeting in the movie.

HARRIS: Well, I didn't have a script. Maybe they saw me take him by the hand and decided to use it, or maybe it was in the script. I don't know. For each shot, they just told me what they wanted me to do or say. James Whale was nice to me.

Q: Do you remember anything specifically about your scene by the lake. Was the water cold?

HARRIS: No, it wasn't. I think it was summer. They shot the scene twice. I remember the first time I hurt my back a little when I was tossed into the lake. I remember asking Karloff not to throw me so hard.

Q: Karloff later said he strongly disagreed with Whale on the shooting of this scene. He said it was the only disagreement they had. He just wanted to put you in the water gently to see if you would float. Then he would panic when he saw you sink. But Whale insisted on throwing you in.

HARRIS: I think Karloff's way would have worked better. They may have talked about it, but not in front of me. I was being dried off, and they were fixing my hair and drying it off. They had to take care of the curls. I didn't want to do the scene again, and Whale took me aside. He was very nice to me. He told me that if I did it, he would give me anything I wanted. He really meant it. Well, I thought it over, and I asked him for a dozen hard boiled eggs.

Q: Really? That was what you wanted?

HARRIS: Yes, [*laughing*] the next week he sent me two dozen hard boiled eggs. My mother was furious. She said I could have had anything so I should have asked for a bicycle or something really nice. But I wanted those eggs.

Q: Did Karloff tell you anything when you asked him not to throw you so hard?

HARRIS: Yes, he said, "I'm afraid I have to, darling. You see, it has to be hard enough that you sink into the water."

Q: Of course, the end of that scene was later cut. For years, it was the most famous deleted scene in film history.

HARRIS: I was very upset that the scene was cut. It made it seem like something really awful happened. My impression of the scene is that when the monster saw that I was in trouble, he wanted to help me. He reached his hand out to me. I don't think the monster wanted to hurt me. But I would have liked it if they could have made it a happy encounter for the monster.

James Whale insisted that it was a ritual that had to happen. He felt it was essential to the film. The notorious cut of this scene of the film occurs just as the monster reaches down to little Maria. The film jumps to some villagers, dancing a country slap dance at the wedding feast. The monster reacts frantically when Maria drowns, and he finally lumbers off. It is a moment of genuine pathos. There is some disagreement as to when the climax of the lakeside scene was edited. Most claim it was after the special studio preview in November 1931 that some changes were made but the scene seems to have remained in a number of prints in some cities according to first hand reports. There were also a limited number of special green-tinted prints of the original release. In some states, there were many additional cuts made to the print as well. In any case, the scene was gone in all subsequent reissues, and it was not seen on television. However, there were occasions of renegade prints being seen at revivals over the years which contained the sequence. Universal stonewalled for years, refusing even to comment on the existence of the scene.

Finally, in 1987, the scene was restored to the MCA video. The monster's killing of the hunchback Fritz was also restored, as was Colin Clive's line at the end of the creation sequence. After "It's alive!" he said, "In the name of God, now I know what it feels like to be God!" In any case, this blasphemous line was obscured by crashes of thunder. *Franken-stein* was whole at last, and film lovers were at last capable of seeing the complete film, one of the landmarks of film history.

Q: Any other impressions of Boris Karloff?

HARRIS: No, he was just someone very special. I recall I later got a picture of his daughter Sara.

Q: She recently led a campaign to have her father honored on a postage stamp ... not just the figure of the monster, but the actor. Lugosi and Chaney were also honored.

HARRIS: That is good, and the way it should be.

Q: Do you remember Michael Mark, the man who played your father in the film?

HARRIS: No, I don't remember him very well. We had a few lines when he told me to play with the kitty. When I came again for more shooting, I was to be carried into the village.

Q: That was a long distance. He carried you past all these dancing villagers. You played dead very realistically.

HARRIS: It was a long scene, and the man was not a very big man. He had a little trouble carrying me. My back was still sore, and the scene hurt my back as well. I recall one stocking was up and the other stocking was down. I was playing dead, so I don't remember much else except I was carried for a long time.

Q: What was the next film you can recall?

HARRIS: I was in *Over the Hill* [1931]. I was up for a part in *Daddy Long Legs* [1931] which I didn't get. My mother was told I didn't smile when I should have, and she hit me across the face. That was right before I came for a reading for *Over the Hill* and my face was still red. They asked me, "What have you been doing?" meaning what films had I been in, and I said I was riding in the car. At first they said I wasn't the right age for the part, and then the casting director went away. When he came back, he said that they would change the age of the character so I could get the part. It was a large part. I haven't seen this movie for a long time. It was done at Fox Studios. It was about a poor widow and her large family who get tossed into the poorhouse. Mae Marsh played the mother. The director was Henry King, and he was my favorite director. When the picture opened at Graumann's Chinese Theater, I had to give a speech before the crowd.

Q: Did you do any live performances or any theater?

HARRIS: In those days they would often have live entertainment between

the films. I would sing sometimes. I would be dressed all in blue, and I would sing *Alice Blue Gown*.

Q: Do you have any memories of *Wild Girl* [1932]?

HARRIS: That was also at Fox. It was a Western of sorts after a Bret Harte story. Joan Bennett was the star. She was a nice lady, but I remember she couldn't see anything without glasses. I was also in *Tugboat Annie* [1933] with Marie Dressler and Wallace Beery. Marie Dressler was one of the nicest people. She would pick me up from home in her limousine on her way to the studio.

Q: What was your impression of Wallace Beery?

HARRIS: I don't think I had any scenes with him. I think Jackie Searle did a lot of work with him. I just remember how nice Marie Dressler was to me.

Q: Your next listing was *A Wicked Woman* [1934].

HARRIS: I won that part over Bonita Granville. We were often up for the same part, and in this case I got it. *A Wicked Woman* was a great movie. It was a melodrama about a woman who kills her husband to protect the kids. It was at MGM and it had quite a cast. Mady Christians was the mother. There was a scene where they drowned my doll and I was upset. I also rebelled in the filming of one scene. I was supposed to say "Cold potatoes." We kept doing the scene over and over again. I rebelled in

another film too. I was supposed to say "vanilla ice cream" but I kept saying it wrong … "Vunulla!"

Q: You are listed in the cast for *Show Boat* [1936].

HARRIS: Yes, but I have no memory whatsoever of that film. It might have been a walk-by that I just can't recall. I was in a lot more films than what is listed. For instance, I was in *San Francisco* [1936]. I was in that great scene after the earthquake. As the camera pans, I am crying over the body of my father. I recall that clearly. I was in the classroom scenes of *These Three* [1936] directed by William Wyler. I remember what we were paid. You got $5 a day, and if you had lines you got $25. I was also in a series of comedy shorts like the Our Gang shorts. This was the *Snookums* series.

Q: When did you leave the business?

HARRIS: Well I got married very young. I got married at 19, and he was a wonderful man. We lived in an apartment, and we both worked nights at the Palladium. My mother would come around and knock at our door in the morning. "There is an audition today for a part that is perfect for you," she would say. I would say, "Yes mother," then turn over and go back to sleep. I was finished with that scene. I had a good marriage. I had a son a year later, and I am very proud of him. I miss my husband. I remarried after his death, and my second husband was also wonderful. He's gone now too, and I miss them both very much.

Q: You never saw any money from your films?

HARRIS: No, not at all. It was a real problem, so the government then passed the Coogan law to protect child performers. You know Jackie Coogan, who worked with Chaplin. I was related to Jackie Coogan by marriage. My aunt by marriage was his aunt. She took me to his house, and it was magnificent.

Q: Do you have any thoughts for all the film lovers who remember you from *Frankenstein* and your other pictures?

HARRIS: I'm grateful that people still care. You know, I used to sign autographs of that still from *Frankenstein* by the lake. I'm no longer able to sign due to my health. I wish I could, but it is no longer possible. I hope everyone understands. I would get many letters for autographs, and people would write, "Don't have your secretary sign it!" [*laughs*] Imagine, people think I have a secretary. I was upset because someone put my name on the Internet, and I cannot deal with the mail. I do appreciate everyone's kind thoughts and best wishes.

12

KITTY DE HOYOS

Memoirs of a Lady Werewolf

The lovely brunette explorer pauses in the great, eerie cavern. She senses something was wrong. Behind her looms a huge creature, a menacing, humanoid figure with the head of a bat. She turns and is overwhelmed by the sight. This extraordinary confrontation occurs in the Mexican thriller *Aventura al Centro de la Tierra* (*Adventure at the Center of the Earth*, 1964) starring Kitty de Hoyos. This picture tells the story of an expedition which uncovers a lost race of giant bat creatures who capture Kitty. The head creature does not harm her, however, but treats her kindly. The film almost parallels *The Phantom of the Opera* in the gentle way the subterranean creature treats the heroine. Eventually, her companions rescue her, and the monsters are destroyed as the explorers make their escape to the surface.

Kitty de Hoyos also played the title role in another extraordinary Mexican horror film *La Loba: Los Horrores del Bosque Negro* (*The She Wolf*, 1965). This was the first Mexican production with a werewolf theme. De Hoyos plays Clarissa Fernandez, daughter of a famous scientist. Clarissa is "la loba," a female werewolf who stalks the countryside under the full moon. Another scientist arrives at their home, Dr. Lisandro Bernstein, who is also a werewolf. They are hunted by special dogs who have the power to kill werewolves. In the end, both wereolves are wounded, and they die in each other's arms, a rather poignant touch.

Kitty de Hoyos: female lycanthrope, Mexican style.

Andres Soler, who was a very good actor. He and his brothers were famous drama teachers. My first work was in a program called *La Comedia* directed and acted by Manolo Fabregas. This was after I was in the Academy for six months. He was one of Mexico's most famous directors of theatrical plays. A week later I was in a production at the Palace of Fine Arts, which is also quite well known. This was in 1954. So I have been an actress now for 43 years.

Q: How many films have you done?

HOYOS: I don't remember the exact count, but it is over 60 films.

Kitty de Hoyos recently took time to talk with us about these two unusual genre classics, as well as other highlights of her career.

Q: Where were you born?

HOYOS: In Mexico City. My mother was sent there from Nueva Sonora by the doctor who thought she was too sick for local care.

Q: How did you get interested in acting?

HOYOS: When I was 13 years old I went to the School of Actors of

Q: What was your first film?

HOYOS: The director of the academy told everyone to have photographs taken so the producers could get to know us. So we all had this done. One actor, Freddy Fernandez was making a film with Joaquin Cordero and Luis Aguilar called *Que Bravas Son las Costenas* [*How Brave Are the Coast Dwellers*, 1954]. They selected me for a part in the film directly from my photograph. I looked older than my actual age. One day I

came home from school with my mother, and we were told there was a call from the film studios to offer me a part. Well, that made me feel great, like I was Susan Hayward or Elizabeth Taylor. So then my mother and I went to Churubusco Studios to the offices of the Rodriguez Brothers. We told the secretary and her manager that we were called to report for this picture, but they didn't know anything about it. So we went over to the soundstage to see the director, Roberto Rodriguez. He said that he didn't call anyone. I got upset and began to cry. But one of the cameramen knew what happened. It seemed Fredy saw my picture and liked me. He thought I would arrive alone, and here I show up with my mother because I was so young. When the director found out, he was very sorry and ashamed about the incident. So the director took us to lunch at the studio restaurant. While we were eating, a man from casting came by and said, "One of the girls can't make it, so you are very lucky, you are going to play a part in this picture after all." That is how I got this role as a companion, a woman from the sea. I was made up, and the first line I had to say in films, after the leading man makes a cute comment to me is, "Stupid!"

Q: You have had a long and varied career. I want to ask about some genre titles that are popular in the United States. One is *Un Viaje a la Luna* [*A Voyage to the Moon*, 1957]. Was this a comedy?

HOYOS: That film was very popular and funny because almost all the famous Mexican comedians were in it.

I played a psychiatrist curing all these patients, who were played by these fabulous comedians. It was a very cute picture. There really wasn't a trip to the moon. Tin Tan [German Valdes] and Capulina [Gaspar Henaine] were in it. So was Alfonso Arau, who went on to become a famous director of such films as *Like Water for Chocolate* [1992].

Q: How did you get the part in La Loba [1965]?

HOYOS: The producers just called me and asked if I would like to work in this picture. I would have the leading part as a lady werewolf. I didn't mind doing out-and-out horror. The whole part was very strange. I thought it was a very good picture.

Q: Were you in the make-up as the she wolf?

Hoyos: Sure, and at the end it was terrible because we were filming in a very cold place. It was a big park in Mexico known as "Theater of the Lion." It is a hilly area, and it was very cold there. The make-up was applied hair by hair. Then there was a wig and the nails. I also wore fangs. It was very uncomfortable. The make-up was quite a process. The suit itself was a leotard. The transformation scene took about two days, and I caught a terrible cold. These scenes were shot at the very end, and then the picture was finished.

Q: Your part called for a lot of physical action. There was another werewolf in the film played by Joaquin Cordero. How did he enjoy his part?

HOYOS: He loved doing films like this. We were very good friends. We were laughing all the time and were very happy. But the cold bothered him too. It was freezing. We were both so cold. We kept rushing the director to continue and get the scenes done.

Q: Some of the film was shot in the studio?

HOYOS: There was a lot of studio footage, but the end of the film was done on location.

Q: How was the director?

HOYOS: Rafael Baledòn was a very good director. He was a very nice person, very handsome. He was married to a fine actress. He was incredible. Rafael also made a lot of other horror pictures like *Orlak, el Infierno de Frankenstein* [1960] and *Pantano de las Animas* [*Swamp of the Lost Monster*, 1956].

Q: Did you have a double in *La Loba*? There was a lot of physical action in the part, jumping from rock to rock.

HOYOS: Yes, there was a double for some scenes so I wouldn't get hurt. But I did some of the jumping, naturally.

Q: The same year you did another interesting film called *Aventura al Centro de le Tierre* [*Journey to the Center of the Earth*, 1964]. What can you tell us about it?

HOYOS: That was actually filmed in these huge natural caverns called "Grutas de Cacahuemilpa" in Morelos about 60 miles south of Mexico City.

It took about five weeks to shoot the film, and since all the action took place in and around the caves, it was very dangerous. We were housed at a town called Taxco, and it was a very hazardous drive to reach the caves, about 18 miles. Just going and coming back to the hotel was an adventure. It was also very dangerous inside the caverns. You had to watch your step every moment. You could fall and hurt yourself. Two members of the crew later died due to the making of this film. They were exposed to diseased bat droppings. There were many bats in the caves, and their droppings can be very dangerous. These two men were not careful and they picked up this disease and died. It was very difficult to avoid these bat droppings, because you had to touch the rocks sometimes to move around.

Q: Was it frightening doing any of the scenes?

HOYOS: Yes. For one of the scenes, I was hiding in the rocks, a very difficult scene, and Javier Solis shouted at me. He was joking, but I was startled and I slipped. I was pretty high up, and I could have had a nasty fall.

Q: Any other dangers?

HOYOS: Well, they shot off flares. They fired these guns at the monsters. They were blanks, but you still had to worry about the sound.

Q: Some of the gunfire seems dubbed in later. But that one big dynamite explosion looked very real.

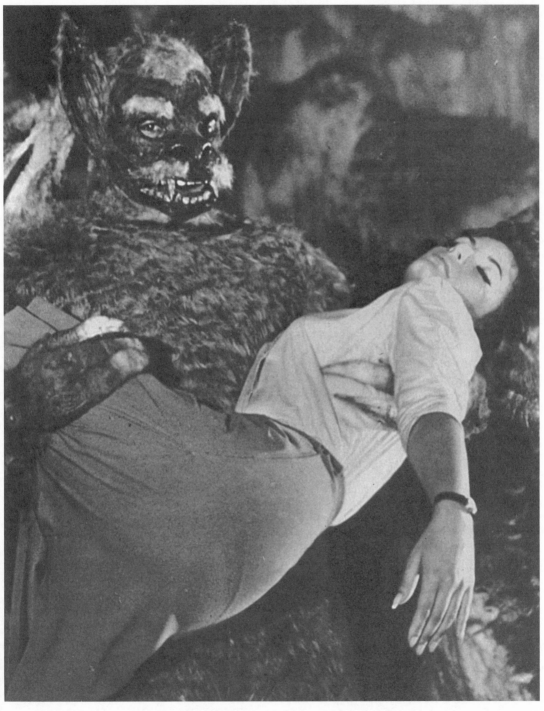

In the arms of a monster from the center of the Earth. Kitty de Hoyos is carried off by the hideous bat-men in Mexico's memorable *Adventure at the Center of the Earth* (1964). The tragic deaths of some crew members marred the production.

The savage, accursed Kitty de Hoyos makes a striking werewolf in Mexico's *La Loba* (1964)

HOYOS: Probably they dubbed in the louder shots. They didn't want to loosen any rocks and have some fall. They probably faked the dynamite somehow.

Q: Did the full length costumes of the Bat Monsters seem very effective to you?

HOYOS: I certainly thought so. The monsters were played by professional stunt men, and they were very good. When I was carried away, they were very careful and there was no problem with these scenes. Their costumes could cause scratches very easily, so they had to be very careful around me. Looking back, I guess we were all very brave to work under such conditions. There were frequent breaks. We had to go up and leave the caves every 30 or 40 minutes.

Q: What do you recall about the director?

HOYOS: Alfredo Crevenna was a very interesting man of German

descent. He tried to keep the cast and crew happy, and he was very professional and considerate of everyone. This film had extremely difficult circumstances.

Q: Any memories about the other members of the cast?

HOYOS: Javier Solis was rather well known as a singer. He made his very first picture with me, and then we made this one. We worked well together. Years afterwards David Renoso became our leader in the actor's association. We became good friends. He was a family man.

Q: Do you have any regrets doing *La Loba* or *Aventura al Centro de la Tierre*?

HOYOS: No, I don't regret them at all. I love horror films. I wish I had made more. They were interesting parts, and it was very nice work. Not only adults, but a lot of children love those pictures. They leave a very strong impression. The atmosphere in them is usually very rich.

Q: What other pictures stand out in your memory?

HOYOS: I enjoyed *El Campeòn Ciclista* [*Bicycle Champion*, 1956] because it was always a pleasure to work with Tin Tan. You can't imagine what a great human being he was. It was one of my first pictures, and he was so warm and nice. Later we worked in *Pilotos de la Muerte* [*Daredevil Pilots*, 1962] which was also excellent. The story was about pilots who help out forest fires. I saw *Muertos de Miedo* [*Fear of the Dead*, 1957] on television the other day. It was

also a horror/comedy that largely appealed to children. The plot revolved about the theft of some jewels. *Las Hijas de Zorro* [*Daughters of Zorro*, 1963] was an action/adventure film, and I had to learn how to fence. I also had a number of scenes on horseback, and I got thrown from a horse for the first time while making this film. In *Asesino S.A.* [*Murder Incorporated*, 1956] I played two roles, a heroine and a villain. Wolf Ruvinskis and Resortes were in that as well. It was directed by Adolfo Bustamante. I did a dance in that film as if I were a bullfighter. And I was amazed at how heavy is the muleta which he carries. The bullfighters make it seem so easy, and it weighs quite a bit.

Q: Was it difficult playing two parts?

HOYOS: No. It was fun. I also played two parts in *Los Jinetes de la Bruja* [*Witch's Horseman*, 1965] where I played both the witch and the heroine. You know, whenever you are making these pictures, people keep telling you how beautiful you are. Well, I deny it. I say that I am an ugly girl, but I have personality. Well, then I played these different characters. I used different make-up each day, and they made me very beautiful as the witch. The wig they gave me was this stunning white hair. It was quite interesting.

Q: What was your favorite role?

HOYOS: There were a number of them. It was quite interesting working on *Los Signos de Zodiaco* [*Signs of the Zodiac*, 1962]. I enjoyed the part as the ghost, the mother ghost, in *Los Cuervos Estan de Luto* [*The Crows Are in Mourning*, 1965] which was derived from this

Latin beauty Kitty de Hoyos strikes a pose.

famous stage play. But my part is not in the play. The producer and director created this part especially for me when they turned it into a film. I was very grateful for this, and it was the most fascinating part I had ever done. This picture is very hard to locate anymore, and I hope it is not lost. You know, there was a terrible fire at the Filmateca Nacional, which was the largest Mexican film archive, and many Mexican films were lost.

Q: Have you done any films in America?

HOYOS: I made a film in New York called *Heroin*, a Puerto Rican co-production. It was in English, and it was very good work. I got some very nice reviews for it, particularly in *Newsweek*. That was my only American film. I also did two others in Puerto Rico, and one in Spain.

Q: Were there any films you didn't care for?

HOYOS: I didn't like *Mujeres Encantadoras* [*Charming Women*, 1957]. I just didn't care for it at all. I would say that *Esposas Infieles* [*Unfaithful Wives*, 1955] was one that I wish I hadn't done, even though it was my first big part. I did a semi-nude scene in that film, and it upset me for almost five years. I was very shy at the time, and it took me a long time to get over it.

Q: Did you ever work with Santo or the comedian Clavillazo?

HOYOS: I knew Santo, but I never worked with him. I was great friends with both Clavillazo and his wife. We worked together in stage shows they have in Las Vegas. We did a number of very funny skits. I also knew Cantinflas, but I never worked with him.

Q: What was the last film you did?

HOYOS: The last one was *El Grand Pero Muerto* [1978] directed by Rogelio Gonzalez. It was also the last picture of a great actor, Fernando Soler, who had been one of my teachers. All the scripts I was sent after that just weren't interesting. They did not seem like good pictures. After I turned down so many, I guess they considered that I had retired from films. But I still do theater. Right now I am researching a part for a new play that will celebrate my 43 years as an actress. It is a comedy of the absurd, and I look forward to doing it. I also want to thank my American fans who have enjoyed my films like *La Loba* that have been seen in the United States. I am very glad to hear that people are still enjoying these pictures.

13

DONNA MARTELL

Indian Princess and Space Commander

Donna Martell's work in motion pictures and television extend well beyond *Project Moonbase* (1953), a bargain basement film with a compelling charm. Dwarfed in notoriety by the bigger budgeted science fiction classics of its time like *Destination Moon* (1950), *When Worlds Collide* (1951), *War of the Worlds* (1953) and *Forbidden Planet* (1956), *Project Moonbase* is finally emerging as one of the more interesting curios of Fifties sci-fi films. For the most part, the film is unexciting but entertaining, capturing that magical mood of some of television's space operas, such as *Space Patrol* (1951–52) and *Rocky Jones* (1953–55). The film's roots in early television perhaps explain its appeal to devotees of vintage television. Project

Moonbase was actually condensed from various episodes of *Ring Around the Moon*, an early, unreleased television series. The plot involves interstellar espionage on an orbiting space station. The astronauts, clad mostly in dress shorts and T-shirts, include Ross Ford, second in command, Hayden Roarke (Dr. Bellows from *I Dream of Jeannie*), James Craven and Larry Johns. Donna plays Col. Briteis, lead astronaut for the new space project. She is one of the film's pluses. A veteran of film and television productions, Donna's striking appearance far outshines the impoverished sets and inadequate special effects.

Of Italian-American heritage, Donna's real name is Irene De Mario. When she was 17 years old, Hollywood talent

Angelic beauty Donna Martell in 1955.

with her, and this time she accepted a contract offer. After signing, her first part was the leading female role in *Abbott and Costello Meet the Killer, Boris Karloff* (1949). Later, she appeared opposite Johnny Sheffield in *Elephant Stampede* (1951), an entry in the *Bomba the Jungle Boy* series. Her other films included *Kim* (1950), *The Golden Hawk* (1952), *Give a Girl a Break* (1953), *The Egyptian* (1954), *Love Is a Many Splendored Thing* (1955), *Ten Wanted Men* (1955) and *Hell on Devil's Island* (1957).

A number of Donna's credits include television work as well. She appeared in many Westerns, working with Dale Robertson in *Wells Fargo*, Gene Barry in *Bat Masterson* (1959–61), Clint Walker in *Cheyenne*, Jock Mahoney in *The Range Rider* and Ray Milland in *Markham* (1959–60). Her last television appearance was on an episode of *Bonanza* opposite Michael Landon.

agent Wallace Middleton signed her to a contract. Six weeks later, as "Donna De Mario," she was the ingenue lead in the Roy Rogers Western *Apache Rose* (1947) at Republic Studios. She was offered an immediate contract at Republic, which her agents suggested she decline feeling it was too early in her career to commit to a contract. Her next feature film was *Robin Hood of Monterey* (1947), another ingenue lead opposite Gilbert Roland. She was later seen briefly in the Abbott and Costello comedy *Mexican Hayride* (1948). Universal was also impressed

But to fans of sci-fi cinema, Donna Martell's best known role is Colonel Briteis (pronounced "Bright Eyes"), commanding officer of a spaceship making the first orbital flight around the moon, in *Project Moonbase*. Directed by stuntman-turned-director, Richard Talmadge, the film may seem awfully campy

to contemporary audiences, but it does have a few notable aspects. Among them is the contribution of legendary science fiction writer Robert A. Heinlein, who is given co-credit for the screenplay. In a typical Heinlein touch, a female is in charge of the expedition; additionally the President of the United States turns out to be a woman. (And this film is set seventeen years ahead in 1970!)

Long before Kate Mulgrew played Captain Kathryn Janeway on *Star Trek: Voyager* (1995), there was Donna Martell as Colonel Briteis in *Project Moonbase*.

Q: How did you get started in acting?

MARTELL: I had enrolled in Los Angeles City College, and I was approached by some fellow students in the photography department to model for them. I agreed, and before I knew it, my photos were all over the campus. One day a young man asked me if I had ever thought of a career in movies. I laughed because I was asked this a few times before, years earlier, when I was a little girl. My parents would never let me.

Q: Did they disapprove of Hollywood?

MARTELL: My father was strict, but very up front. I was persuaded to see this particular agent. The young man worked as a house boy for the agent. I went to see him with my mother and father. We went to this very plush office on Sunset Strip ... Sunset Strip, mind you, was not only well respected and high class but so very clean and beautiful back in those days. This was around 1947. We talked and they liked me. They wanted me. My father put

the cards on the table about what he expected from them. Wally Middleton respected this and honored my father's wishes. Wally was just two years older than my father, and he agreed "to watch over me" so to speak. We signed on the spot, and just weeks after I signed, I was doing the lead opposite Roy Rogers and Dale Evans in *Apache Rose* [1947].

Q: Any recollections about working with them?

MARTELL: Roy and Dale were wonderful to me. Roy taught me to play gin rummy [*laughs*] and Dale took me under her wing as though I was one of her own kids. She would take me over to Ventura Boulevard to the costume outfitters, and she would have them make some special costumes and dresses for me. Those were the great days of Republic pictures, and I made a lot of friends there. I'm Italian, and there were a lot of Italian people who were working on that picture behind the scenes. A lot of Italians played Indians in those days. Years later, I played an Indian in an episode of *Bonanza* called "An Indian Princess."

Q: What was your next picture?

MARTELL: My second picture was *Robin Hood of Monterey* [1947] and this was Gilbert Roland's comeback to the *'Cisco Kid* series. We shot it on location, not too far away in Newhall [California]. In those days, that was a location! [*laughs*] It was blistering hot and raining buckets, but it turned out

to be loads of fun. Evelyn Brent was a silent screen actress, and she helped me out in some key areas of this picture, offering good advice and other things helpful to my work.

Q: Which of your early films most stand out in your mind?

MARTELL: I would say *Secret Beyond the Door* [1948] with Joan Bennett. I worked with many directors, but my fondest memory of a director would have to be Fritz Lang. He became quite enchanted with me ... so enchanted that he gave me an impromptu screen test right there on the set of *Secret Beyond the Door*. Others told me that this was not normally done, and Fritz wanted to put me under personal contract. This occurred at the same time Universal wanted me under contract, so Fritz and Universal were bickering back and forth. My agent thought I should go with Universal because of the buildup and training they offered. They felt that Lang could not offer me these qualities the way a major studio could. There was something special about Fritz that I admired. Looking back, maybe I made a mistake not going with Fritz because he made stars of Joan Bennett and many others. He was so very intense, and I was very comfortable with him.

Q: Were you happy at Universal?

MARTELL: Universal had problems with me when they did not want to loan me out to other studios at that time who had better projects for me. So later my agent tried to get me out

of my contract, but couldn't. I did some featurettes with Tex Williams. Television productions had become popular, and there were many things I did for TV. I pioneered television. There were other television projects I could have done during my time at Universal, but I had to pass on them due to my contract.

Q: While at Universal, you appeared in *Abbott and Costello Meet the Killer, Boris Karloff* [1949]. What was this duo like to work with?

MARTELL: Lou Costello was a fine person, but he was still trying his best to get over the death of his infant son [Lou Costello, Jr., died in 1943], so his actions were indeed acting and nothing more. After his son's death, something died in him, and I think it was apparent to just about everyone who worked with him. Still, despite his sorrow, Lou managed to muster up some high jinks, and he would often play practical jokes. Bud Abbott would play cards with me from time to time, and I became friends with Bud's sister, Olive.

Q: What about Boris Karloff?

MARTELL: Boris was just the opposite of the characters he played. There was no killer or monster in this man. He was the perfect gentleman; sweet, calm and very even-keeled.

Q: What did you do next?

MARTELL: After *Abbott and Costello Meet the Killer*, I did *I Was a Shoplifter* [1951] and *Peggy* [1951], which was about the Rose Bowl Beauty Pageant. I was one of the Princesses, and we

went out to Pasadena to one of the parades and were shown how the girls prepare for the parade. You know, I later became a judge at a real beauty pageant. I was married in 1953 to Gene Corso, who became the center fielder for the Pittsburgh Pirates. When he played for the Southern Association, we were in Burlington, North Carolina, and we found out my picture *Ten Wanted Men* [1955] was showing there. I became a big star in those parts. They had life-sized posters of me outside the theater, and the people were lined up around the block. Everyone knew I was married to Gene, so they invited me to become a judge of the drama section of the Miss America Beauty Pageant in North Carolina. Afterwards, they made me queen of their Fourth of July Parade. It was a grand time.

Q: You were also in *Elephant Stampede* [1951], one of the *Bomba the Jungle Boy* pictures.

MARTELL: I had a wonderful time working with Johnny Sheffield. We both had to swim in that filthy lagoon out at the Arcadia Arboretum. And when I say filthy, I mean filthy. My hair was shoulder length, and they had to stop shooting a few times in order to get all the encrusted gunk and stuff out of my hair. It was awful.

Q: What do you remember about the making of *Project Moonbase* [1953]?

MARTELL: We filmed it over at the old Hal Roach Studios in Culver City and, of course, the budget was very low. We shot the picture in about 10 or 11 days. I believe it was among the earliest science fiction films dealing with outer space exploration. This was 1952 and the people involved with the film were very excited about it. In fact, everyone involved was wonderful to work with, and we looked forward to coming to work each morning to shoot more scenes. The director, Richard Talmadge was a little guy, very nice and full of fire. There was a lot of promise with this picture. It was unique, since I believe it was among the earliest of science fiction films dealing with space exploration.

Q: This production was initially intended to be a television series. When did they decide to turn it into a feature film?

MARTELL: When I got started on the project, it was originally shot as a pilot for a television series, I believe. As each day progressed, everyone would become so excited about it that they would add new dialogue. That was fine, but they would add this new dialogue just before I was to go before the camera! [*laughs*] I was handed a new page of dialogue and was told that they had decided to make it into a feature film. It was a somewhat impromptu decision on the part of the producers [Jack Seaman, Galaxy Pictures Inc]. They sprang this on us in the middle of shooting what we thought would be a television series. Again, this was 1952 and at the time, I had no idea just how many people were interested in science fiction. They must have had scientists from around the country advising those who were

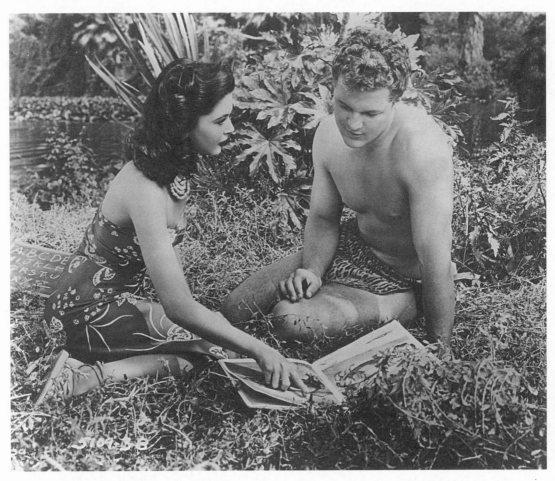

Donna Martell takes on the role of teacher to Bomba (John Sheffield) in *Elephant Stampede* **(1951).**

making the picture about key points of interest and other scientific information. Then they would write this into the script.

Q: One aspect that really stands out is the decidedly low-tech space wardrobe you and the other cast members wear at the space station.

MARTELL: The outfits they made for us were actually men's clothes. The clothes I wore—the shorts, shirt and those stinky felt skull caps—were all made and cut from men's clothes. At that time, I had a gorgeous mane of jet black hair. So, not only was I wearing men's clothing, but my head of hair was stuffed into a skull cap. How they managed to do it is beyond me. [*laughs*]

Q: This was a low-budget production. Did they offer you much salary?

MARTELL: Well, after the picture was completed, they offered me a choice of straight salary or a piece of

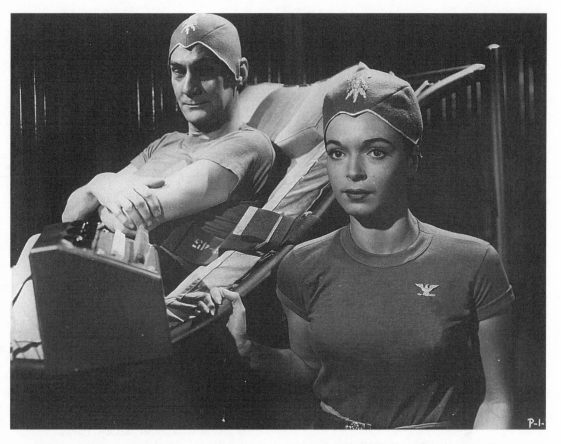

Space traveler and intergalactic bride Donna Martell in *Project Moonbase* (1953). On her left is Herb Jacobs.

the picture. I was still a kid, a green-horn in the business, so I asked my agent what to do. He told me, "Take your salary and run." This was good advice for the moment, but not for the future. The picture has since played all over the world. When it was released back in 1953 it didn't do that well, but through the years, it must have been on television nine million times! [*laughs*] But who knew the kind of interest it would create all these years later?

Q: You worked in both "B" movies and "A" productions.

MARTELL: Oh yes, I was in several "B" Westerns. I was in a couple of Westerns with Gene Autry, *Twilight on the Rio Grande* [1947] and *Hills of Utah* [1951]. Working with Mr. Autry was memorable. He was a nice man and a very good businessman. Gene was quite frugal in a keen business sense. He had his own airplane, and I flew with Gene to a location to shoot one of his Westerns. It was Pioneer Town in the mountains above Palm Springs. I was the only woman on location there. Well, I quickly began to wonder, since there was no make-up, no hairdresser and no wardrobe

person. I found out that Mr. Autry provided it all, and he did a great job of it. He wanted me to star in the *Annie Oakley* television series that he was producing, and his manager, Mitchell Hamilburg, wanted to put me under contract. But I loved my agents dearly, so I didn't sign and Gail Davis, of course, got the role.

Q: Tell us about some of your "A" films.

MARTELL: In terms of the bigger productions, I played Jennifer Jones's sister in *Love is a Many Splendored Thing* [1955]. It was a thrill for me to have played opposite Jennifer. Henry King is the finest director I ever worked with. In *The Egyptian* [1954], I was supposed to have had a better part in that film, but there was a contractual agreement with Jean Simmons, so the studio [20th Century–Fox] decided to showcase her instead. One big role that got away from me was the female lead in *Around the World in 80 Days* [released 1956]. I met with the producer, Michael Todd, and he fell in love with me for the part. Well, he wanted to hire me on the spot, but I had to turn it down because I was eight weeks pregnant with my first child, and that picture was in production for almost two years. Todd wanted me for the movie, but I knew there was no way I could do it. So Shirley MacLaine was cast in the role. She's multi-talented and very deserving of her stardom, but it would have been a big break for me.

Q: Who were some of your favorite people you worked with in Hollywood?

MARTELL: Christian Nyby was one of the best directors in the business. I was doing a magazine ad for Raleigh cigarettes. I didn't smoke and didn't know the first thing about smoking. I spent a whole weekend trying to look as though I were a smoker. The door of the office where I shot the commercial was open, and from across the hall I saw a tall, handsome man in the corridor. It was Christian Nyby, and he yelled, "I want that girl!" So I starred in *Hell on Devil's Island* [1957], which he directed.

Q: Of which performance are you most proud?

MARTELL: One of my best roles was on the television show *Death Valley Days*, which was narrated by Ronald Reagan. I went from an 18-year-old girl to an 80-year-old woman in one episode. The episode was called *She Burns Green* and James Griffith played my husband. It was about a man who takes a wealthy girl out of her lifestyle and onto a ranch. The role was a demanding one for me and one I truly loved doing. My peers applauded me for it afterwards. I must say that I liked myself ... my performance, for the very first time.

Q: Any unpleasant experiences you care to tell about?

MARTELL: My least favorite memory is of a foreign director on an episode of a TV show called *American Heritage*. William Bishop was playing Jean LaFitte, and I was playing his wife. It may have been Reginald Le Borg, but I'm not sure. He wanted me

to "parrot" his exact words in the exact way he was speaking them. My character did not call for this kind of style, so I did something I'd never done before. I turned to him and told him I was not a "parrot" [*laughs*] and it just was not me or what my character needed. He got me so mad. I remember repeating, "I am not a parrot! I am not a parrot!" [*laughs*] He apologized to me and I got through it okay.

Q: You retired in the 1980s. Any particular reason?

MARTELL: Well, my last feature was the made-for-TV film *Grace Kelly* [1983], and it was a sad thing for me to see the radical downslide the industry had taken. Not only in product quality but in moral issues as well. I bowed out gracefully, and I'm glad I did. I loved the people and the industry that I was a part of, and it makes me sad to see something that I love go to the dogs. Hollywood was a very classy place, and genuine class and respectability have long since vanished.

Q: Any closing thoughts?

MARTELL: When I think back on my earlier career, I can understand why *Project Moonbase* and many other films like that are held so dear to the hearts of fans. I'm very proud to be a part of that bygone period.

14

JOYCE MEADOWS

The Beauty and the Brain

Sally Fallon and her father have just discovered the body of Dan Murphy in the cave when they are startled by a strange light. They turn to see a huge, floating brain, trailing a long stem. The brain has two rather kind-looking eyes which observe them closely.

"Earthlings!" he says to them telepathically. "Do not be afraid. I am not of your earth. My name is Vol. I was sent by my leader to capture the criminal Gor who escaped to your planet Earth. He has already voided that human in the passage. He is cunning and dangerous!"

The alien explains that the criminal has possessed the body of Sally's fiancé, Steve March, and asks their help to save Steve and capture Gor.

This remarkable encounter occurs near the beginning of *The Brain from Planet Arous* [1957] starring John Agar, Thomas Browne Henry, Robert Fuller and Joyce Meadows in the role of Sally. Her performance is one of the highlights of the film. Most heroines in similar plots are in the dark and unaware of the true danger confronting them, but Sally knows exactly what is happening, and it is this knowledge that makes her role so interesting and which provides additional depth to her characterization. She is a lovely, charming woman who must show great courage as she deals with a criminal alien posing as her love.

This was the first major role in films for Joyce Meadows, who remains an active performer today. Her career has

John Agar and Joyce Meadows are matched in romance in Howco International's entertaining sci-fi classic, *The Brain from Planet Arous* (1958).

included television, including numerous appearances on *Alfred Hitchcock Presents* [1955–65] and many others, such as *L.A. Law* and *Lois and Clark* [1993–1997]. She is also an experienced singer, and has toured widely in theatrical productions. She has even appeared as a recurring character on *Santa Barbara* and *Days of Our Lives*. For the past 12 years, she has also done more and more Shakespeare, from Mistress Page in *The Merry Wives of Windsor* to Hamlet's mother in *Hamlet*.

Q: Where were you born and what is your background?

MEADOWS: I was born in Alberta, Canada, in a small prairie town outside of Calgary called Arrowwood. It was all farmland, and there were not too many modern conveniences. After the chores were done, everyone relaxed on the back porch, and they would dance, sing and play music. They taught me everything. I never saw a movie until I came to Montana when I was 11 years old. We stayed there a year and then moved to Oregon. Finally, a year later, we settled in Northern California. This was in the late forties.

Q: When did you first consider becoming an actress?

MEADOWS: It was in high school that the idea of acting first interested me, when I did school plays. I became fascinated with the art of acting—and it is an art. I also picked up a book in an old bookstore in Sacramento by Stanislavsky called *To the Actor* and that book inspired me very much. Before I got out of high school, I was singing at Lake Tahoe. The Junior Chamber of Commerce saw me and thought I would be a good candidate for the Miss America contest.

Q: Did the idea appeal to you?

MEADOWS: The chance to perform before a crowd is what interested me. I sang at the Memorial Auditorium in Sacramento with a large orchestra. I thought it was wonderful to perform for so many people. I won the contest as Miss Sacramento. The following year, when I crowned my successor, I sang and also did a monologue. I was part of the entertainment while they counted the ballots.

Q: Who were your favorite performers?

MEADOWS: I was always in love with James Mason. He was such a fine actor. Among women, I always looked up to Ingrid Bergman. I also enjoyed Katharine Hepburn's work. I used to hang their pictures in my room.

Q: Did your parents encourage you to go into acting?

MEADOWS: My mother was fascinated with the idea, but not my father. He was born in Iowa and moved to Canada. He then went to college at UCLA. He became familiar with the Hollywood scene in the twenties, and he was horrified that I wanted to go there.

Q: How did you get started?

MEADOWS: I worked as an apprentice at the Sacramento Music Circus while I was in high school, and I got to know a lot of the musical comedy performers. Amy Torrianni knew I wanted to come to Los Angeles, and she got me into the Hollywood Studio Club. That was in 1954, and she helped me get into acting classes in Pasadena. I also studied with some drama coaches such as Jeff Corey and Mira Rostova.

Q: What was your first professional performance in the theater?

MEADOWS: It was still in Sacramento at the Eaglet Theater, where I played Juliet in *Romeo and Juliet*. I wasn't quite 19, and this was the greatest thrill for me.

Q: You have a particularly charming and lilting voice. Did you do anything to cultivate this quality?

MEADOWS: Basically just singing lessons. I started with semi-classical and then pop. I also sang country and Western style. I had been graced with a nice voice since I was very young. I had a singing teacher when I was 16 who ruined my voice. I couldn't talk, and it took a year to nurse it back to health with another teacher who was very good.

Q: How did you break into motion pictures?

MEADOWS: I was in a play at the Glendale Center Theater, and an agent named Alan Connor came to the theater. He handled a number of known stars like Gloria Swanson and Hermione Gingold. He worked very hard taking me around to the studios, and he got me into television and films. *Omar Khayyam* [1957] was my first picture, and I played a harem girl. I recall the interview. There were all these girls lined up, and two men looked us over like products in a market. They asked me if I had a SAG [Screen Actor's Guild] card and I didn't, but I said I did. It was one of those things where you couldn't work without a SAG card, and you couldn't get a SAG card unless you worked. Well, I got into trouble, but I got my SAG card because of it.

Q: What do you recall about your part?

MEADOWS: They put this liquidy make-up all over you, and you had to stand there like a scarecrow until it dried. Then you could put your costume on. It was strange make-up that darkened your skin. I only worked with the second unit director. I saw some of the main actors perform, such as Cornel Wilde and John Abbott, but I had no real contact with them. I then did another picture with a feature role in *Flesh and the Spur* [1956], a Western. It was released before *Omar Khayyam*, but the harem girl part was shot first.

Q: What part did you play in the Western?

MEADOWS: One character ran a medicine wagon, and I was his daughter. I fell in love with a cowboy played by John Agar. I got killed in the film, and John eventually wound up with Marla English, who played an Indian girl. It was all very new to me, and I was fascinated with the technique. It was all shot on location out at Iverson's ranch.

Q: Did you work well around horses?

MEADOWS: Yes, in fact I drove the medicine wagon in the film, and I actually had to drive a team of horses.

Q: What do you remember about this film?

MEADOWS: Not too much. It was the first time I met John Agar, and he was a very nice, lovable person. He helped me very much, and he made me feel very comfortable. John took me under his wing, and as a film greenhorn, I was in very capable hands. Of course he was also my leading man in *The Brain from Planet Arous* [1957].

Q: How did you get the leading role in *The Brain from Planet Arous*?

· MEADOWS: I got the interview because Jacques Marquette remembered me from a television show I did, *The Man and the Challenge* [1959–60] with George Nader. It was a science fiction series produced by Ivan Tors, and Jack was first cameraman on that show. Jack was not only cameraman on this film but producer as well. It was Jack who cast me in the role.

Q: What was your impression of the script?

MEADOWS: I was very excited by it. I mean I was playing the lead. I was also a science fiction fan from way back. When *Star Trek* [1966–69] came on, I was one of the show's biggest fans. I thought *The Brain from Planet Arous* was a wonderful opportunity for me. It certainly helped my career by getting me more guest roles on television.

Q: You certainly were very good in the picture.

MEADOWS: You know, they didn't have a lot of money for it, so Jack would do these creative things. They would set up a shot, and Jack would move the camera in and out. He would start from a longshot and later work out to a close up and then move back again. Today, people are fascinated by the camera technique on this film, and he did it that way to save money. There wouldn't be cuts or the need to cover the same scene twice. So we had some very long takes, and the camera work was quite interesting. It was a technique that Ingmar Bergman liked to use as well. I was still very innocent about the technique of film when I shot that picture. At one point we were doing a rather long scene, five minutes, and the assistant director spoke with me, wanting to know if I could handle it. Well, I had just finished doing Helena from *A Midsummer Night's Dream* on stage, and I thought, "Why are they worrying about five minutes?" Of course, it is a totally different medium.

Q: Jack filled the film with interesting touches, like when he shot that scene of John Agar's face through the water cooler.

MEADOWS: My only disappointment was that there were so few close-ups, but Jack was saving the cost of doing that for John's close-ups (when his eyes change as he uses the "Brain's" telekinetic power.) The metal contacts hurt John. Sometimes when we were shooting, we had to stop because he would start to tear. Tons of water would flow out of his eyes. It was a real shock for him when he first put them on. I recall being very happy I didn't have to wear them.

Q: How long did it take to shoot the film?

MEADOWS: Not too long … I think about ten days. Jack put together a crew that he knew, so everyone worked very well together. I had a lot of fun making the picture.

Q: Where was the home where your character lived in the film?

MEADOWS: It was a real house, either Jack's home or the other producer, Dale Tate. That's where most of the scenes with the "Brain" were shot.

Q: What can you tell us about the "Brain" prop?

MEADOWS: They also brought it to Bronson Canyon, and they had a lot of production problems with it. First they had to light the cave. Then they had to make sure that the "Brain" looked like it was floating by itself. They wouldn't allow us into the cave until the "Brain" was all set up, and we sat

around for such a long time. It was very cold inside the cave, which is another reason they didn't have us in there. I remember when we did get in the cave that the "Brain" looked very convincing because of the way they lit it. That was also the first time we had seen the "Brain" and they wanted it to be a surprise. My first reaction to it was I jumped out of my skin. My initial reaction in the film was an actual, impromptu shock. It was really kind of fun, because I was looking forward to seeing it. I did not know what to expect. You know I thought it would be small, and it turned out to be pretty big. Thomas Henry, who played my father, was surprised too. They also kind of swooshed the "Brain" when we first saw it, like somebody saying "Boo!"

Q: Were there any times where the "Brain" fell or had other problems?

MEADOWS: Not in the cave, but they had some problems on the set. They just couldn't eliminate the piano wires. They could always be seen, and they finally gave up on that. Nowadays, they would just eliminate them optically, but this was a low budget film. You know, John Agar and I are supposed to attack the "Brain," and it was hard to give that illusion without destroying it. John and I had a lot of rehearsals. At one point, John gave the "Brain" a good blow. The director yelled, "Cut!" and everyone rushed over to try to repair the particular area. John kept saying he was so sorry. It was really funny. Every moment right near the "Brain" had to be carefully timed.

Q: Did you do a lot of reacting to the "Brain" when it wasn't actually there?

MEADOWS: Sure. It was a very delicate prop, so they didn't use it unless they really had to show it.

Q: What color was it?

MEADOWS: It had subdued colors. The brain part of it was off-white. They tried hard to make it look realistic and colored it with the black-and-white photography in mind.

Q: The good alien "Brain" was supposed to possess the dog in the film. How was it working with the dog, who was so important to the plot?

MEADOWS: I always have a camaraderie with animals. The dog and I became very good friends. He was such a pro, and beautifully trained. We worked very well together. It was wonderful to watch him work with his trainer. You know the scenes where the dog is supposed to be watching the "Brain," and how his eyes would follow it? Well, the dog was responding to his trainer who was making motions with his hand. He was trained to do what the hand did.

Q: Were there any high jinks on the set?

MEADOWS: John was always a lot of fun. There was the one scene where he is possessed by the "Brain," and he comes on top of me like he is going to rape me. John did a lot of joking about that. Jack would come up to him and say, "You must do the scene like we discussed. Make sure you rip the entire bra off!" Then John would say, "Is that all I get to rip off?" Then

With a few swings of an ax, hero John Agar frees himself from the spell of *The Brain from Planet Arous* **as Joyce Meadows looks on in horror.**

everyone would giggle. Even the gaffers would get in some good comments. Jack would tease them, saying they were going to make it a closed set. I was the only girl around, but the teasing was always good-natured and never offensive.

Q: How did you like working with Thomas Browne Henry?

MEADOWS: He was an old pro. He got everything right on the first take. He became like a real daddy to the rest of us. It was wonderful to watch him perform. I enjoyed him.

Q: A lot of your scenes also involved food. You often had to nibble while you performed.

MEADOWS: Well, when you are acting on the stage you develop a technique for handling drinks and food. On film, it has to look natural, and food can be distracting. Sometimes it is very difficult.

Q: Those hamburgers looked delicious.

MEADOWS: I was actually complimented because of the nonchalant way I handled the food. Another problem

can come from your motions. When you are sitting and you have to get up, you have to do it more slowly than normal so the camera can follow you smoothly.

Q: When did you first see the film?

MEADOWS: Jack had a private screening for us. He put on a party when the film was ready, and that is when we all saw it. I also went to see it in the theater.

Q: Did you enjoy the completed film?

MEADOWS: Very much. It was very entertaining. I was in a state of shock seeing myself on the big screen. One thing, however, I thought looked really phony. When my father and I come down the embankment to get to the cave, and I am wearing the pith helmet, I really start panting. It is so overdone. I don't know why the director didn't catch it. It makes me laugh now, but I cringed when I first saw it.

Q: Did you enjoy working with Nathan Juran, the director? He was billed as Nathan Hertz in the credits, Hertz being his middle name.

MEADOWS: I really don't remember him that clearly. He worked with us and took us through the scenes just fine. He deferred to Jack who was both cameraman and producer, which was an unusual arrangement. They were comfortable together, and it worked out all right.

Q: Your next film was another Western with John called *Frontier Gun* [1959]. Any memories of this film?

MEADOWS: I recall there was a lot of flirting by some of the fellows on that set. You either took great offense, or you kibitzed back and made it a game. Well, I made a game of it. Someone told me that was the same way Rita Hayworth handled it, so that made me feel good. Morris Ankrum was also in that film. What a great character actor he was, and I enjoyed studying him when he performed.

Q: Did you enjoy Westerns?

MEADOWS: It was OK, but they got a little boring sometimes. I wish I had done more science fiction.

Q: *The Girl in Lover's Lane* [1959] was a rather unique role. You played the heroine, Carrie, who is murdered during the last fifteen minutes of the film. How did this role come about?

MEADOWS: Jack Elam played a character who was basically a stalker. A stalker becomes fascinated with a particular person. Everyone thought he was harmless in the film except me. Brett Halsey shows up in town, and he is a drifter. He falls in love with Carrie. Jack Elam goes bonkers with jealousy, and kills me. I remember that I really fell in love with the director of that picture, Charlie Rondeau. He was a very talented director who usually worked a lot in New York theater.

Q: How did you enjoy working with Brett Halsey?

MEADOWS: Oh, I fell in love with him too. He was charming and handsome. He knew this, and he was not into acting as much as he could have

John Agar and Joyce Meadows confront trouble in *Frontier Gun* (1959).

been. He was like Tyrone Power. When you were next to him, you were in awe of his good looks. It was quite interesting working with Brett because of this. It was fun because he was one of the most handsome men I ever worked with as an actor. Of course, when someone is that sexy and good looking, it is hard for some people to take him seriously as an actor.

Q: How was it working with Jack Elam? He was so creepy in the film.

MEADOWS: It was so hard to be frightened of him. I had to completely block out his personality when acting in the picture. Jack was so sweet and very talented. You know he had these wild eyes too. You loved being around him, and it was hard to ignore that and be frightened of him. That was very difficult.

Q: What do you remember about doing the scene where he murders you?

MEADOWS: I kept giggling a lot. It was so funny watching Jack get into playing this nasty, crazy person. He kept whispering, "You must not laugh, you must not laugh!" right into my ear. Of course, that would make me laugh even harder. After I spoiled three cuts, we had to stop and I had to walk away from it for a little bit. I finally told Jack, "Don't say one word to me!" Then Jack said, "Okay. You just con-centrate, and I am really going to scare you." Well, he really did, and that final take was perfect.

Q: Did you notice the reaction of the audience when this film was shown?

MEADOWS: I recall seeing the film in the theater, and the reaction of the audience. Nice girls seldom get killed in the movies, so it wasn't expected. I went with a good friend, a gentleman who was a real supporter of my career. I remember his reaction. He was stunned. There was a shock value in the theaters. You know, you feel the audience reaction when you do live theater. In one play, I was arguing with my husband, and one old lady in the audience spoke out, "That's showing him!" But on film, it is unusual to get that powerful a reaction.

Q: Was there any connection between your death in this film and Janet Leigh's death in *Psycho* [1960]?

MEADOWS: *Girl in Lover's Lane* was first, so it wasn't a reaction to the film *Psycho*. Let me tell you, I was afraid to go see *Psycho* and I thought it would give me nightmares. I could get very upset because of certain films. There was a lot of publicity about *Psycho* at the time, and I knew it would get to me. Recently, my husband took me to a scary film, and I shut my eyes through a lot of it. I enjoy these films, but sometimes I chicken out.

Q: You were then in another Western, *Walk Tall* [1960].

MEADOWS: It was a real action film shot in the Sierras in the gold country area, and I recall the mountains and riding the horses. Willard Parker played the lead. We were being pur-sued and always on the run. It was a very difficult movie, going up and down those hills. I had some very

good dramatic scenes in the film, and I loved being able to handle the scenes on horseback. It was very funny, there was one horse who was a big ham. He'd done so many movies. I never rode him, one of the other characters did, but every time the horse heard the word "Action," he would gallop forward. So the director, Maury Dexter, never used the word "Action" in the scenes with the horse. Whenever the horse would gallop, if he passed near a tree, he would snatch a leaf from a nearby branch. It was so funny, and sometimes we had to do retakes because of him. I also remember that the stuntmen were incredible on this film. The regular cast would watch them and applaud when they did these marvelous stunts.

Joyce Meadows—horror strikes in *Girl in Lovers Lane* (1957).

Q: You were in the classic tearjerker *Back Street* [1961] with Susan Hayward.

MEADOWS: That was just a small part as a model. It was the first major motion picture I was in, and I was surprised how many takes they did for the smallest scenes ... such as 20 takes. I enjoyed watching Ross Hunter, the director, work. It was interesting because you could really polish your performance and get it right. In *The Brain from Planet Arous*, I wished many times that I could do a scene over, but they couldn't afford it. You know, I was used to working fast for television and low budget films. I would shoot an entire film in the time they took to shoot just a few pages of the script.

Q: What do you remember about Susan Hayward?

MEADOWS: She was very polite. We had only one scene. I was on a pedestal modeling a dress, and she would come up and look at me. Well, she came out to do the scene, and said, "Good morning." She looked closely at me and said, "Would you do me a favor, and turn sideways?" I did, and then she got excited and said, "Look, Ross! She could be my sister. We have the same nose." I said, "You have a Bob Hope nose too," because that's what we called it in our family, and my dad and sister also had the same nose. The comment just slipped out,

and I didn't know what Susan would think, but she broke out laughing. It was so charming. She said, "I didn't know it was a Bob Hope nose, but you're right. Do people ever tell you we look alike?" Susan was very nice. Some of the big stars might have taken offense when I let the comment slip, but not Susan.

Q: What part did you play in *I Saw What You Did* [1965]?

MEADOWS: Thinking of *Psycho* again, this was the film where I was murdered in the shower. I was axed to death, and I never even knew what character was supposed to be wielding the ax. That was my only scene. It was a William Castle film starring Joan Crawford, Leif Ericson and John Ireland. I didn't work with any of them. You know, Joan Crawford did a scene just before me, and she wouldn't allow me on the set until she was done and had left. I couldn't even have my make-up done or anything. Then I did my scene, and Joan returned to do another scene. Well, I was curious, so I snuck back onto the set, and Joan saw me out of the corner of her eye. Well, she stopped the scene and pointed to the door and demanded, "You get your ass off of this set!" I felt about two inches tall. The assistant director then told me, "This woman will not allow a younger woman around her in any way, shape or form, so you must leave." I was so mortified that I never even went to see the film and pretended I never did it.

Q: Was that your worst experience in the business?

MEADOWS: I believe so, but I had very few bad experiences. I had an awkward moment once when I did a show for the military up in Alaska. Jayne Meadows was also doing the show, and she confronted me at one point over my name. "Is that your real name?" "No, it is my professional name." "Well, Meadows is my real name, and I insist you change your last name!" I had been in the business for quite awhile at this time. Later, I learned her real name wasn't Meadows at all but Cotter, and she had to change her name when she appeared in a film with Audrey Totter. The producers didn't want a picture with both "Totter" and "Cotter," so she changed it. The name was in her family, but it still wasn't her real name. Her sister, Audrey Meadows, also took the last name to avoid confusion with Audrey Totter.

Q: You also worked on an Ivan Tors film?

MEADOWS: That was *Zebra in the Kitchen*, which was shot at Ivan Tors' ranch up in Canyon country. He had a zoo there where he kept his and other people's animals that worked in the movies. Some were big animals like lions, tigers, elephants and bears. The story was about zoo animals that got loose in a town. It was a charming film with a Disney flavor. You could only work with the larger animals for about a half hour or less. That is about as long as they would tolerate being used for filming. One day I was performing on an outdoor set, and we could hear screaming. Then somebody shouted, "Look out!" and we didn't

know what to expect. Suddenly, a lioness came racing through the set. She had just worked, and she was not in a good humor. Everybody scrambled to get out of her way. It took a few minutes for some trainers to corner her. I'll never forget that. It was both funny and scary.

Q: Who else was in that film?

MEADOWS: The picture was built around Jay North, who had played Dennis the Menace. Andy Devine was also on the picture. Every meal break, he and these old gaffers and technicians would gather together and swap stories. It was great listening to them. Jim Davis was also there. Martin Milner from *Route 66* [1960–64] played a veterinarian.

Alluring beauty Joyce Meadows in 1957.

Q: What do you remember about Ivan Tors?

MEADOWS: I worked with him on television for a number of shows like *Sea Hunt* [1958] with Lloyd Bridges. Ivan was a very sweet and kind man who really cared for the animals. They were treated with kindness. There was an area where they were going to build a dam in South America, and he was concerned about saving the animals who would be affected by this project.

Q: *The Christine Jorgensen Story* [1970] tells the story of the first person who had a sex change operation. It is now regarded as a camp film. What part did you have?

MEADOWS: In the early scene when he was a young man, I played a model who befriended him. I was the first and only girlfriend he ever had. The

most memorable thing about making the film was that Christine Jorgensen herself was on the set. She was in her fifties at the time. John Hansen was chosen to play her because he resembled her when she was a man. He was very charming, but he had little acting experience. It is such a different role. The movie wasn't put together too well either, so these things also led to it becoming a camp film. If a really talented actor was cast, the scene we had could have been so poignant. Jacques Marquette, by the way, was the cinematographer on that picture.

Q: You had supporting roles in many more films.

MEADOWS: Yes, quite a few, including *Bad Influence* [1990] and *True Identity* [1991]. But I never had the opportunity in motion pictures to play a lead role in a major motion picture. That's what was missing in my career. I love the intimacy of film, but I guess my best work was on the stage where I had a chance to play major roles and expand my craft.

Q: You mentioned some of your work on television.

MEADOWS: I did far more television than films, well over a hundred shows. I did so many, such as *Wells Fargo* [1957–62], *77 Sunset Strip* [1958–64], *Richard Diamond* [1957–60], *Rawhide* [1959–66], *Wagon Train* [1957–65], *Gunsmoke* [1955–75], and I was on *Perry Mason* [1957–68] three times.

Q: What do you recall about *Perry Mason?*

MEADOWS: The formula was interesting because the first half was usually straight drama, and the second half was the court scenes. If you were a guest star, and not the murder victim, you would be around for the court scenes. Funny things always seemed to happen, especially with Bill Tallman as Hamilton Burger and Raymond Burr as Perry Mason. Raymond was always an old movie heavy, and it was fascinating to watch him play the hero. He really knew camera technique.

Q: Did you ever work on *Alfred Hitchcock Presents* [1955–63]?

MEADOWS: Yes, four times, but unfortunately never with Hitchcock directing. He only directed a handful of episodes, and then he came in to do his introductions all in a bunch, which he shot on a different soundstage, so we never saw him. The first one was called *The Last Dark Step* in 1959. I was the "other woman" over whom Robert Horton kills his wife. But then he is picked up for my murder since it turns out his wife had previously killed me. I did another one the same year called *A Night with the Boys* where my husband loses his money playing poker. He tells me that he was mugged instead. Later, the police pick up a mugger, but my husband doesn't press charges. He learns that the mugger had robbed the man who won the money from him at poker. The third one was *The Throwback* where two men battle over me, and the older man outwits the younger one with a clever ploy. The last one was from *The Alfred Hitchcock Hour* [1963–65] called *Completely*

Foolproof where a husband and wife plan to kill each other, and both succeed. These Hitchcock shows were always top notch, and I was glad to do them.

Q: Does any other television part stand out in your mind?

MEADOWS: There was an episode of *Wells Fargo* where I was out for revenge when someone murdered my father. I had to walk into this saloon and get into a gunfight. Well, I never handled guns, but I told them I could. I took someone into my confidence, and he took me aside and showed me how to draw the gun. I practiced so hard for three days. When I finally shot it, I learned they filmed these gun scenes slowly, and later speeded up the camera so it looked like a quick draw. So all my worry was for nothing. Dale Robertson was great in that series, but we would argue about acting styles. Dale was a natural talker like Will Rogers. He could go on a stage cold and just talk and keep everyone entertained. He wasn't really interested in the art of acting.

Q: Are there any current projects that you are working on?

MEADOWS: I just completed playing Amanda in *The Glass Menagerie* at UCLA, and now I am developing with a partner, David Sage, a 90 minute stage presentation of Shakespeare's sonnets. I hope this will be a successful program for colleges, universities and also for a theatrical production. We are not just going to read them as poetry, but perform them. We talk

about them too, so it is in script form. We have put several years work into this project. My husband, Merrill Harrington, is planning to make a video of it as well.

Q: Do you have any regrets about your career?

MEADOWS: I was very timid when I came to Hollywood and followed everyone else's advice. I should have gone for more theatrical training to New York or London. Hollywood can be very intimidating, and then you get fearful if you are an actress, of passing the age of 30. So many actresses got tossed aside when they reached 30. Nowadays, it is different and there are good roles for women in their 40s and beyond. Look at Meryl Streep and Sally Field.

Q: You did a lot of theatrical tours?

MEADOWS: I hit the road for about ten years from the early Seventies through the early Eighties, mostly in the Mid–West and the South. I did theater in the round, as well as a lot of singing engagements as part of a quartet that did four part harmony. We sang music from the Beatles, *Hair* as well as old classics like "Danny Boy." Then when I came back, about 1984, I really shut the door on my past, and tried to start all over again. I refused to even think about my earlier work. This interview has shown me that this is an incorrect thing to do. I now have a whole new appreciation of my past career, and I am grateful for it. I have learned to accept it. It has made me aware that films like *The Brain from Planet Arous* have touched a generation of fans.

15

MARY MURPHY

Wild One's Sweetheart

The discovery of Mary Murphy reads a bit like Hollywood legend. In 1951, the doe-eyed beauty was wrapping packages at Saks Fifth Avenue in Beverly Hills when Paramount talent scout Milton Lewis first spotted her and later signed her to a long-term contract.

Born in Washington, D.C. and raised in Cleveland, Ohio, Mary and her family moved to Long Beach, California when she was 11 years old. From there, she graduated from University High School without the slightest thought of theatrics or a future in motion pictures. She was stunned when she was asked to come to Paramount for a screen test. When producer Lester Cowan asked about her previous stage experience, Mary replied with an uneasy smile,

"Wrapping packages at Saks on Wilshire Boulevard."

Her girl-next-door innocence is perhaps best remembered in Stanley Kramer's praiseworthy production of *The Wild One* [1953]. Hailed as the archetypal motorcycle film, *The Wild One* set the tone for similar films to follow. Mary plays the romantic interest as the daughter of a small town sheriff. Brando, the leader of an unruly motorcycle gang, finds the clean cut Miss Murphy irresistible.

Mary appeared in a number of memorable films, such as *The Lemon Drop Kid* [1951]; *Carrie* [1952]; *Off Limits* [1953]; *Main Street to Broadway* [1953]; *Beachhead* [1954]; *Make Haste to Live* [1954]; *The Desperate Hours* [1955];

Mary Murphy—memorably seductive in *Love Is a Weapon* (1954).

top ten list. Mary's third film in this genre was *The Electronic Monster* [1957], which was filmed in England. Slow moving, but visually and conceptually interesting, this film told of strange dream-inducing experiments performed at a remote clinic in France. The film featured Rod Cameron as the tall American insurance investigator. Mary plays his former fiancée, who is now engaged to a mysterious industrialist. It is this man who is behind the experiments.

Mary Murphy here reveals for the first time her recollections about her interesting career.

Hell's Island [1954]; *A Man Alone* [1955] directed by Ray Milland; *The Maverick Queen* [1956]; *Sitting Bull* [1955]; *Live Fast, Die Young* [1958]; *Crime and Punishment USA* [1959]; *Harlow* [1965]; and *Junior Bonner* [1972].

During the heyday of horror and science fiction in the fifties, Mary gained notoriety appearing as the female lead with Vincent Price in *The Mad Magician* [1954]. Filmed in 3-D and enjoyed by genre fans, *The Mad Magician* nevertheless does not rate a spot on Mary's

Q: What inspired you to become an actress?

MURPHY: I guess I am one of those rare exceptions because I had not planned on becoming an actress and never desired to be in motion pictures. I was chosen, so to speak, when I graduated from high school. I did not, nor did my mother, have the funds to send me to college. I was working as a package wrapper in Beverly Hills, and I was 18 years old. By this time I had moved out of my home and was on my own, living in a rooming house in Culver City. One rainy morning, my hair in

rollers and wearing no makeup, I decided to stop at Milton Kreiss' drugstore for coffee. I was sipping my coffee when an older man, quite short and bald, walks up to me and introduces himself as a talent scout from Paramount Pictures. He said that he would often see me there at the drugstore, gave me his card and said he wanted me to come to the studio one day. I thought to myself, "This guy must be trying to put the moves on me, so I'll just ignore him." I also thought how unfortunate it was. Some of the other girls I knew would get the tall good looking blond guys, and there I was, looking for a nice husband, and in walks this older bald man. [*laughs*]

Q: When did you find out it was a genuine offer and not just a pick-up line?

MURPHY: I worked with a lovely gal named Fern Goodman, and later that day I told her of this incident. She immediately knew who this guy was and confirmed his sincerity in wanting me to go to the studio. He was Milton Lewis, and he turned out to be one of the dearest, sweetest, and kindest men I've ever known. I was taken by surprise with all of this, and so Fern called the studio for me and set up my appointment.

Q: What was your reaction to the studio?

MURPHY: I went to Paramount to see the drama coach, Charlotte Clary, and she asked if I had ever acted before, and of course, I had not, nor

did I have any stage experience. I grew up around the industry, and my friend's father was a writer. But it was not an inspiration of mine, and I never thought of all this for myself. Well, they thought I was very pretty and had a lot of natural qualities, so they asked if I wanted to pursue a career in acting. I agreed to come into the studio and learn to act on my days off for about three months. They had a little stage there at Paramount which is now the music department, and it had a glass partition with lights hitting it so they could see in, but you couldn't see out. I worked up this little scene with William Reynolds. It was quite boring, but they were pleased with me and signed me to the standard seven-year contract with options. They told me that they would be training me and I wouldn't be going right into films, but I did get to appear in a few films as an extra with considerable visibility.

Q: What was your first screen appearance?

MURPHY: At the time, Bob Hope was filming *The Lemon Drop Kid* [1951] and Bob Landry of *Life* Magazine was following me around wanting to do a story about me getting into a movie. They put me in the picture, and I only had one line, and after that I was ready to quit! They had about two hundred people, and it was a snow scene. Bob Hope is playing Santa Claus, and I come up to him wanting to give him some money, but only have a dollar bill and no change. Hope then lifts up his Santa suit and displays a

commercial coin changer and gives me change for a dollar. It was very hot on this set, and I had on a heavy coat and leather gloves. The director, Sidney Lanfield, made matters worse by telling me after the shot that, "A lady would always remove her gloves when dealing with money." Well, we did the scene again, and now it's even hotter, and my hands are sweating, and I can't get the gloves off! This was my very uncomfortable introduction to films [*laughing*] with Bob Hope, a zillion lights and a zillion people standing there waiting for this woman to get the scene done! Mind you, I was still in such shock about all of this! Afterwards we went on tour with Bob Hope to Ohio for *The Lemon Drop Kid*. The reason I went was because I grew up in Ohio. There I was, dressed in saddle shoes, keeping company with Marilyn Maxwell, Bob Hope and Gloria Grahame.

Q: What was your next project?

MURPHY: It was *When Worlds Collide* [1951], and I didn't get to say a word in the film. They wanted background people, and since I was under contract they figured why should they pay an extra, so there I was. I was in a number of scenes including the shots when everyone is preparing to leave Earth and also in the rocket ship strapped into my chair. I remember this film to have been a low-budget production, and it didn't seem like much at the time. I remember the director, Rudolph Maté, to be very European, very polite, short and a bit portly. I think he was a cameraman at

one time. I clearly remember waiting hour after hour for shooting to start and being moved around like cattle when they were focusing on shots I wasn't in. All this was about a week or two of work for me and the other background contract players.

Q: What performers most impressed you during your film career?

MURPHY: On *Carrie* [1952] I met my idol, Laurence Olivier. Ingrid Bergman was my female idol, but I never got to meet her. Here I was appearing in the same film with Olivier, looking hideous in braids and no make-up. He paid absolutely no attention to me at all. I was 18 years old and was playing the daughter who was supposed to be 15, and at one point I was able to look Olivier right in those beautiful eyes of his. He looked back as though I was not there. I had little to do in this picture and had, I believe, about two scenes with a few lines. I got to work with the film's director, William Wyler, once again in *The Desperate Hours* [1955]. I went to New York to film *Main Street to Broadway* [1953], and we had the Theater Guild behind this one and all of these wonderful stars were there. In the film, Tom Morton writes a play, and during the opening night sequence, I walk through the audience, and there are all of these famous movie stars sitting there. This prestigious group included Ethel Barrymore, Lionel Barrymore, Rex Harrison, Helen Hayes, Henry Fonda, Tallulah Bankhead and others. I'm trying to remember my lines and at the same time I'm in awe of them all.

We were in New York shooting for about two weeks, and this film was my first starring role. Who do you think my first scene is with? Tallulah Bankhead! Oh boy! When we meet, she looks me up and down with such loathing, and to me she looks like the witch of Endor! I had a very calm demeanor about me and looked as though nothing could bother me. Well, I wound up having to take some medication to calm me down. I was scared to death of her.

Q: Why did Tallulah intimidate you?

MURPHY: When she would speak, her words would growl out at you, totally smothering my dialogue. So the sound man, John Kean, who later became my boyfriend, had problems mixing the sound between us both due to the drastic range differences in our voices. They kept asking me to bring my voice up, and as if this wasn't hard enough for me, Tallulah would ad lib a lot, which I was unprepared for. In one scene, I'm to exit and walk away from her and as I did, she kicked me! Well, of course I took this very personally, and I think it may have been due to her working with an inexperienced actress whom she felt was not up to par with her style.

Q: You then had a project with Otto Preminger?

MURPHY: After we finished that picture, I received a call from the studio that Otto Preminger wanted to see me. The only time I was able to see him was late at night, in his office. One light was on, and the dome of his bald head was about all that I could see. His desk and chair were raised so that you were sitting below him in the dark, and once in a while the light would hit his glasses. Got the effect? [*laughs*] He told me that he admired my work and wanted to star me in a theatrical play called *The Moon is Blue*. I was to take over the role for a pregnant Barbara Bel Geddes. Preminger stressed one thing quite firmly: no publicity was to come out about this until I opened in the play in New York. He admired my work in *Main Street to Broadway* and was ready to fly me out to New York when Lester Cowan, the producer of *Main Street to Broadway* released a publicity ad. It said something like, "Mary Murphy, star of *Main Street to Broadway*, soon to be a Broadway star, will begin touring…" and so on. When Preminger's people got wind of this, they canceled it! I had let my apartment go, sold my car and was packed and ready to leave for New York the next day. I was hysterical! No place to live and no transportation. Luckily, this had not affected my contract with Paramount. I had the option at the time to fight the decision, but I was just a wimp about it and did nothing. Well, aside from being foolish and not getting in there and fighting, they let me stay in my apartment a few days longer. A week later I was out hunting for another apartment and a car. I finally found a new apartment and another car and that's when I got a call from Columbia Pictures for *The Wild One* [1953]. I was still so humiliated because I had told my family and all of my friends about the New York role.

Q: Was there much delay before shooting *The Wild One* [1953]?

MURPHY: No. They put me right into the film, having seen my earlier work. I got to meet the writer, John Paxton and was told that the picture was based on an incident which occurred around 1950 in a small town in northern California. A group of motorcycle riders tore the town up, breaking windows and causing all kinds of damage. *The Wild One* was one of the last films Stanley Kramer produced before going into directing. I read for the part and loved doing the role. It was perfect for me at this stage in my life, but I had no idea who Marlon Brando was. They told me that Marlon was going to be the male lead. After replying, "Who's he?" I was told that our pairing would not work unless Marlon felt attracted to me. So there I am, sitting in Stanley Kramer's office alone, and in walks Marlon, dressed in Levi's and a T-shirt.

Q: What do you remember about this first encounter with Brando?

MURPHY: He didn't even look at me. He was very slim and had a very nice build, and was quite attractive. He looked out of the corner of his eye and said, "Hi." I acknowledged his hello and he began asking me questions about what I liked to do and what my interests were. He made casual conversation but all the while, he was sizing me up. I was very attracted to him, as most women were, and when Marlon smiled, well, that was it!

Q: Where was the film shot?

MURPHY: The first day of shooting was out at the Columbia ranch in the San Fernando Valley. I was very sure of myself. They built a set of this little town, including the streets and the coffee shop. I played the daughter of a police officer, Robert Keith. I was basically your average small town girl. As soon as I stepped in to shoot and saw all the lights, Marlon, Stanley Kramer, Laslo Benedek, the director and everything else, then bang! Terror strikes! My mouth seemed as though it was sealed shut, and Marlon was like a cat because he picked it up instantly. He saw that I was tense and a bit scared. He sat with me for a while and clasped my hands in his and was wonderful. He was a gentleman and there was no flirting. He knew I was scared and he wanted to build my confidence up again so we could move on.

Q: What was your most outstanding memory about doing this film?

MURPHY: It probably is the scene in the town park. In the film, there are two groups of motorcycle gangs. I guess one could say there was the "Good" group and the "Bad" group. Lee Marvin was the leader of the more violent group. It becomes quite tense when both gangs are about to clash, and I go out to look for my father, to inform him about what is about to happen. It's a pretty strong scene and afterwards I'm caught by Lee Marvin's gang. Well, Marlon's character and my character had already flirted with one another. When Marlon is asked if he is going to "move on," he replies, looking me straight in the eye, "No, we're going to

Brando puts the moves on a lovely Mary Murphy in *The Wild One* (1953).

stay here." So, afterwards, Lee Marvin's gang chases me into this dead-end area to terrorize me. Laslo Benedek said to me that he was going to have about five or six cameras working on this shot showing various close-ups of my face, their faces and some long-shots. He didn't want to over-work the scene. He said that these guys were going to come in and terrify me. Not hit me, but really terrorize and terrify me and so I thought, "Oh, well, no problem, no big deal, I have an older brother [*laughs*] and boys will be boys." Then we began the shot. It

was a night-for-night shot and the only lights we had were from the motorcycles and some from atop the buildings, and it was very cold. The scene has these guys on their motorcycles tormenting me by weaving around me and pulling at my sweater. In one shot, one motorcycle came so close to my leg, I felt my skirt lift up. Laslo wanted to capture this kind of torture as intensely as possible and when it was over, I broke down in tears from fright. It was that realistic, having done this shot and going into it head first. John Paxton, the writer, came

over and we went off into his car, and I cried my eyes out. It's amazing to me when I think of it, because off camera we would all clown around and were friends, but it actually became reality for me doing that shot. I was really terrified.

Q: It is quite a draining experience, getting such a difficult and important scene done right.

MURPHY: When the scene began to get intense, I really started to become scared, and so I went with it, and the fright became more intense, as did my performance. Riding it out as I did was probably why it affected me in that way. By this time I had enough experience behind me to know how to "go with it." Well, we picked up shooting again and just as these guys are about to get me, Marlon rides in and I hop on the back of his motorcycle, and we drive off to a park where he and I have this wonderful scene together.

Q: *The Wild One* was a major film. How did it impact on you?

MURPHY: When I finished the picture, Columbia Pictures wanted to buy my contract, but Paramount refused. Then they wanted to buy half of my contract, but they still refused. Actually, *The Wild One* did not do very well when it was originally released, but did very well when they re-released it. In France, Italy and Germany, and all over Europe, the picture did wonderfully, considering it took only about six weeks to film. It really took off in Europe first, then in the States. It did not have a very large budget. By comparison, when we shot *The Desperate Hours* [1955], the scenes we did in the house took over three months to finish!

Q: How did you get the lead in *The Mad Magician* [1954] with Vincent Price?

MURPHY: By the time I made *The Mad Magician* [1954], I was still under contract at Paramount, and they loaned me out to Columbia Pictures to do the picture. I really did not want to do this film, but I was one of these timid souls, unfortunately, and did not become vocal enough about it. I felt a film of this kind was not my forte, but I loved working with Vincent Price. He was wonderful and made it all so bearable [*laughs*]. He thought it was very camp and had a lot of fun off-camera poking fun at his role. When Price and John Emery would get together, my God, did we laugh. They would tease each other mercilessly, and it became one hysterical road show behind the scenes. Vincent was playing this hideous character who is planning to murder all these people, and had to indulge in this kind of behavior to keep any kind of sanity.

Q: What did you think of the director, John Brahm?

MURPHY: I didn't care much for Brahm because he was the opposite of Rudolph Maté, who was very gentle. Brahm seemed rough and gruff. The finest director I ever worked with was Tay Garnett on *Main Street to Broadway* [1953] which I had done prior to *The Mad Magician*.

"I did not want to do this film. I loved working with Vincent Price. He made it all bearable."
Mary Murphy and Vincent Price in *The Mad Magician* (1954).

Q: You later did some films in England. How did this come to pass?

MURPHY: By 1956 I felt that my career hadn't really taken off and I had been at Paramount for six years. I thought I should leave and try something different. At this time I went to England to do *Finger of Guilt* [1956], and after that, *The Electronic Monster* [1957] aka: *Escapement*. I did *Finger of Guilt* at Shepperton Studios with Richard Basehart and *The Electronic Monster* with Rod Cameron. It was popular at this time to send American actors over to England to appear in British films, and lots of us did this.

Q: *Escapement* is a rather stylish little film, very off-beat. Any particular recollections of the filming?

MURPHY: My clearest recollection of making *The Electronic Monster* is one of great humor. Rod Cameron was well over six feet tall, and I had been told before production started that he was going through a divorce, and that things were very complicated with him. I didn't think this was made clear enough, so I asked jokingly "What do you mean? ... Is he violent?" [*laughs*] They said that he was involved with an older woman who turned out to be his ex-wife's mother! Here I am at the Dorchester Hotel in England, and my leading man is with his wife's mother! [*giggling*] So, each day the limousine would pick us up to take us to the studio, and there he was, never without her, in the same car with me. He would rarely speak to me. She was quite short and most unattractive, but covered in jewelry. As far as I'm con-

cerned, it was a most unfortunate situation.

Q: Did you encounter any other unusual situations in your film career?

MURPHY: Yes. I had an experience making *Beachhead* [1954] that I'll never forget. To start out, I didn't get along with the director, Stuart Heisler. He always wanted to mold me into a model of his wife. [*laughs*] It was strange, I know, but his wife had short curly hair, so he thought I should have short curly hair, and it was this sort of thing that bothered me about him most of all. I hated Frank Lovejoy at the beginning of the production, but by the end of filming I adored him. When I first met him, he seemed cold and sarcastic, and he had one of these hideous abilities to read nine pages of the script and just know it! [*laughs*] A photographic mind! Frank was simply phenomenal!

Q: Where was *Beachhead* filmed?

MURPHY: We were on location on one of the Hawaiian Islands for about five weeks, and I was the only girl in the picture. There were very few women overall working there with us. So, there I was jumping in and out of the water, frolicking about in this little dress, and I didn't think I was being terribly flirtatious. I was just playing around in the water, and we're into shooting for a few weeks. We were staying in these lanai-type of rooms. Just about everything in Hawaii is very open and airy, and we had basically a screen for a door. Not much protection at all. One night, in my

room, I got a call from this guy who was a camera operator on the film. It was very late, and he whispered my name eerily on the other end. I thought my heart had stopped. I asked him who he was, because I didn't know who it could have been until later, and he would reply with a whisper, "You know who." At this point I'm very scared and alone, and I hung up the phone. Two seconds later he's on the phone again, asking me if I want to join him at the bar. I hung up and called the front desk and told them not to put any more calls through to me until morning. As soon as I hung up the phone, I heard a noise outside the door. Well, if I had a weak heart, that would have been it for me. I was scared to death, and just as I was reaching for the phone to call the front desk to put me through to Tony Curtis who was in the lanai next to me, I heard a thump, thump, thump on the door. Now, I was on the phone with Tony Curtis asking him to come over with Frank Lovejoy to check out my prowler situation. All of a sudden, the door burst open and literally split in two, and this man fell into my room. He was about six feet, four inches tall and every bit of three hundred pounds, in his bathing suit and dripping wet. I jumped up and ran past him out of the doorway and into Frank Lovejoy's arms, just as Tony Curtis arrived, very excited about it all, and running around frantically. Frank took me into his room and calmed me down and was very consoling. The camera operator was taken off the film and didn't work for a number of years due to this incident. Later on,

I was told that he was indeed drunk, but he was also married with seven children. There was no excuse for his behavior, and most film companies would not have tolerated this kind of action from any employee. Frank Lovejoy and his wife became very good friends of mine afterwards.

Q: You got married to one of your leading men?

MURPHY: Yes. I met Dale Robertson while making *Sitting Bull* [1954]. We later got married, but the marriage didn't last. We filmed in Mexico and Mexico City entirely, and although it was a romantic shoot for me, I became deathly ill with "the bug." We were down there for about six weeks, and we stayed at the Reforma Hotel in Mexico City. I became so ill that I had to be fed intravenously. I felt the director, Sid Salkow, was ill-suited for that type of picture, and the camera work was dreadful for all of us. They used some kind of awful color process for this picture. I was very sick, and when I could eat and drink, I lived on 7-Up and hard-boiled eggs throughout the shoot.

Q: Any recollections about J. Carrol Naish?

MURPHY: J. Carrol Naish was a real hoot! He didn't want to be there, and they wouldn't let him go home. He played Sitting Bull, and one day he was riding his horse and it was barely trotting, just walking along. He told them he fell off his horse and had to go home. So they sent him home! He got his way after all.

Q: You already mentioned *The Desperate Hours* [1955] which was also a major film. What can you tell us about this production?

MURPHY: I truly enjoyed working with Humphrey Bogart. Director William Wyler was quite unpleasant with me but said very little. Dewey Martin and Wyler did not get along too well. Wyler just rode him to no end, and I thought this was terrible. Bogart had a great sense of humor, but looked painfully thin by this time. His hours were from 9 AM to 6 PM. Even if he was in the middle of a scene at 6 PM, he would leave. I thought Fredric March would be the classic, austere type, but he was quite the opposite. He was a lot of fun, a real practical joker. I played his daughter, and there was a scene where I come in the door, and Robert Middleton is standing there looking like he wanted to rape me. My father attempts to stop it, and we try to take on the criminals. Dewey Martin is holding the gun, so I bit his hand. Apparently, I bit it a little too much because later on the studio nurse called me to say that they had to give Dewey Martin a tetanus shot! Well, when everyone else found out about it, they thought it was very funny, and I felt like Typhoid Mary.

Q: You also worked with Ray Milland. What are your recollections of him?

MURPHY: He was a very fine gentleman. My experience working with Ray Milland when he directed *A Man Alone* [1955] was wonderful. It was a rather suspenseful Western. Ray was very charming, and he oversaw my wardrobe and hairstyle and took very good care of me. He had just finished *Dial M for Murder* [1954] with Alfred Hitchcock and Grace Kelly, and I believe this was Ray's directorial debut. We got along nicely, and Ray had specifically asked for me. Of course, Grace Kelly was very influential at this time. At one point, even Ray seemed to try to make me into Grace Kelly. He wanted me to come across like her, and I couldn't do it. [*laughs*] There was only one Grace Kelly. When all things were done, *A Man Alone* was a rather personal film, and a pretty unique Western. I think Ray was quite proud of it.

Q: Any thoughts about *Maverick Queen* [1956] with Barbara Stanwyck?

MURPHY: Well, when I worked on that film, I knew enough to stay as far away from Barbara Stanwyck as I could. It's not that she was rude or awful to me. She just emitted this air of austerity that seemed to look down on you, and I didn't take too well to it. Of course, there was only one Stanwyck, but I could feel those vibes saying, "Keep your distance." We worked out in Silverton, Colorado for this film, and it was a nice experience. James Cagney was also shooting in or near Silverton where we were, but I didn't have the chance to meet him. He and Barbara Stanwyck would visit one another on occasion, but I didn't go over to see them.

Q: *Live Fast, Die Young* [1958] was a rather intense film noir. You seemed very sharp in that film. What do you recall about it?

MURPHY: *Live Fast, Die Young* was done during a very traumatic time in my life. I was going through my divorce. But working with Norma Eberhardt was a pleasure. She was very congenial, and I knew her before we did the picture. We lived at the Studio Club for Women. I never really connected with Paul Henreid. He directed the film, and I can't quite say why I didn't connect with him, but maybe it can be attributed to what was going on in my life at the time. He wasn't mean or anything like that. This was one of those stupid, young and hysterical times in my life.

Q: What was your next film?

MURPHY: I got my part in *Crime and Punishment U.S.A.* [1959] through Dennis and Terry Sanders, brothers whom I had known socially through a friend, Yale Wexler. At this time, they were looking to promote an actor they really believed in—George Hamilton. They approached me as though this was to be a collaborative effort. For this role, I went down to where the prostitutes pled their cases before the county judge, and it was a very hot day in August 1958, and we interviewed one of the prostitutes there. We told her that we were doing a film, and she agreed to the interview. Whether they slipped her some money, I don't know, but the most interesting thing about her was that she was a girl in her thirties, and when I looked into her eyes, they looked absolutely dead. I was playing the part of a prostitute in the picture and wanted to develop my character through these women, but when I got

to see more of them, I realized that there was no spark in any of them. There was just a deadness. It was a very uncomfortable situation for me. It was unlike anything I'd ever experienced before. Then we went to the Los Angeles Women's Jail, and it was like hell in there. It was a most unnerving way to train for a part, but I wanted to have this same kind of deadness for my character, Sonya.

Q: You also appeared in a little known anti–Communist documentary called *Two Before Zero* [1962] as an on-screen co-narrator with Basil Rathbone. This film contained a lot of gruesome stock footage depicting the evil doings of Nazi and Communist governments. How did you feel about this?

MURPHY: I had no idea what *Two Before Zero* would eventually turn out to be. I think Basil and I both knew that it was an anti–Communist message the makers were attempting to convey, but we just shot our scenes in a studio in Chicago. It seems that the producers later turned it into a graphic docu-style format, unknown to us both. Not that I object to it because I am anti–Communist, but I did not know what the outcome would be with this film. It was good money for me at the time, and I was planning to marry a year later and took the job gratefully. The images can be quite disturbing, and it does succeed in getting across its message. When I arrived in Chicago to shoot *Two Before Zero*, someone stole all my luggage out of the airport. It was not the most pleasant trip of my life, and I did it on the fly, so to speak. It was nice meeting

Basil Rathbone and his wife. Basil was very formidable. He also has a very alert type of attitude, and I thought it was very gauche because he didn't try to hide his way of sizing you up as a performer. I guess we all do this to one another, but rarely or never do we show it. But I was still fascinated with Basil as an actor. He was quite intelligent and very articulate.

Q: You were then in *Harlow* [1965]. There were two competing films that year with the same title. Which one were you in?

MURPHY: I was in the Carroll Baker version directed by Gordon Douglas. I played an executive secretary, and here again, having seen my earlier work, they put this part into the film just for me. They paid me very well. I got to meet Angela Lansbury while making this film, although Angela wasn't in the picture. I must say that I admire her very much.

Q: Tell us about some of your work on television.

MURPHY: By the early sixties, I really had become absorbed in television and did a lot of work on many shows. Gosh, I did *Alfred Hitchcock Presents* [1955–63], *The Outer Limits* [1963–65 episode: *The Premonition*], *Wagon Train* [1957–65], *The Virginian* [1962–71] and lots of other shows. I did two *Matinee Theatre* shows and found them to be exciting because they were live shows. You would wear about three outfits over one another, and they would just rip them off you [*laughs*], and you would go to the next show.

Q: What was your last film?

MURPHY: My last theatrical motion picture was *Junior Bonner* [1970] with Steve McQueen and Sam Peckinpah. Sam was a friend of mine for years, going back to when we did Westerns for television. *Junior Bonner* was filmed out in Prescott, Arizona, and we had lightning storms just about every day. My daughter and her girlfriend were both with me, and Sam loaned us his car, and I took the girls on a tour of Arizona. We had a lot of fun. Ida Lupino was wonderful, and I worked with her earlier, years before on a television show called *The Investigators* [1961]. She directed one of the episodes, but she didn't remember me! [*laughs*] That's okay, since directors go through so many episodes all the time, it is hard to keep track of faces.

Q: You later did a telefilm?

MURPHY: I made *Born Innocent* [1974] with Linda Blair. It was at this point that I began to turn against some of the types of films that were being made.

Q: You didn't care for the changes in the motion picture industry?

MURPHY: No. The motion picture industry today is a great disappointment to me because I met some of the most talented people through the years and do not regret for a minute being in the film industry at the time I was involved in it. I consider it a very fortunate event in my life. However, over the past 20 or 25 years the film industry has become so sick that it nauseates me terribly. I appreciate the

fact that I'm way out-of-step, age wise, but I don't think that's all of it. My daughter is 32 years old, and she now agrees that I had it much easier than she does. If someone today asked me to appear in one of these modern slasher films, I wouldn't do it. To participate in all of this gore, sex and depravity would be very unlike Mary Murphy, and I know there are a lot of others from my generation who agree. I believe it was when I appeared in *Born Innocent* [1974] that this change in the industry became clear. The story was about a group of girls at a correctional facility who rape another female inmate with a broom handle. I didn't want anything to do with it at the time. I played the head of the correctional institution and knew what the story was about, but decided to do it anyway. I hated this film. I wouldn't let my daughter see it and told all of my friends not to see it. This sort of subject matter is such a minute part of society, so why glorify it? Well, after the film was shown, don't you think some sick person emulated this incident? The only good thing that came out of this picture, I feel, is that they started rating the films made for television at that point.

Q: Do you have any regrets about your career?

MURPHY: If I had the chance to start again, I would have defended my career a lot more than I did back then. If one doesn't, no one will, and I should not have been so obedient all the time. I should have disagreed more often when I felt a certain role or film was not for me, as in the case of *The Mad Magician*. In this business, if you're just a nice little person, you wind up with a nice little career. Short and sweet like mine. There were better things for me to do, and I should have fought harder for them, but didn't.

16

NOREEN NASH

Encountering the Phantom from Space

Barbara Randall has been locked in her laboratory in the Griffith Observatory by an invisible alien. He lifts his space helmet, which she has been analyzing, and gasps a few breaths of the alien air supply. The spaceman starts tapping out a code with a pair of scissors, trying to indicate his supply is nearly exhausted. He is suffocating trying to breathe oxygen. Barbara shines an ultraviolet light at the scissors, and the alien's hand, which appears human, becomes visible. Startled, Barbara screams, and the alien flees through an open window.

This intense encounter occurs near the climax of *Phantom from Space* (1953), a modest science fiction gem that is more natural and effective than many larger budgeted films of its kind. Like *It Came from Outer Space* (1953), the picture avoids the traditional clichés of the genre. It depicts the predicament of an alien astronaut who crashes on earth and desperately tries to survive. This phantom from space quickly draws the attention of the authorities. The alien tries to communicate, but his voice is beyond the range of human hearing. Neither can he be seen by humans, except under ultraviolet light. The plot may be slight, but it is compact and effectively told. The alien comes to a tragic end, but the efforts of both police and scientists to understand what is happening are especially touching.

The visitor from outer space is portrayed by Dick Sands, and Barbara

175

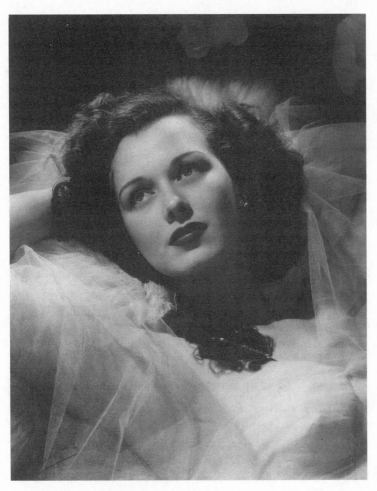

The beautiful Noreen Nash in 1945, the year she appeared in *The Southerner*.

practice, but he was the medical director at 20th Century–Fox. Together, they often traveled the world, attending to the urgent medical needs of many of Hollywood's most well-known personalities. Their many friendships make Noreen's life and collection of behind-the-scenes anecdotes far more out of the ordinary.

Noreen's own on-camera career was notable, including such films as *Girl Crazy* (1943), *Broadway Rhythm* (1943), *Monsieur Beaucaire* (1946), *Devil on Wheels* (1947), *The Big Fix* (1947), *Miss Body Beautiful* (1956) and the George Stevens' classic *Giant* (1956) with a cast including Elizabeth Taylor, Rock Hudson, James Dean, Dennis Hopper and Rod Taylor. Noreen's recollections also include fascinating portraits of Clark Gable, Turhan Bey and Marilyn Monroe.

Randall is played by Noreen Nash, a lovely and appealing actress who appeared in numerous film and television shows since the mid–Forties. Noreen was born Norabelle Jean Roth in Washington state, where her mother was a teacher and her father owned a Coca-Cola bottling plant.

Shortly after arriving in Hollywood, Noreen met Dr. Lee Siegel, and they had a whirlwind romance. Their marriage was a long and happy one. Dr. Siegel not only had a flourishing medical

Q: What first brought you to Hollywood?

NASH: I had a very idyllic life in Washington state. I became the Apple Blossom Queen in 1942, and I was sent to Hollywood to publicize Washington apples. It was at this time that Solly Biano, a talent scout from Warner Brothers, spotted me and

invited me to come to the studio for a screen test. At this time my name was still Norabelle Roth, and I was 17 years old, shy and in awe of Hollywood. Alexis Smith came to the set where I was testing, and I heard her say, "I have to see Norabelle Roth, the Sawdust Queen from Wenatchee Washington." [*laughs*]

Q: Did they offer you a contract?

NASH: I was offered a contract as a showgirl by MGM, but that was something I did not want to be. I had been accepted at Stanford University in San Francisco when one day Louis Schurr, Bob Hope's agent, saw me at the Brown Derby. He was very nice and convinced me to sign. So I took his advice.

Q: What was your first film?

NASH: I was a showgirl in *Girl Crazy* [1943]. I remember Mickey Rooney referring to us as the "Kiester" parade [*laughs*] because we really did look like a kiester parade in our draped jerseys. I think Mickey and Judy Garland were truly spectacular together.

Q: When did you get married?

NASH: I met my husband, Dr. Lee Siegel, through a friend. It was truly love at first sight and I only knew Lee six weeks before we married. We met in October, 1942. Since he was called to war, we married in Las Vegas just before he left. Some said it wouldn't last, but we had a beautiful marriage that lasted until his death 47 years later.

Q: You then started to get bit parts in films?

NASH: I played the maid in *Mrs. Parkington* [1944]. I recall how nervous I was when Katharine Hepburn came to the set. I was trying to do my little part, and she was scrutinizing me. Hepburn was quite intimidating, but Greer Garson was gracious and helpful. I appeared in two scenes in *Ziegfeld Follies* [1944], one with Lucille Ball and one with Cyd Charisse. This was the first time I met Cyd, and we became friends. Later we took a painting class together.

Q: Did any actor really impress you at this time?

NASH: I played Robert Mitchum's girlfriend in *Thirty Seconds Over Tokyo* [1944], but my scenes were later edited out. I danced with him in the scene, and I recall thinking that this guy was going to be a big star. He was so sensuous and so charismatic, and it showed in the way he walked and everything about him. He was private and kept to himself on this picture, but we became friends years later.

Q: Did you have any specific friendships?

NASH: I became close friends on the MGM lot with Kay Williams, who later married Clark Gable. She had divorced her husband, and began dating Clark. She would call me and say, "Let's go visit Clark" and I would come along. She was crazy about him, but then she met and married Adolph Spreckles of the Spreckles Sugar Company fortune. He was not my idea

of a terrific person. They had a won-
derful daughter, but he used to treat
Kay badly. Later, Kay and Clark
finally got together. I thought they
were ideal together. Kay had a great
sense of humor, like Carole Lombard
must have had.

Q: What film provided your first
major role?

NASH: It was *The Southerner* [1945].
I had asked for my release from
MGM, having grown tired of showgirl
parts. I was in blue jeans, painting my
sun deck, when the producer Robert
Hakim came by. My hair was in pig-
tails and I had no make-up on. He
asked me if I wanted to be in *The
Southerner*, and I was thrilled and
wanted to get dressed up, but he said,
"No, come just the way you are." Jean
Renoir, the director, hired me on the
spot to play the farmer's daughter in
the film. The next day I went to see
him all dressed up, and he said, "Who
are you?" [*laughs*]

Q: What did you think about Jean
Renoir?

NASH: He was the greatest director
and the finest human being I ever met.
He was totally and completely warm,
compassionate and caring. When you
would do a scene with him, he would
say, "That was fine but let's do it
again." [*laughs*] He wanted you to be
as natural as possible. He said he
wanted actors to read their lines like
they were reading them from the tele-
phone book. He didn't want anyone to
give him "big" scenes. His main con-
cern when directing was simplicity.

His thoughts on everything enlight-
ened me greatly. In many ways, he
changed my whole life.

Q: Did he ever mention his father, the
great impressionist painter Pierre
Auguste Renoir?

NASH: Yes. One time, he was
speaking about how perfectionism was
ruining Hollywood. He said that great
art, like the art of his father, is great
because of the humanity in it. If
everything is perfect, it loses some-
thing. He liked spontaneity. If you
were rolling in a scene, he would say,
"Just keep going." Wonderful advice!

Q: You mentioned earlier that one of
your scenes was cut.

NASH: Renoir had asked me if I
knew how to milk a cow. So my hus-
band took me to the San Fernando
Valley where we found someone to
teach me. It is not that easy. I worked
at it all day until I got it down right.
We shot the scene, but then the head
office censored it! They thought it
would not be appropriate to show!
Imagine!

Q: Is this when you changed your pro-
fessional name?

NASH: Yes. J. Carrol Naish played
my father in the film. My friends in
high school always called me Noreen.
So my agent got the idea to drop the
"i" from Naish and use that as my last
name, so I became Noreen Nash.

Q: You then went over to Paramount?

NASH: I had become pregnant at
this time. I was close friends with

Burgess Meredith and Paulette God-
dard, and so I asked Paulette if I
should tell Paramount. She suggested
not to tell. Well, complete with morn-
ing sickness, I did the test with a scene
from *Thirty Seconds Over Tokyo* and it
worked out perfectly because my char-
acter was also pregnant. Paramount
wanted to put me in *The Blue Dahlia*
[1946] with Alan Ladd, but since my
pregnancy was growing, I couldn't do
it and my part went to Doris Dowling.

Q: Do you have any memories of *The
Red Stallion* [1947]?

NASH: We shot that in Dunsmuir,
California, near Mount Shasta. It was
directed by Leslie Selander. We did a
number of films together. He was fun
to work with while doing *The Red
Stallion*. Every evening we would all
meet up in my room. My mother,
Leslie Selander, Robert Paige and the
others would come and listen to
Benny Rubin tell stories. The assistant
director, Howard Koch, later went on
to become a top producer.

Q: I understand that *The Adventures of
Casanova* [1948] was quite a difficult
production for all involved.

NASH: We were on that film for
over three months. It was shot at Chu-
rubusco Studios in Mexico City. The
producer didn't speak much Spanish,
but he managed to learn how to say
"demasiado" meaning "too much."
Every time the Mexican crews said
something to him, he would say,
"Demasiado!" After a while, they
became annoyed with him, and as far
as they were concerned, they turned

"demasiado" into "more time." Turhan
Bey played my love interest in the
film. At the time Turhan was going
out with Linda Christian, and Linda
had been quite popular with Mexico's
ex-President. One day, someone
approached Turhan and threatened
him, saying he better leave Linda
alone or he might not leave Mexico
alive. Linda was a beautiful woman,
and a lot of men were crazy about her.
Turhan did not take the threat lightly,
and he spoke to the producer. They
decided to write Turhan out of the
picture, and the whole movie had to
be changed. Turhan is killed in the
film, and I had a scene where I am
crying over his dead body. As I was
doing the scene, I started missing my
husband and child so much that tears
were just streaming down my face.
When the scene was over, everyone
applauded, including Turhan. My
mother was watching and thought it
was great too, but when I later
attended the premiere I wasn't
impressed with the scene.

Q: Did your family concerns have any
impact on your career?

NASH: Yes. My son was two years
old at the time, and by the time he
saw me, he hardly remembered who I
was. That was the end of location
shooting for me. It was difficult to be
an actress and have a home and chil-
dren. My family always came first, and
that is something I don't regret. My
sons are successful today, and when I
look around at some of the others
whose careers came first, I've seen
their marriages and children suffer.

Q: After this, did you concentrate more on television?

NASH: Actually, I did television from the very start. The screens were so small. I did a program with Robert Preston, and I joked that there were only a hundred television sets around the city. [*laughs*] This was when I was pregnant while at Paramount. After my son was born, I did a lot of TV. I played Hugh O'Brian's wife in one show. At noon, I would rush home and nurse my baby. They would tease me about that, but nowadays it is a pretty common practice for actresses to work and care for their children.

Q: What shows do you remember doing?

NASH: I did *Kraft Television Theater* [1947–58], *Playhouse 90* [1956–61], *The Life of Riley* [1949–58] and *77 Sunset Strip* [1958–64]. I was on *Yancy Derringer* [1958–59] with Jock Mahoney, one of the nicest people I ever worked with. I did several episodes of *My Little Margie* [1952–55] with Gale Storm and Charles Farrell. When Charles Boyer started doing *Four Star Playhouse* [1952–56], he cast me in two of them. In one episode, "The Wild Bunch," Natalie Wood played my daughter. I first met Boyer when I was 12 years old, on a cruise to Honolulu in 1936. Boyer had asked me to dance. I couldn't dance, and stepped all over his feet. [*laughs*] He was so gracious, and he asked if I wanted to be in pictures some day, never dreaming someday we would be performing together.

Q: What other films did you do?

NASH: I especially enjoyed *Assigned to Danger* [1948]. I liked the way it was directed, and I loved the mood of the piece. My brother in the film is a gangster, and I hide him at this hotel that I own. Then Gene Raymond shows up, and sweeps me off my feet. About the same time, I worked with Joe E. Brown in *The Tender Years* [1948] and Tim Holt in *Storm Over Wyoming* [1949]. In *Aladdin and His Lamp* [1952], I was cast as "the most beautiful girl in the world." Another interesting one was *We're Not Married* [1952] with Zsa Zsa Gabor and Louis Calhern.

Q: What was your impression of Zsa Zsa?

NASH: She had a scene where she was to walk into the shot all dressed up and say a few lines and that was it. So she walks in and suddenly stops the scene, waving her hand. Edmond Goulding, the director, asked what was wrong. Zsa Zsa answered in her own special way, "I just didn't feel it!" I can still hear Goulding yell, "Oh, cut for lunch!" the scene was perfect and she didn't have a thing to do but stand there and look beautiful. [*laughs*] Zsa Zsa is wonderful! She has a charm all her own and great wit.

Q: *Phantom from Space* [1953] is now a popular cult film, featuring a stark tone and approach inspired in part by the *Dragnet* radio and television series. Did you feel your role as Barbara Randall was unique, since your character was a married career woman?

NASH: When you put it that way, it certainly was uncommon. At one point, I even send my husband out

Shapely and seductive: Noreen Nash attracts *The Phantom from Space.*

grocery shopping when Dr. Wyatt asks me to work late. So often the lady scientist in these films provides a romantic interest, but this plot included no such distraction. The focus was kept entirely on the alien and the people tracking him.

Q: You also are allowed to take your dog to work, another more modern concept.

NASH: That also served the plot since only the dog could hear the alien's voice. It was no trouble working with that dog. Animals, you know, can be great scene stealers, but I enjoy working with them. I worked with another dog as well as the horse in *The Red Stallion*.

Q: Almost all of *Phantom from Space* was shot on location in and around Los Angeles, particularly at the Griffith Observatory. How did you enjoy working there?

NASH: The thing I remember most about making *Phantom from Space* was how it boosted my sincere interest in astronomy. I loved shooting at the Griffith Observatory. The atmosphere of the planetarium added greatly to the mood of the picture we were making. Every chance I had when I wasn't doing a scene I spent with the planetarium director. He would show me around the place and let me view the large telescope. I remember him saying that he felt we would be landing on the moon within ten years. That seemed so farfetched to us all in 1953, but he wasn't far off … it was only 16 years later.

Q: The phantom in the film was played by Dick Sands. What do you recall about filming your scenes with him?

NASH: The way we filmed the scenes was very unusual to me. When the phantom abducts me and carries me through the planetarium, he is supposed to be invisible and I appear as though I am floating in the air. It was quite strange to film these scenes. The phantom was draped from head to toe in a solid black body cloth. Since special effects were not nearly as sophisticated as they are today, this body cloth was necessary for the optical effects technicians, headed by Howard Anderson, to make the creature a total blackout. Then the invisibility effect is easier to accomplish. All I knew is that I was supposed to be in a dead faint, and there I was being carried through the observatory by this tall man covered completely in a black cloth. Thankfully, he was able to see out from behind that sheet or we would have been in trouble for sure.

Q: Dick Sands didn't have any lines in the film.

NASH: We just heard his heavy breathing, but the actual breathing you hear in the film was added in later by Jack Solomon, the sound technician. The entire plot hinges on the fact that our atmosphere is not fully compatible with the alien's lungs, and he is slowly suffocating. You do get to see Dick briefly at the conclusion of the film when we shine an ultraviolet light on him as he is standing on the telescope scaffolding. Then he falls to the floor

and becomes visible as he dies. The optical effects make his body look hazy, and then he evaporates into nothing, but it is obvious to the audience that the alien is supposed to be naked. Nothing is shown, but it drives home the utter helplessness of the alien.

Q: Do you have any other recollections of members of the cast or crew from *Phantom from Space*?

NASH: W. Lee Wilder was the producer and director, and Lee was the older brother of Billy Wilder. Myles Wilder was Lee's son, and he wrote the screenplay with Bill Raynor. I recall Myles was so young at the time, maybe 17 years old. Ted Cooper, who played Hazen, the F.C.C. official, was quite good. He was dating Kim Novak at the time. In 1953, I hadn't heard of Kim Novak, but Ted would always say that she was going to be a big star. Harry Landers, who played police Lieutenant Bowers, had a striking way of delivering his lines. He sounded remarkably similar to Rod Serling in his introductions to *The Twilight Zone*.

Q: Did your children later enjoy watching this film?

NASH: Yes, and they would tease me about it. You see, in *Phantom from Space* and *Assigned to Danger*, my character was supposed to smoke, and they know I didn't smoke.

Q: You mostly seem just to hold the cigarette or flick the ashes into a tray. I recall you took a puff at one point and began to cough.

NASH: [*Laughs*] I didn't know the first thing about smoking. I always thought Bette Davis did it so well, and I thought maybe I could imitate her, but it didn't come off so well.

Q: As your children got older, you must have given your career much less attention.

NASH: After *Phantom from Space*, I found my real life was so much richer than my screen life. My husband and kids would go to Palm Springs every weekend with the Zanucks. My social and family life was so much more interesting than what went on in front of the camera.

Q: Your husband treated a number of well-known celebrities.

NASH: Yes. He was medical director at 20th Century–Fox at this time. One time, Judy Garland had a breakdown, and asked Lee to come to Hong Kong to treat her. We were good friends. He also treated Orson Welles, John Garfield, Errol Flynn, Susan Hayward, Marilyn Monroe and many others.

Q: What are your memories of Marilyn Monroe?

NASH: We knew each other a long time. I modeled with Marilyn Monroe when she was just a young girl of 16, long before Hollywood got to her. I have a picture of a photo shoot we did together in 1943, when she was Norma Jean Dougherty. She wasn't all that beautiful at that time ... in fact she looked like a poor little waif with no make-up on, her hair disheveled, and blue jeans torn off like shorts. But the

moment the camera was on her, something magical happened, and you could see that. She had this certain vulnerability about her, and this I feel was one of her great qualities. I almost felt sorry for her. A few years later, when I was in New York to do publicity for *The Red Stallion* [1947], I saw Marilyn at Bloomingdales, and a transformation had taken place. Her hair was lighter, and she had on a tight dress. She was stunning.

Q: When did your husband treat her?

NASH: Marilyn had numerous doctors through the years, and Lee treated her for a time. He took care of her sinus infection not too long before her death. He remembered her to be quite radiant around this time. One of Marilyn's problems was she took sleeping pills, and when she woke up in the morning, she did not like the way she looked. She would sit in front of the mirror for two hours. There was no way she would get up in the morning and be on the set at 9 AM. Lee went in before production started on *Something's Got to Give* [1962] and advised that the only way they could use Marilyn was to start shooting her scenes around noon. The head of the studio was Peter Levathes, a solid business man but very nice. *Cleopatra* [1963] was running way over budget, and Peter felt that he could not give in to actors who could not be on the set on time. They started shooting the picture, but they had to work in the morning.

Q: This is the uncompleted film with Dean Martin where Marilyn had a famous scene coming out of the swimming pool?

NASH: Yes. There were problems when Marilyn would disobey the studio, such as when she went to sing at President Kennedy's birthday party. She kept having trouble showing up for work, and the studio fired her. My husband never saw her after that, but he was convinced she did commit suicide because she had tried it so many times before. There are so many books that want to portray it as murder, but that is pure fiction. It was so hard for her to integrate these two personalities, the little foster child and the stunning woman. We were having dinner with Jean Renoir, and he was considering doing a film of *Nana* based on the classic novel by Emile Zola. He wanted to do the film with Marilyn, and it would have been a tremendous part for her. He wanted to shoot it in Europe, and he would have had no trouble arranging his production schedule to start in the afternoon. Lee tried to call her but couldn't get through. After she was fired, no American studio would use her because they couldn't get insurance on her.

Q: What can you tell us about *Giant* [1956]?

NASH: By the time I arrived on the set, James Dean and director George Stevens were not getting along well at all. George Stevens felt he had paid a lot of money to hear James Dean's words and wanted him to say them clearly, not mumble or slur them. They had their disagreements. I had

Circa 1943, Noreen Nash (right) poses with an almost unrecognizable teenage Marilyn Monroe (left).

one or two scenes with Stevens, and I knew I was in the hands of a master. I enjoyed watching him work, with his special way with actors, how he explained what he wanted and expected from you. I played the "film star" who comes to the opening of the hotel in the picture, and Stevens was great at conveying what your emotions should be when preparing your scenes. The overall mood on the set was a happy one and everyone seemed to know they were making a wonderful film. I didn't have any contact with Elizabeth Taylor, but Lee and I became friends with her a few years later.

Q: You did a feature film with Clayton Moore as the Lone Ranger.

NASH: That was *The Lone Ranger and the Lost City of Gold* [1958]. I played a woman who appeared to be lovely and sweet, but I really was pretty bad, and by the end of the film I wind up axing one of the actors. [*Laughs*] I didn't want my kids watching me play a murderer. Wouldn't you know it, my son was in Mexico and saw a huge billboard of the film with my name on it, and went to see it.

Q: You also did a film with Ernie Kovacs and Dick Shawn?

NASH: I really enjoyed my role in *Wake Me When It's Over* [1960] where I played Dick Shawn's wife. Dick is in the army, and I try to convince him to purchase some army insurance. One night, I decide to seduce him into taking out the insurance. I dress up in a long, flowing nightgown. To give you

an idea about how times have changed, they would not allow either of us to sit on the bed together. Someone would come on the set to make sure there was no cleavage showing, and I laugh to think of how this scene would play if it were remade today. Ernie Kovacs was a tremendous talent, and it was tragic when he died in an automobile accident about two years after we made this film.

Q: You were a regular on *The Charlie Farrell Show* [1956–60]?

NASH: I was the female lead. The show ran three seasons as a summer replacement program, and Charles played the manager of an exclusive Racquet Club. By this time, I was winding my career down. One of the last things I did was a show with Vincent Price. In it, I commit suicide over Vincent. At the time, one of my children, who was 13 years old, said to me, "Mom, are they trying to tell you something?" [*laughs*] Well, that comment changed my life, and I decided to enter college as a freshman. It was so fulfilling when I graduated the same year as my son.

Q: What are some of your other achievements?

NASH: I wrote a historical novel called *By Love Fulfilled* that was published in 1980. It was set in the sixteenth century and the central character was a doctor. It was quite a lot of work doing the research and preparing the manuscript, but it provided a great sense of accomplishment. You see, I more or less just fell into my film

career. I realize how lucky I was to have been a part of Hollywood at that time. They took care of you and treated you in a professional manner with respect. So much has changed and it is so very different now.

Q: What is your most striking mem-ory of the many celebrities you have known during your career?

NASH: One of my most vivid mem-ories was when Richard Burton recited the soliloquy from *Hamlet* in German in my living room. This was just one of many wonderful events.

17

CYNTHIA PATRICK

Mole-Man Memories

The Mole People (1956) was a rather unusual entry by Universal in their series of science fiction projects featuring John Agar. This film combined elements of *Lost Horizon* (1937) and the various "lost civilization" romances of writer H. Rider Haggard into an unusual fantasy film with science fiction trappings. The film was produced by William Alland, directed by Virgil Vogel and developed from an original script by Laszlo Gorag. This same team was later behind one of the more intriguing dinosaur films, *The Land Unknown* (1957).

The Mole People opens with popular television commentator Dr. Frank Baxter, who narrated a number of documentaries in the Fifties. This prologue covers theories about a hollow earth, and it tends to give the film more of a science fiction flavor. Then the actual story kicks in.

John Agar plays Dr. Roger Bentley, leader of an Asiatic archaeological expedition which uncovers a huge network of underground caverns in the high mountains. Bentley and two companions La-Farge (Nestor Paiva) and Dr. Bellamin (Hugh Beaumont) become lost in the maze until they stumble upon a lost civilization of Ancient Sumerians. These people live on a diet of mushrooms that is so meager that they cannot support a community of more than 150 people. They believe that they are the only people on earth. Their leader is King Sharu, but the power behind the throne is the High Priest Elinu (Alan Napier) who

1824-1 AD

Cynthia Patrick is manhandled (molehandled?) by stuntman Eddie Parker in this publicity shot for *The Mole People* **(1956).**

leads in the worship of Ishtar. There is also another race of beings, the Mole People, semi-human burrowing creatures who are held as slaves by the Sumerians. The explorers are captured and condemned to death, but they escape. LaFarge is killed and buried by his friends. Elinu then locates Bentley and Bellamin, and tells them the king now considers them gods because of the flashlights they carry. The Sumerians are all albinos, blinded by any kind of strong light. Dr. Bentley befriends Adel (Cynthia Patrick), a Sumerian of normal coloring with no light sensitivity. Eventually, Elinu schemes to obtain the flashlights of the explorers, considering them a source of divine power. He steals the lights, and forces the explorers into a chamber to face "the eye of Ishtar" which is deadly to the Sumerians. This turns out to be merely a shaft of sunlight that leads back to the surface. The Mole People revolt and overrun the Sumerians. Adel escapes through the "eye of Ishtar" and joins Bentley and Bellamin as they climb to the surface. An earthquake strikes, however, and she is killed by a falling pillar.

The rather elaborate plot has so many different elements that many are left unresolved. Who exactly are the Mole People, for example? Were they humans who degenerated or a separate breed of animals with intelligence? Because of the many plot loopholes, many critics, including Bill Warren in *Keep Watching the Skies*, have dismissed the picture as just a hybrid adventure film. The film is really a fantasy rather than science fiction, and this seems to annoy some fans. But there are many impressive elements in this modestly budgeted production. The matte drawings are wonderful, particularly the shot of the giant ziggarat in the huge cavern. The underground lair of the Mole People, for example, is an extraordinary and powerful sequence that seems out of Dante's *Inferno*. The acting in the film is also convincing for the most part. John Agar, Hugh Beaumont and Nestor Paiva deliver credible performances, and Alan Napier is crafty as the pasty-faced Elinu. The Mole People are rather effective in their brief appearances, particularly when they are seen emerging from the ground. They wear dark clothes, and have a pronounced hump on their backs. They cannot speak, but they try to communicate to Dr. Bentley with soft groaning sounds when he sets several free who were being tortured by the Sumerians.

Finally, there is the performance of Cynthia Patrick as Adel. She brings a quiet dignity and gentleness to the part which is most appealing. Her part is like the eye of a hurricane in story terms, and her scenes are the only ones that permit the audience to relax. She seems to be a real person, not artificial like King Sharu and most of the other Sumerians. Cynthia is also beautifully photographed by Ellis Carter, and she appears simply radiant in her close-ups. Cynthia Patrick's Mole-Man memories remain fresh.

Q: How did you feel about doing this picture?

PATRICK: Originally I wasn't too happy about having to do *The Mole People*. In 1955, I was a contract player at Universal Studios, so that was that. When I started in the business, I had been in a number of commercials for

White Rain, which got me a SAG card. I danced with Ray Bolger in a TV show, and I danced with Fred Astaire in *Daddy Long Legs* [1955] during one of the dream sequences. Then I went to Universal.

Q: What films did you do for them?

PATRICK: I did *The Benny Goodman Story* [1955]. In *Showdown at Abilene* [1956], a Western with Jock Mahoney, I played the wife of Grant Williams [who had portrayed *The Incredible Shrinking Man*]. I also did *Four Girls in Town* [1956] and others.

Q: What was your first impression of *The Mole People*?

PATRICK: It was totally different from anything I'd done up to that time. William Alland, the producer of *The Mole People* objected to one thing. He thought my voice was too low for a newcomer and he asked me to raise it an octave. I tried to do that throughout the entire picture, which I thought sounded kind of silly.

Q: Not knowing your real voice, the audience doesn't get that impression.

PATRICK: I did not like having so little dialogue in *The Mole People*, but that was the way it was written. They tried writing me a few more lines, but that was it.

Q: How did you enjoy working with the cast of the picture?

PATRICK: Everyone on that film was good to work with. Alan Napier and Nestor Paiva were just wonderful. Hugh Beaumont told me my face was too flat and wished I had higher cheek bones. At the time it bothered me a bit that he said that, but John Agar was there to make it all better. John was such a sweet man, and he still is today. He lifted my spirits so I could go on with the show.

Q: What did you think of the director?

PATRICK: *The Mole People* was Virgil Vogel's first film as director and the only complaint I had with him was that they did not tell me I had to fall through the mole hole.

Q: That was the scene when one of the Mole People captured you. What problems did you have in that scene?

PATRICK: The mole holes were built well above the stage floor and were worked from below with hydraulics. I did not want to fall through that mole hole, and they had a tough time with me on that shot. They told me that they would have a stunt person who would actually fall through the hole, but that's not what occurred. Stuntman Eddie Parker [who doubled for Bela Lugosi in *Frankenstein Meets the Wolfman*] was the main Mole monster who interacted with me. He would tell me not to flinch if he were to suddenly grab me as I neared the mole pit, just before I would be dragged down into it. Well, those Mole man suits were like concrete against my skin, and when he did grab me, I did indeed flinch a bit. As we went down through the mole hole, I sliced my little toe on a piece of the underlying set. It nearly

Poster art for *The Mole People.*

sliced it off! Well, I was bleeding all over and I wasn't too pleased with that. Eddie Parker, who was ever so gentle with me, would be sent up the hydraulic lift to reach up out of the hole and grab me. The lift would return down with both of us going through the pit with all the debris, as though we were falling through a bottomless pit. It went very rapidly, and I had many cuts and bruises. I was pretty battered.

Q: You enjoyed working with the stuntmen who played the Mole People?

PATRICK: My relationship with stuntman Eddie Parker was brief. He was very caring and nice to me during filming. I had worked with Eddie on some other films and I knew him through another friend, Jock Mahoney. Some of the other men who played Mole men were Bob Hoy, George Robothom and Bob Herron.

Q: Stuntman Bob Herron spoke with us earlier, and he had some comments about the part. He said "There were two main holes that the Mole men would crawl out of on the set. At first they were called the "A" hole and the

"B" hole, and that caused a lot of laughs on the set, so we changed it to "One" hole and "Two" hole for obvious reasons. There was not much room in the holes either, and you really had to bunch up. The Mole man mask would twist and we groped about a lot."

PATRICK: Bob did the best he could with the Mole man costume. They did not have moveable eyes. Eddie Parker, who worked with me, did a great job too. They would tease me every now and then about how they were going to slip me a tainted mushroom [*laughs*] and they would have me in stitches most of the time. You might catch a bit of this on film when I speak. In some scenes, you may see me suppress a smirk here and there.

Q: Were any other of the cast or crew particularly helpful to you during the filming?

PATRICK: Eddie Keyes, the prop man, cared for me and guided me along the way during the production. He was wonderful. He made moleskin feet for me every day and helped in bandaging my bleeding toe when I had the accident going down the mole pit. Eddie Keyes was the best, and very memorable to me. He owned a restaurant across from Universal so we were all friends.

Q: What did you think about the sets for the film?

PATRICK: The sets were very interesting and realistic in every way. It had a very eerie quality to it and working amidst it all has remained strong in my memory. I especially liked how they lit the sets with the smoke, and how the Mole men would climb out of their pits. It was fascinating to see it all done right there before your eyes. Universal was always top notch when producing, and it showed.

Q: The ending of the film is similar to the ending of *Lost Horizon* [1937] when the girl perished after leaving Shangri-La. Was this on purpose?

PATRICK: No. The original way the finale was filmed showed John Agar and me walking out of the subterranean world into the sunset and off we went. I did not die, and that is how *The Mole People* was filmed. A couple of weeks later the studio called me back to re-film the ending with John Agar and Hugh Beaumont. They told me they had some questions about a Sumerian woman breeding children … strange children out into the world. So I had to die. So I came back and died! [*laughs*] After they film me walking out with Hugh and John, the earthquake occurs and the giant pillar falls. They actually cut to a stunt double who falls beneath the rubble … then cut to a close-up of me. When I found out they substituted a man for the double in that scene I cringed. He was a crew member who was short, stocky and had a big posterior. He must have looked like a klutz in that brief shot. But that's not me, folks! It's a man! That didn't make me too happy either, as I was quite slender with red hair at the time.

Q: Did anything interesting happen behind the scenes during production?

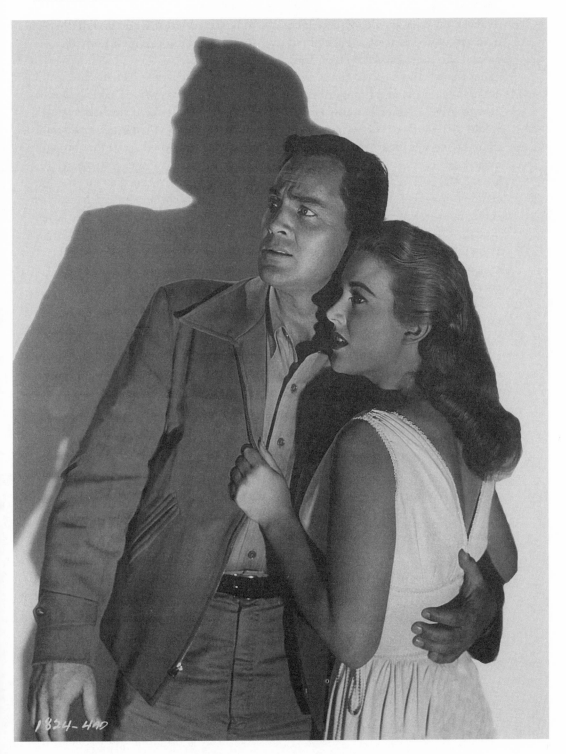

Cynthia Patrick with John Agar in a publicity shot for *The Mole People*.

PATRICK: One incident I remember occurred on the Universal backlot around the time *The Mole People* was being filmed. I was good friends with actress Gia Scala, and I taught her how to drive. I remember how no one would drive with her because they thought she was crazy! Well she owned this car and we were driving around the backlot and she really couldn't drive well at all at this time. As we approached the parking area near the talent department, she forgot to brake and instead hit the gas and took the side view mirror off John Agar's little MG. She was hysterical. I had the pleasure of handing John his mirror that day. We laughed about it though. It was a fun time indeed. I would frequent the beach at Malibu. I was a California beach girl, and I got to meet a lot people. I would often see Ben Chapman [the original title-role on-land Gill Man from *Creature from the Black Lagoon*] at the beach. We would see Tony Curtis often and he'd always clown around. Jeff Chandler was a dear friend of mine. I used to call him "great white father" and he would call me "Tiger." After I gave birth to my son, Jeff sent me a telegram saying that he did not want to be called "great white grandfather" so I had to stop calling him that!

Cynthia Patrick hadn't seen John Agar for 40 years when Paul and Donna Parla brought them together for a reunion in 1991 at Charlie's Restaurant in North Hollywood. Later they brought her to attend one of the Hollywood Collector Shows. Cynthia was surprised at the warm reception she got from fans who indeed remembered her, and when John Agar joined her for an informal photo session at the show, it was one of the highlights of the event.

Q: Any final thoughts about *The Mole People*?

PATRICK: I have no regrets and enjoyed the whole experience. I was actually happy to have gotten the work at the time. Looking back, I'm glad I did the film because it's still, 40 years later, holding up and so many fans admire it. It has stood the test of time and I'm grateful that so many still enjoy seeing me in *The Mole People*. John Agar was such a peach then, and he still is now. He made *The Mole People* the fun experience it was for me. Getting to see John 40 years later is something I will always treasure.

18

PAULA RAYMOND

Pursuing the Beast from 20,000 Fathoms

"I can't believe it's been 44 years since I made *The Beast from 20,000 Fathoms* [1953]," remarked actress Paula Raymond at the time this interview was arranged. "For years I considered it to be a black spot, but as it turned out, it's become one of the brighter spots in my career." This film really launched the cycle of prehistoric monster films that culminated with *Jurassic Park* (1993) and the new *Godzilla* (1998). In *Beast from 20,000 Fathoms*, a nuclear explosion frees the monster from an ice block in the Arctic. The monster, the Rhedosaurus, is seen by a scientist whose story is dismissed as a hallucination. In reality, the Rhedosaurus never existed but was created especially for this film. The monster travels south and destroys a

ship, and later a lighthouse off the Maine coast. The destruction of the lighthouse was the original inspiration for the film, based on a short story by Ray Bradbury. Eventually the monster attacks New York City, spreading death and destruction. The creature's blood also proves to be highly contagious and deadly. The monster is finally destroyed with a radioactive isotope shot into his wounded neck. This dinosaur-on-the-loose tale was special effects maestro Ray Harryhausen's first solo credit and it ushered in a new era of Atomic Age science fiction chillers. Plus, it provided Paula with her best known and loved movie credit.

The striking brunette was born Paula Ramona Wright in San Francisco on

Paula Raymond on *The Beast from 20,000 Fathoms*: "I don't regret doing this film, but at the time, I knew it did not have the production values that my MGM pictures had. *Beast*, at the time, felt more like a throw-away."

November 23, 1924. Her grandfather was the famous pioneer magazine editor Farnsworth Wright, who was famous for the ground-breaking magazine *Weird Tales*. In this magazine, for example, Wright introduced first printed works by H. P. Lovecraft, perhaps America's greatest writer of fantastic fiction. Paula was also the daughter of a distinguished attorney. She was considered a child prodigy and studied singing, piano and ballet, becoming a valued member of the San Francisco Opera Ballet and the San Francisco Children's Opera Company.

A graduate of Hollywood High (Class of '42), Paula has appeared in over 25 films, starting with *Keep Smilin'* in 1938. Other movie credits include *Blondie's Secret* (1948), *Adam's Rib* (1949) with Spencer Tracy and Katharine Hepburn, *Crisis* (1950), *Devil's Doorway* (1950), *The Duchess of Idaho* (1950), *King Richard and the Crusaders* (1954), *The Gun That Won the West* (1955), *The Flight That Disappeared* (1961), *Hand of Death* (1962) and *Blood of Dracula's Castle* (1967).

Paula was also no stranger to television either, guesting on such popular

programs as *77 Sunset Strip* (1958–64), *M—Squad* (1957–60), *Bat Masterson* (1959–61), *Have Gun—Will Travel* (1957–63), *The Untouchables* (1959–63), *Perry Mason* (1957–66), *One Step Beyond* (1959–61), *Mannix* (1965–67) and *The Man from U.N.C.L.E.* (1964–68).

In this interview, Paula Raymond reflects upon a career filled with triumphs and setbacks, starting with the breakup of her early marriage.

Q: How did you get into show business?

RAYMOND: At age 21, I had just divorced my husband. I had never earned a living before in my life. I had a three-month old baby to support and wondered what I could do to make a living. I had been out of practice with all my artistic talents ... piano, ballet, singing ... but I knew I could still act. So I went over to MCA, and they suggested I look into modeling. They rattled off a list of names and phone numbers. After calling a few, I made an appointment with the firm of Mead-Maddick, who turned out to be cover photographers. When Mary Mead answered the door, I introduced myself as Rae Patterson ... which is a contraction of my middle name Ramona and my married name Patterson. Before I could get another word out, she yelled to her husband Tam Maddick, "She's just our type!" So I started modeling and doing a lot of covers for them.

Q: How did you move from modeling to acting?

RAYMOND: At this point, I had forgotten about acting. After three months of modeling, Mary asked me if I could act. When I told her, "Yes, I am an actress," she made an appointment for me to see Al Lewis, who was a friend of hers at casting at Paramount Pictures. After reading for him, they offered me a studio contract. Mary felt I should have a players contract, so I tested for that contract. Paul Stewart [who played the butler in *Citizen Kane*] directed the screen test and I did a scene from *Night and Day*. They signed me and I was under contract to Paramount for one year.

Q: What did you wind up doing at Paramount?

RAYMOND: I did absolutely nothing. You see, all this occurred during labor troubles with the union. This was the IATSE strike of 1947, and the studios were placed in the position where they had to let people go. So at the end of 1947, Paramount let me out of my contract. At this time I was also having problems with my ex-husband, who was one of these, "If I can't have her, nobody will" type of men. He kept trying to kill me. This was all very distressing. Soon enough though, I got a call from Max Arnow's office at Columbia Pictures. The last agents I had spoken with were Elsie Cukor and Leon Lipton [Cukor-Lipton Agency] and they escorted me to Arnow's office, where I was offered a seven-year base contract.

Q: Did you actually get to appear in movies at Columbia?

RAYMOND: Yes, but I was very unhappy at Columbia because I was

being given what were basically nothing parts in films like *Rusty Leads the Way* [1948] and *Challenge of the Range* [1949] with Charles Starret. So I began eating my way out of my contract. I was getting so plump they couldn't use me as a leading lady; in six months I was gone.

Q: How did you wind up at MGM?

RAYMOND: After I left Columbia, I began doing *Storybook Theater* on television, a series that presented classic stories. I was doing an episode based on Mark Twain's *The Million Pound Note*, and on that day Leon Lipton came to the set. The people who were running the show told him that they hoped he wasn't going to waste me on television. So it was off to see director George Cukor at MGM. He was directing *Adam's Rib* [1949] there, and I think he must have had the writers come up with a character just for me. He cast me as David Wayne's girlfriend, and during the film's courtroom scenes, there were a lot of close-ups of me. This was George Cukor's way of introducing me at MGM.

Q: What picture did you make at MGM?

RAYMOND: I was in *East Side, West Side* [1949] with James Mason. Of course, I had a crush on him ever since I saw him in *The Night Has Eyes* [1942]. I played Mason's secretary in one scene, and it was one of the best things I had ever done.

Q: What was your first starring role at MGM?

RAYMOND: That was *The Devil's Doorway* [1950] with Robert Taylor. It was one of Robert's favorite roles. He was cast as an Indian who fought in the Civil War. When he got home, he had to struggle with the injustices inflicted on his people. Anthony Mann directed the film. Mann didn't want me for this role at first. He had Robert Taylor, Louis Calhern, Spring Byington and a whole host of great professionals for this film. He wondered if "Miss Nobody from Nowhere" could be his leading lady. So on the day of my screen test, he was absolutely awful … purposefully awful. He would tell me to do it one way, than he'd cut and say, "No, no no … do it this way!" He kept trying to confuse me, not knowing that he was working with a professional and not just some good-looking girl someone plugged for the part. The rest of the crew all knew what he was doing. Finally, I turned to him and said, "Mr. Mann, when you make up your mind as to how you want me to do it, then I'll do it that way." So the next time he told me how to do it, he was pretty much stuck with it because I was doing it his way.

Q: Did relations improve with Anthony Mann once the filming got under way?

RAYMOND: No. We went on location to Aspen, Colorado. I knew of his resentment of me as his leading lady. I kept out of his way, wouldn't make any noise, and I would stay in the corners when I wasn't needed, and so on. Then things changed, and Anthony Mann

decided he wanted to get me into bed. Later, I heard the crew was making bets about who was going to win! Here I was, playing opposite Robert Taylor, one of MGM's top stars, and nobody knew who Paula Raymond was. That's what helped me, because I had a publicity man, Jim Campbell. He was always nearby. Mann would ask me to dinner after the day's shooting was done, and I would turn and say loudly, "Oh, that sounds fine, doesn't it, Jim!" [*laughs*] So Mann could only get me as far as his cabin door, and things never got out of hand.

Q: So did your success in *The Devil's Doorway* lead to other parts?

RAYMOND: Yes and no. It almost sabotaged my part in *The Duchess of Idaho* [1950]. I had already been assigned to the role of Ellen before I left for location shooting on *The Devil's Doorway*. I had the script with me in Colorado. Joe Pasternak was the producer on *The Duchess of Idaho* and Robert Z. ("Pop") Leonard was director. Pop had directed many of MGM's hits through the years. The character of Ellen was a light, comedic style role, and my character in *The Devil's Doorway* was strictly dramatic.

Q: Which did you prefer?

RAYMOND: I preferred comedy. Anyway, when Joe Pasternak and Pop Leonard viewed my rushes from *The Devil's Doorway*, they thought I was a dramatic actress and not cut out for comedy. I had fallen in love with the part while reading it on location. I knew exactly how to play the character

of Ellen. Anyway, I had been taken off that picture for two weeks due to Pop's decision. Then Joe Pasternak insisted that I be given a chance. Before they started shooting *The Duchess of Idaho*, they had me rehearse the first scene. This is rarely done, and Pop still thought I would murder the role. The writers, Sidney Field and Dorothy Cooper, were on the set too. They were scared to death I would ruin the role they created. After the rehearsal, Dorothy walked up to me and said, "Paula, Sidney and I wrote the script, but I wrote the role of Ellen. You are indeed Ellen!" What a nice compliment from a writer.

Q: How did you feel about *The Duchess of Idaho* after you completed it?

RAYMOND: I would say it was my favorite role. I loved doing comedy. There also were a number of interesting people in the cast, such as Esther Williams, Van Johnson, Amanda Blake, Eleanor Powell and Lena Horne. It was all about Esther trying to patch up my romance, and falling in love herself.

Q: So was your next part comedic or dramatic?

RAYMOND: It was dramatic, and it was again a part that I almost didn't get. It was *Crisis* [1950] with Cary Grant. I thought Nancy Davis was going to get the role. This was before she married Ronald Reagan. Nancy was a very good friend of Dory Schary, who had sort of taken over the reins at MGM from Louis B. Mayer.

Nancy's stepfather was a doctor who operated on Dory's wife and saved her life. So, Nancy was the darling of the studio. Now at this time, I was getting calls about my next role. There were so many roles I could play, but as time went on I just knew that I was not going to get the part of Helen Ferguson in *Crisis* opposite Cary Grant.

Q: You assumed the role would go to Nancy Davis?

RAYMOND: Yes. We tested on the same day. I tested in the morning in a scene with Cary Grant and Leon Ames. Nancy was to test after me, and I heard that Nancy had been on the set. I wanted to go over and wish her good luck, but someone in the crew told me to stay away. That Saturday, I went to the premiere of *Annie Get Your Gun* [1950] and my date was Sidney Sheldon who wrote the screenplay. Afterwards, he took me to Artie Deutch's home for the after-premiere party. Artie turned to me and said he was a dear friend of Nancy, but he was glad I was going to play Helen Ferguson. So I thought, "Could it be true?" Then I later got a call to come in and see Arthur Freed, who had done the tests for *Crisis* the previous week. Now I was apprehensive because I had known about Arthur's reputation with women. When I walked into Freed's office, he said to me, "Paula, you are going to play Helen Ferguson." I wondered if he was leading up to something, but Freed was a perfect gentleman. Then the phone rang, and Freed told the party on the other end, "Yes, Paula Raymond is going to play Helen Ferguson." I still couldn't believe it.

Q: When did you feel certain?

RAYMOND: Well, *The Duchess of Idaho* had just previewed, and for the first time in the history of an Esther Williams movie, another actress had walked away with all the preview cards. So when Dory Schary came up to me and said, "Paula, congratulations, you're going to make a lovely Helen Ferguson," I knew it was true. *Crisis* was my most enjoyable experience in motion pictures. Cary was such a gentleman. It was overwhelming to star with him. He played a doctor who was hired to treat a Latin American dictator who was played by Jose Ferrer. So Helen Ferguson was my second favorite role.

Q: What part did you play in *King Richard and the Crusaders* [1954]?

RAYMOND: I played Queen Berengeria, the wife of Richard the Lion-Hearted, who was performed by George Sanders. Rex Harrison was Saladin. The film was really more of a fantasy than history. Because of this, I wanted to inject some humor into my character, but the director, David Butler, wouldn't allow it. He wanted me to play her straight. I have a funny anecdote about George Sanders. There was a "cliquish" atmosphere on this film ... actually two cliques. You had Laurence Harvey playing the hero, and he was brought in from England for his first American film. One clique was Laurence Harvey, Virginia Mayo and Robert Douglas. The other was George Sanders, Rex Harrison and myself. Not much was known about Laurence Harvey at the time, but we

CRISIS - MGM
1950
CARY GRANT - PAULA RAYMOND
RAMON NOVARRO

Paula Raymond assumed the part of Helen Ferguson in *Crisis* (1950) would go to Nancy Davis but was pleasantly surprised to share on-screen time with Cary Grant and Ramon Novarro (right).

did know he was in the process of making a serious decision. One night he would be out with the boys, and the next night out with the girls. He was sort of sitting on the fence, not knowing which way he would go. Well, George made up limericks about all the cast members. George made up a classic one for Laurence Harvey, and it went like this:

> "Hark now to the tale of a lad called Larry,
> Who's likened to Shakespeare and Madame DuBarry,
> With the vices of both, and the talents of neither
> He cries to the world, "You may have me as either!"

I never forgot that clever ditty by George Sanders.

Q: Things then began to go wrong for you at MGM. What happened?

RAYMOND: After a while I felt that Elsie Cukor and Leon Lipton were not representing me at the studio as I should have been. I felt that I should have been receiving better publicity than I was getting. I played opposite a lot of great names, but my representation was the main problem. When Harry Friedman of MCA came to talk to me about this matter, I wanted to be sure that Elsie and Leon would get their commission as long as I was at MGM. He said yes, and that the only commission MCA would get would be on anything I'd do outside the studio on loan-out. So that's what I did, and it infuriated Elsie and George Cukor. George went to Dory Schary and gave him the sign of the slit-throat and

told him Paula Raymond was finished. I was at MGM for one more year and, to bury me, they had me assisting in screen tests.

Q: For any particular performers or films?

RAYMOND: One was *Mr. Imperium* [1951] with Lana Turner and Ezio Pinza. The director, Don Hartman, as a joke, told Ezio Pinza that I was interested in him. Poor man. [*laughs*] You know, my parents were patrons of the San Francisco Opera, and always had the lead singers as guests at parties. But Pinza and Elizabeth Rethberg were never invited because both were married to other people and they were having an affair. Hartman knew about this, and he kept telling Ezio how elated I was working with him. [*laughs*] Ezio took Don Hartman seriously. At one point, Hartman called me into Ezio's dressing room, and told me that Ezio had a suggestion about doing a certain scene. Ezio said, in his Italian accent, "When I go to kissa you, you pusha me away!" [*laughs*] So Hartman interjects, "Oh, I don't think that is going to be easy for Paula to do." Then I responded, "Sure it is! I was taught to push them away when I was knee-high!" and I made a gesture about two feet high. [*laughs*] Ezio was the matinee idol of his day. We did a scene from *South Pacific* for his screen test, and I played the Mary Martin role. The test came out fine, despite all of Hartman's baiting.

Q: What films did you make during this "blackball" period at MGM?

RAYMOND: Billy Grady asked me to play Red Skelton's sister in *Texas Carnival* [1951] as a favor. Next, I was in *The Sellout* [1952]. It was a nothing part that made me feel like a piece of furniture. After that, they let me go. I learned later that George Cukor had planned to star me in *The Actress* [1953]. Jean Simmons wound up playing the role that he had in mind for me. If I had a chance to go back and change things around, I would have never fired Elsie Cukor as my agent.

Q: Where did you go after your stay at MGM?

RAYMOND: I was in *The Bandits of Corsica* [1953] for United Artists. I was lucky to have gotten that job because I had been blackballed in the industry due to the George Cukor incident. The big studios wouldn't touch me. And then *The Beast from 20,000 Fathoms* stepped into my life. [*laughs*] You can imagine my embarrassment having to go from the MGM star treatment to *The Beast from 20,000 Fathoms* [1953].

Q: Are you embarrassed by your association with the film?

RAYMOND: Not at all. I am quite proud of having done it, but at the time, I was embarrassed. I knew it was not going to have the production values that the MGM films had. It didn't have the same kind of ambiance I was familiar with.

Q: How did you get cast in this picture?

RAYMOND: I was automatically cast. I didn't interview for the part. They simply asked me. What was fascinating about this film was that it was done quite speedily ... in about 30 days ... and the cost of the whole show was, I believe, around $250,000. We never expected it would gross nearly five million dollars. *The Beast from 20,000 Fathoms* was an independent production. One of the producers was Hal E. (Hally) Chester, a former member of the "East Side Kids." When it was completed, Chester sold the film to Warner Brothers, who released it in 1953. That same year, Warner Brothers also released *House of Wax*, which was made in color and 3-D. Studio head Jack Warner thought for sure that *House of Wax* would fare better at the box office, but it turned out that *The Beast from 20,000 Fathoms* out-grossed *House of Wax*, which surprised even Jack. And back in those days, there were no residuals given to actors. When the film was in preparation, it was not deemed to be an important production. The public's attraction to it made it important as a film and as an impressive artistic piece for its time. It's definitely a nine on my one-to-ten scale because it's so credible in its execution.

Q: Ray Harryhausen did the special effects for the film. Did you get to see the "master" at work?

RAYMOND: No ... the shots of the Harryhausen model were put in later, so I never got a chance to see the effects until after the film was completed. And I never did get to meet Ray because he worked separately from the actors.

The Beast from 20,000 Fathoms, Argentinean poster.

Q: Speaking of actors, what was it like on the set?

RAYMOND: It was a very happy set and we all got along well. Paul Christian was sort of distant, but everyone from Cecil Kellaway and Kenneth Tobey to the director, Eugene Lourie, was simply wonderful. I played Kellaway's assistant in the picture, and Cecil was so very charming. You probably know already that the picture was originally titled *Monster from Beneath the Sea*, taken from a short story by Ray Bradbury called *The Foghorn*. Well, years later, I had an interesting conversation with Ray. My uncle, Farnsworth Wright, had been publisher-editor of *Weird Tales* magazine, and Ray told me that he had been selling his paintings on commission. On one particular day, Ray had three paintings to sell, and he took them to show my uncle. When Ray mentioned that he was a science fiction writer, my uncle asked to see his work. Not only did my uncle become the first publisher to publish Bradbury's stories, but he bought all three paintings. Rod Serling was also first published by my uncle.

Q: What else do you recall from the film?

RAYMOND: I guess I was one of the first of a long line of lady scientists in these types of films. My character was called Lee Hunter, and some of her wardrobe was my own. I wore one of my own smocks in the film. There also was a lovely dress which was an I. Magnin piece. Some of my other evening clothes in the picture were done by my couturier, Genia. Her trademark with collars was "no seams." She cut them a certain way that they would just lay and fold beautifully in a collar. She was superb.

Q: You were then offered a role in *Battle Cry* [1955] as the wife of Tab Hunter. Why didn't you take it?

RAYMOND: I had a choice of going to New York to do a pilot for a show with Tom Helmore, a crime-type series, or to play the part that Dorothy Malone played in *Battle Cry*. I chose the show in New York, and we all know what happened to Dorothy's career after that film was released.

Q: You did a Western for William Castle?

RAYMOND: Yes, that was in some ways my favorite Western. One thing that has made me rather unidentifiable in films was that my character-type kept changing. What I liked best about *Gun That Won the West* [1955] was working with Dennis Morgan and Richard Denning. I never had to contend with children, dogs or horses!

Q: You then turned your attention mainly on television for the rest of the decade.

RAYMOND: Yes, I was in countless shows as a guest star, including more Westerns like *Bat Masterson* and *Cheyenne*. I also did *77 Sunset Strip* and *The Roaring Twenties* [1960–62]. I turned down a role in a continuing series for CBS. It was the role of Kitty Russell on *Gunsmoke*. At the inception of the show, Miss Kitty was a cheap

barmaid-type of part. That is how it was played on radio. I would have done the part in a movie, but I felt I couldn't have done it on a continuing basis. That was my mind-set. Amanda Blake got the part, and the role was refined. Amanda was great in it, and didn't leave the show until 1974.

Q: Your next genre film was a fantasy called *The Flight That Disappeared* [1961]. That film was once considered lost, but copies of it have resurfaced. It was an unusual picture about an airplane that was hijacked into another dimension. Any comment on this film?

RAYMOND: It sort of was an extended *Twilight Zone* type of story. Craig Hill played the lead. There is not so much to talk about as far as behind-the-scenes anecdotes because the film was shot so quickly. I was impressed by the story. I don't think anything had been done quite like it before. The idea of these people being held accountable for their earthly actions by a sort of netherworld jury was interesting. The director, Reginald LeBorg, handled it with finesse and didn't make it seem moronic or overdone. *The Flight That Disappeared* suffered from poor promotion, actually the total lack of any promotion. Marketing a film is expensive, and if you don't set aside a budget for promotion, nobody is going to hear about your film. That is what happened here. But I believe the film is quite good for the time it was made.

Q: What do you remember about *Hand of Death* [1962]?

RAYMOND: That film seems to have totally disappeared. Gene Nelson, who directed the picture and who recently passed away, had been searching for it for years. This was Gene's directorial debut. The picture was about a scientist who gets infected with radiation, and gets transformed into this bloated monster who possesses a deadly touch whenever he comes in contact with living matter.

Q: Where was the picture shot?

RAYMOND: Most of the locales we used were in Malibu and Santa Monica. I remember John Agar in that grotesque costume he had to wear. It was outstanding and frightening to look at. But I knew it was indeed John under all of that, so it helped. [*laughs*] To this day, I have never seen this film.

Q: Any other recollections?

RAYMOND: Actually, it's not the film that I remember so much as what happened shortly after completing it. On August 20, 1962, I was being driven home by a friend, Gloria Beutel. Her car had a bench seat in front and I was seated in the middle of the front seat. We were headed east on Sunset Boulevard. We were five minutes away from my home when she lost control of the car and hit this huge tree head on. All I can remember is me screaming, "Gloria!" and then the impact. The rear view mirror crushed my face, taking my nose off completely. Then the car overturned six or eight times, and I was later told that I was pulled out of the car seconds before it exploded. I have often thought that if

Trapped in a strange, fog-shrouded netherworld, Paula Raymond and crew members are among the ill-fated passengers aboard *The Flight That Disappeared*.

I hadn't been pulled out of the car, I may have escaped so much agony. Even after five and a half hours of surgery, they were unable to replace the bridge of my nose. I never worked as much after that as I had years before because of my slight disfigurement.

Q: But you still got acting roles?

RAYMOND: Oh, yes. The first thing I did was a show called *Temple Houston* [1963–64] with Jeffrey Hunter and Jack Elam. It was a Western, and there was a funny bit between Jack and me. When I first came on the set, Jack turned to me and said, "Happy Holiday Motel, No. 7, at noon!" I didn't know what to make of it, and my hairdresser told me Jack was a great kidder, and he told that to all the leading ladies. [*laughs*] Now Jack and I played Liar's poker, and I lost ten dollars to him. So I had the prop department dress up a dummy like me. Prior to this I had scoured the town for the worst looking poker-playing dollars I could find. I slipped my ring onto the dummy's perfectly parted fingers, and placed the poker dollars in the palm of its hand. I placed my wig on the dummy, and hid in his dressing room with my camera. The prop department alerted me when he was on his way to the room, and when he opened the door, I whispered, "Come on in, Jack." As he approached the dummy, I snapped the picture. It alerted him when the flash went off, but I actually missed getting a shot of his face. He told Jean Riley that if I hadn't come out of the closet, he was going to go for the dummy! [*laughs*] Another show

I did one year after my accident was *Death Valley Days* [1952–75]. Think of that title ... not bad for a gal who was pronounced Dead-On-Arrival.

Q: You also worked in soap operas?

RAYMOND: Yes. In 1977 I did a one-day job on *Days of Our Lives* and loved the role. I was 52 years old at the time, and I was playing a 40-year-old hooker! [*laughs*] The casting girl's eyebrows hit her hairline when I began reading for this part. She took me back to the producer's office, and they told me that they knew who I was and were aware of my body of work. They said they couldn't hire me just for one day's work, but I insisted. I wanted to get my foot back in the door. They hired me, and after the morning's shoot the producer had my character, Nancy, written into the show. So on Monday morning at 8:15 I got a call in my dressing room. The telephone cord had gotten wound around my left foot. When I whipped away from the phone to leave my room, the cord took me off my feet. I broke my foot so badly that they couldn't put it into a cast. Now I was on crutches, and this became my "sexy, naked left foot" look. Of course they started writing me out of the show. Who wants a 40-year-old hooker on crutches? [*laughs*]

Q: You also appeared in *Blood of Dracula's Castle* [1967] for director Al Adamson.

RAYMOND: Al Adamson was quite nice. Alex D'Arcy and I played Count and Countess Dracula. John Carradine

A desperate Paula Raymond pleads with her radioactive spouse (John Agar) during the finale of the rarely seen and possibly lost *Hand of Death*.

played our right hand man, George. The most comical thing about this film was that Adamson originally wanted John Carradine and me to play it all straight. I can't help thinking that if we had, it would have really been a "horror" film. [*laughs*] I felt more comfortable playing it with some humor.

Q: Where was this film made?

RAYMOND: We shot that picture in Indio, California, and there was a castle which we used for interior and exterior scenes. Back in 1960, I had been in this part of California, near the Salton Sea area, filming a documentary on the plight of the American Southwestern Indians. Doing *Blood of Dracula's Castle* brought back memories of it. I wrote, produced and edited this documentary.

Q: You've had many highs and lows, personally and professionally, yet you've managed to keep your sense of humor and good spirits.

RAYMOND: Of course I have regrets, but I've always felt that you can always find laughter, even during the darkest moments. If you don't laugh at your tragedies, then "the beast" will have won.

19

JOAN TAYLOR

The Indian Maid vs. The Flying Saucers

Once heralded as one of the most promising actresses of the fifties, Joan Taylor remains a familiar face to screen fans thanks to her starring roles in *Earth vs. The Flying Saucers* [1956] and *20 Million Miles to Earth* [1957]. In the former, she had the monumental task of helping to save our planet from alien invaders, while in the latter, she confronted a Venusian monster (unnamed in the film, but referred to as "the Ymir" by film historians and fans). Since Earth is still very much intact, we all owe Joan a huge debt of gratitude. In her film career, Joan also appeared in the role of an Indian maiden, in various films such as *The Savage* [1952], *Rose Marie* [1954] and *Apache Woman* [1955].

Joan Taylor was born Rose Mary Emma in Geneva, Illinois. Her mother, Amelia Berky, was a dancer and vaudeville headliner during the twenties. Joan's Sicilian father, Joseph Emma, had worked in Hollywood as a prop man in the era of Rudolph Valentino. Shortly after Joan's birth, the family moved to Lake Forest, Illinois, where her father managed the Deerpath Theatre. Not surprisingly, Joan saw lots of movies and later worked at the theater as a cashier. Her childhood screen favorite was Shirley Temple, who strongly influenced Joan's ambitions. As a teenager, Joan also imagined herself dancing and gliding with her other screen idol, Fred Astaire.

At age 16, Joan's dream of becoming an actress in motion pictures was

Harryhausen's saucers attack Paris as Joan Taylor and the late Hugh Marlowe watch in super-imposed horror in *Earth vs. the Flying Saucers* (1956).

temporarily sidelined due to a bout with scarlet fever. But she eventually bounced back and continued her singing and dancing studies, graduating from the Chicago National Association of Dancing Masters.

In 1946 Joan headed to California to pursue a performing career. She enrolled in the famed Pasadena Playhouse, where she appeared in everything from Greek tragedies to Shakespearean comedies. She even wrote a one-act play titled *She Knew What She Wanted*.

Victor Jory, a frequent guest artist at the Playhouse, felt that Joan's talent was ideal for films. Jory arranged an interview with producer Nat Holt. This resulted in her first movie role *Fighting Man of the Plains* (1949), opposite Randolph Scott.

Joan went on to appear in numerous films, including *The Savage* (1952), *Off Limits* (1953), *War Paint* (1953), *Rose Marie* (1954), *Apache Woman* (1955), *Fort Yuma* (1955), *Girls in Prison* (1957), *Omar Khayyam* (1957), and *War Drums* (1957). She also made guest shots on various television shows of the period, such as *Gunsmoke* (1955–75), *Rawhide* (1959–66), *The Millionaire* (1955–60), and *Perry Mason* (1957–74). From 1960

to 1962 Joan was a regular on the popular series *The Rifleman*, playing storekeeper "Miss Molly Scott." In 1963 she retired from acting, devoting her time to raising her children. In this interview, the unpretentious former actress recalls some of her memorable career highlights.

Q: How did you get started in show business?

TAYLOR: I always was interested in dancing. I practiced faithfully many hours a day. My ambition grew, as well as a desire to become a screen actress. People were always saying to me things like, "You can't do it ... it's impossible ... you'll never get in." That's all I heard. "Can't ... Can't ... Can't!" I just encountered so much negativity. However, I did what I wholeheartedly wanted to do, and was quite fortunate to become associated with Gilmore Brown, who was head of the Pasadena Playhouse at that time. He put me into many, many plays and I did everything, including stage managing. I was given a wonderful background by working in all forms of drama.

Q: Victor Jory guided you into your first screen role.

TAYLOR: Victor was a frequent guest artist at the playhouse during this period. One day I was sitting in the patio at the Pasadena Playhouse and Victor came up to me and said, "Come on, we're going some place." I had no idea where he was taking me. I had no make-up on, and I was wearing a little sundress. I wasn't wearing stockings. I was certainly not dressed for an interview. But that is where

Victor took me ... into Hollywood for an interview where I read for a part. At this time, I had been doing *John Loves Mary* on the road. When I got home on the night of the last performance, I got an appendicitis attack. I went to the hospital only to get flowers from producer Nat Holt saying, "Congratulation!" I got the part.

Q: That film was *Fighting Man of the Plains* [1948]?

TAYLOR: That was my first motion picture with Randolph Scott, which was done for 20th Century–Fox. It was one of Dale Robertson's first pictures. Victor Jory was in it also. There was one scene where there was a fire in the house, and I was supposed to get hysterical, standing on the steps. Edwin Marin, the director, said, "roll it" and then Victor Jory called my name and when I turned to him, he smacks me right across the face. It was a dead-on solid slap, and of course by now I am really crying. Then Marin yells, "Cut!" Something had gone wrong technically with the fire, so we had to do it again. So we did the scene again, and smack, right across the face again. We wound up having to do this three times. It was only years later that Vic told me how bad he felt about having done that to try to get realism into the scene. It was the worst experience I had encountered in films. I can assure you Jory's slap was real. But, honestly, Vic did take care of me on this picture. He was there as my guide.

Q: Was this the first time you used Joan Taylor as your professional name?

TAYLOR: Yes, I became Joan Taylor on this film. Randolph Scott was exactly what one would expect him to be, an elegant gentleman, just as he appeared on the screen. There were no mishaps on the picture, except the experience of learning to ride a horse ten days after an appendectomy. One exciting thing was that the film had a big premiere which I attended with Randolph Scott and Dale Robertson in Topeka, Kansas. Then they took the film back to my home town in Lake Forest, Illinois, where we premiered it at my father's theater. I'll never forget seeing my name up on the marquee, and it was great. It was sort of a "local girl makes good" event.

Q: Your next film was *The Savage* [1952]?

TAYLOR: Yes. I was still appearing at the Pasadena Playhouse. Paramount became interested after I portrayed a 60-year-old woman in *The Master Builder*, and then Columbia tested me for *Sirocco* [1951]. I didn't get the part, but the executive saw the test, and put me under contract at Paramount. I was offered the role of Luta, a Sioux Indian maiden. It was a wonderful part. The picture was originally called *War Bonnet*.

Q: *The Savage* was a big breakthrough role for Charlton Heston.

TAYLOR: Yes, Charlton was superb in the role of the hero, a white man raised by Indians. Susan Morrow was also quite good. *The Savage* was directed by George Marshall. George was from the old school, going back to the silent days of motion pictures. He would tell us such interesting stories of the old days when there were really no scripts to work from. I enjoyed his tales of what it was like making pictures back then. George was a wonderful man. We went out on location to the Dakotas for this picture. I can't remember if it was North or South Dakota, but I do remember that we were rained out for the first two weeks. The real joy of doing this picture was the unity of everyone on it. It was on this picture that I learned quartet singing, during the rain. We would all gather underneath the picnic tables and Milburn Stone taught us to sing *Heart of My Heart* in quartet-style fashion. It's things like this that make my memories so special.

Q: Your next film came right after this one?

TAYLOR: Yes, I did a bit part in *Off Limits* [1953] with Bob Hope and Mickey Rooney. It was again directed by George Marshall. I appeared in a fight scene wearing a silver fox jacket and a turban. At this time, I was under contract to Paramount until 1954. I was interviewed in a room that we called "the fishbowl" over a hundred times or more. Around this time, I started doing more Westerns, and I really began to appreciate the stunt people. They all took good care of me and made sure I didn't get hurt. I really began to appreciate them as I did pictures such as *War Paint* [1953], *Fort Yuma* [1955] and *War Drums* [1957].

Q: Any specific memories associated with these films?

TAYLOR: I believe it was on *War Paint* that I was the only gal in the film, working with Robert Stack, Peter Graves, Walter Reed, John Doucette, Robert Wilke and Charles McGraw. Working with Charlie McGraw was really great. Much of that film was shot out in Death Valley. Robert Wilke told me it was always important to work with stunt people when doing fight scenes. Robert was very protective of me during the fight scene I did with him.

We went off to Utah on *Fort Yuma* for director Lesley Selender. We would call him "The Great White Cloud" because he always sought out the highest mountain to do his filming. I recall following him up these big mountains. I did not work well around horses, however.

I remember that for a scene in *War Drums* [1957], I had to lead a group of horses down a hill at a fast pace. I didn't want to do it, but the director, Reginald LeBorg, kept pushing me to do the scene. I still refused, so they got a stuntwoman to do it and she wound up falling off her horse. The horses that were following trampled her. When they realized she was injured, they dressed a stuntman up in my outfit. He did the scene. But I wasn't as happy working with LeBorg as I was with my other directors, and that's where I'll leave it. I was very happy with my make-up man, Del Armstrong, one of the best in the business. He made me look so good. He was Lana Turner's make-up man.

Q: Who starred in *War Drums* with you?

TAYLOR: There was Lex Barker, Ben Johnson and John Colicos. They were all fine. There was one incident where Ben Johnson and I locked stirrups because the horse they had given me to ride was just too frisky.

Q: You also starred in *Apache Woman* [1955].

TAYLOR: That was a quick shoot. I worked with Lloyd Bridges on that film and he was wonderful. A real pro. It was one of Roger Corman's first films. As for Roger, he's a very smart man. He depended a lot on his cameraman to get the scenes just the way he wanted them. Lloyd and I also worked together to get scenes just the way he wanted them, as well as just the way we wanted them. Lance Fuller played my brother, and again we relied on each other to develop our scenes.

Q: Let's cover a few of your other films before we turn to your science fiction films. Which one did you enjoy most?

TAYLOR: It would have been the musical *Rose Marie* [1954]. That was a first class production in cinemascope and technicolor. It was originally filmed in the Thirties with Jeanette MacDonald and Nelson Eddy, but that film really strayed from the original story. This version stuck pretty close to the original operetta by Rudolf Friml. The film starred Ann Blyth, Howard Keel, Fernando Lamas, Marjorie Main and Bert Lahr. I played an Indian maiden again, and I got to do the totu, tom-tom number. That was my experience with Busby Berkeley, the great choreographer. We had

rehearsed for this dance for 13 weeks, and then everything was changed by Busby. I remember him up real high on the camera boom. At that point, we didn't have any music to work with, but it all turned out fine. I had a good part. The sets were really magnificent, as were the costumes. Ann, Howard, Fernando and everyone had a good time. We would be laughing all the time, particularly when Bert Lahr started joking around. But there wasn't much time for pleasure, because this film required a lot of hard work.

Q: What do you recall about the director, Mervyn LeRoy?

TAYLOR: He was a real gentleman until I spilled hot coffee on my "made in France" white Indian outfit. It was gorgeous and made of the kind of kid-skin used for making gloves. I was walking very carefully with a cup of coffee, and the cup started leaking onto the front of the skirt. Then I heard a voice that was very angry. It was an awful moment. I have always done my best to perform profession-ally, both on and off camera. I was blessed to have worked with nothing but professionals. You come to work and study your lines and perform them professionally. This was an unfortu-nate accident, but time is money.

Q: Did you ever have any other difficult moments while making films?

TAYLOR: Something happened while I was making *Omar Khayyam* [1957]. My boss at Paramount was Y. Frank Freeman, and his son was the producer of this film. Bill Dieterle directed it wearing his white gloves.

His lovely wife would bring home-made donuts to the set. What hap-pened was I had to do one scene over 20 times, and that was no fun. It was embarrassing to me because I was used to doing scenes in one or two takes. For some reason, I had trouble giving Bill what he wanted in this scene. In the film, my character falls off a cliff. When my daughter saw the film, she was quite young. She had terrible memories of it, not realizing it was a dummy that went over the cliff, not her mother.

Q: You are best remembered for your science fiction films. What do you recall about *Earth vs. the Flying Saucers* [1956]?

TAYLOR: We did that film in ten days, and I mean ten days! There was no fooling around. We worked hard to cram it all into that short shooting schedule.

Q: That film has quite a number of on-location shots. Where were they filmed?

TAYLOR: We shot some scenes out at UCLA and out by Zuma Beach. We did some of the truck sequences, such as the one with Hugh Marlowe and me in a truck during the saucer attack, out on the old Warner Brothers ranch facility in Burbank. For the scenes when the saucers attack the military base and Hugh Marlowe and I are running through corridors and up steel steps, we filmed out at the Hype-rion plant down near El Segundo. We then flew to Washington D.C. to do those exterior scenes at the end of the picture. I remember shooting was

delayed a few days because of a fierce hurricane that struck when we were doing the Pentagon sequences. Because of that delay, I missed my daughter's first birthday party, and it hurt. I never went far away on location after that. We tried to do as much as possible after the hurricane passed. I even wore all of my own clothes in this picture, and I think I may have even done my own hair for the location shots in Washington.

Q: What do you recall about Hugh Marlowe, your leading man in the film?

TAYLOR: Hugh was very involved with the unions and I got quite an education from him on this subject. We got along wonderfully, but once in a while he would get stern with me when I would agree that I'd go another five or so minutes on a scene. Hugh would step in and say, "Oh, no you won't!" This led up to me learning about what you do and don't do regarding the unions. Hugh had a theatrical background and was such a professional. We both took our jobs quite seriously. This was a great experience for me in learning my trade because there was little time to do these pictures.

Q: In addition to Ray Harryhausen's brilliant flying saucer effects, the ray-shooting robots are memorable images.

TAYLOR: Those robots look sort of corny when you see them in the film, but in person they were quite ugly. At least we got to see the robots. We never saw any prop flying saucers, as they were only small, miniature models that Harryhausen animated and added in after all our scenes were done.

Q: The special effects for *Earth vs. the Flying Saucers* and *20 Million Miles to Earth* [1957] were done by Ray Harryhausen. Did you ever get to meet him?

TAYLOR: Yes. Ray Harryhausen would visit the set during filming. But at the time I didn't know how great his talent was because I didn't witness the creation of his technical effects. My scenes were done as though I were reacting to the saucers or the monster, which, of course, I was not. Those effects were created later by Ray. I still have a great respect for him and his work.

Q: Some of the scenes for *20 Million Miles to Earth* were shot in Italy. Did you go on location for this?

TAYLOR: No. All my scenes were done here in Los Angeles. I wanted so much to go to Italy for the location shoot but they sent my clothes instead. [*laughs*] They sent my clothes for the woman who was doubling me in the long shots at the end of the picture. I was very disappointed.

Q: Any recollections of William Hopper on *20 Million Miles to Earth* [1957]?

TAYLOR: Bill was Hedda Hopper's son, and he was a lot of fun but our relationship was totally professional. We discussed the film, and chatted about things in general while we had coffee during our breaks. We rarely got involved in other matters.

Though she says, "There was no fooling around" during the short shooting schedule, Joan Taylor found some time for laughs behind the scenes during filming of Ray Harryhausen's science fiction classic, *Earth vs. the Flying Saucers.*

William Hopper and Joan Taylor cower in fright at the sight of Harryhausen's agile "Ymir" in
20 Million Miles to Earth.

Q: You then landed a regular role on the television series *The Rifleman* with Chuck Connors. When did you join the series?

TAYLOR: That was in 1960. The way I was hired for that show was unique, to say the least. I told the producer, Jules Levy, that I wouldn't sign a contract, I wouldn't ride a horse, and I wouldn't go out of town for location filming. This way, if I wasn't any good, they could get rid of me. But they hired me anyway, and I wound up saying, "They went that-a-way" for two and a half years! [*laughs*] I played Milly Scott, owner of the general store in North Fork, so I was generally used

only on that one set. Originally, I was supposed to be a romantic interest for Lucas McCain, the rifleman. Later on, he became more involved with another woman at the hotel who was a bit of a con artist. But *The Rifleman* was perfect for me at that time in my life. My husband was working more, and my children were growing. I was able to work and still be home with my family. That was my phasing down period.

Q: When did you retire?

TAYLOR: The last acting job I did was for television in December of 1963. I don't remember the show, but Jeff Hayden was directing. After that,

I decided I really didn't need to continue working—my husband was doing quite well—and I quit. I'm glad I was able to meet so many interesting people and travel and see the world. I do admit that for the first year or so after I quit, I missed the attention and the fact that I was no longer meeting fascinating people. These were my withdrawals. [*laughs*]

Q: How do you feel about your career today?

TAYLOR: I've often asked myself if I did it for myself or for my parents. They wanted me to pursue it. Overall, I have no regrets. I achieved my dream and was able to move forward with my life. So you could say that the screen personality Joan Taylor "died" in 1963.

Q: Yet, thanks to video and cable television, people are still watching and enjoying your work.

TAYLOR: As far as *Earth vs. the Flying Saucers* and *20 Million Miles to Earth* being the films that I will be most remembered for, well, that's fine. I'm amazed and flattered that I'm still alive somewhere out there as an actress. My gosh, you've managed to resurrect Joan Taylor, because as far as I'm concerned, she passed away years ago! [*laughs*] But it seems Joan Taylor will live on after all.

20

June Wilkinson

Defying Macumba Love

In many ways, lovely June Wilkinson best typified the glamour girl of the late Fifties and early Sixties. She had appeared more frequently in *Playboy* than any other model and her career expanded far beyond these origins in film, television and live theater. It is perhaps on stage where she has had the most lasting success, particularly with the play *Pajama Tops*, which she has played on Broadway and a number of national tours throughout the United States and Canada. Besides theater, June has promoted physical fitness. She is also a sports enthusiast, and she has become known for the accuracy of her sports predictions on *Las Vegas Sports Line*. She is also a producer, developing new programs for television. In this interview, June reflects on the many aspects of her career, including her voodoo thriller *Macumba Love* [1960].

Q: Your career as a pin-up model has been incredible. Do you feel this has overshadowed your accomplishments as an actress?

WILKINSON: Yes. A lot of people assume you don't have any acting talent when you're a pin-up model. The type of jobs I got offered at times only required a good-looking body. Even if I were the most stunning woman on earth, that is only good for about 15 minutes on stage. There is then another hour-and-a-half left to the show, and if you were boring, the audience could get very restless.

June Wilkinson in 1957, one of the world's most popular models.

Q: In your publicity, your measurements varied greatly. Why is that?

WILKINSON: The way reporters covered me, I thought my name was June Wilkinson 44-23-36. I mean they would always put measurements behind my name. I got a little tired of that, especially when I did these little junkets to publicize a film like *Macumba Love* [1960]. I would do about eight interviews a day, and if the reporter was a jerk, I would give him some ridiculous measurements, and if he was a nice guy, I would give him an honest answer. I had a heavier bust when I was in my teens. When I was in my twenties, I went for a thinner look, and then you lose a little in your bosom size too, so it was normally about 40 inches.

Q: Tell us about your early memories of your childhood in England and the Second World War.

WILKINSON: I was born in 1940. My father had a small window cleaning company, and I came from a middle class background. I didn't really sleep in a bed until the war was over. When the sirens went off for an air raid, you would seek shelter under a table, so if the building collapsed, you would be protected. We had this big steel table, and we would sleep under it so we wouldn't be disturbed by the frequent air raids. Until the war was over, I remember sleeping under that big table with my mom and my elder brother. I was too young to realize the danger of the Blitz. My mother tried to make it a game. I do recall one time when we were living on the coast watching a plane come in, and it was

shooting at people down the street. I didn't really understand what was happening, and I was far enough away that I didn't see the blood and devastation that occurred.

Q: How did you get interested in dance?

WILKINSON: I had been taking dancing lessons since I was about six. A producer came looking for a girl to be in pantomime. I wasn't the best dancer in class, nor was I the most beautiful. But I was the most outgoing. If you wanted a kid to perform, you had to find one who wasn't shy. That was the reason I was picked. I wound up working several times for that producer, and that is how I got started in show business professionally when I was 12. My first production was *Cinderella* in 1952.

Q: What do you remember about that part?

WILKINSON: This was an English pantomime, where most of the female parts were actually played by men. Cinderella was played by a girl, and so was Prince Charming. I was very impressed by one of the fellows who played the evil step-sister. He had elegant handwriting, and his name began with a "J" too, so I asked him to teach me how he wrote it. I adopted that "J" as part of my signature, and it still is to this day. I was in a lot of ballet productions, and I enjoyed it most whenever I had a solo. My mother loved the ballet.

Q: Did your mother push you?

WILKINSON: Not at all. It was my ambition to be a ballerina, but I was already getting too tall. In those days, they wanted ballerinas to be short. My mother was always supportive of my career. She even helped make some of my costumes with her sewing. She especially loved the stage work. She was a little put off by some of the magazine poses, but she really was proud of my work in the theater. She had been the only daughter with six brothers, and she was always over-protected by them. Her attitude was that her daughter could do anything. She thought that if the boys could do it, then I could do it. My father got a kick out of everything I did in my career, even the magazines.

Q: Do you wish you had continued in ballet?

WILKINSON: Then, yes; now, no. It is a very hard life, and it is much more difficult to make a name. You could easily name hundreds of film actors, stage actors, and even models. But you would have a hard time naming 20 ballet dancers.

Q: You joined the Windmill Theater at a young age. Could you describe the importance of this theater in England?

WILKINSON: The Windmill Theater was a real British tradition. Even though there was nudity involved, the Windmill was mainstream, and a landmark. It was the one theater that did not close during the war. Their motto was, "We never close," and there was even a Hollywood film about the theater called *Tonight and Every Night* [1945] with Rita Hayworth. It was famous for its comedians like Peter Sellers and Harry Seecomb. When I was 15, I got booked at the Windmill as the lead dancer.

Q: Did you consider using a stage name?

WILKINSON: No, I always used my real name, but sometimes I think I was the only one. At every performance the Windmill would put on a Can-Can and a Fan dance. I always did them, because I was good at the Can-Can. I could do the flying split. I also did the Fan dance because I could handle the large fans. They were not that easy to handle. They could easily collapse on you. In England, they had a law that it was illegal to move on stage if you were naked. You had to be stationary. So you had to know how to work the fans because you were naked. A body suit was never used. The Windmill treated all their performers very well. It was a nice environment, and the operators and owners looked after us like we were their sons and daughters. They put on a new show every six weeks, and my mother and grandmother would always come. My grandmother was a bit of a prude, but she loved the Windmill. She thought my Fan dance was great.

Q: Did you leave the Windmill to do television?

WILKINSON: Yes, both myself and Ann Donohoe, who later married Tommy Steele, left to do a BBC program called *Pleasure Boat*, but it was not very successful.

Q: How did you get started as a model?

WILKINSON: Well, the pictures mostly came from my stage shows in England. The poses often came from my shows at the Windmill Theater. Sometimes, after shooting on the Windmill stage, they would take us out to the beach for some additional shots, but this was all associated with the Windmill. Mark Harrison became a good friend of mine, and he took the best pin-up photographs in England. Being a big-time photographer, he managed to get my pictures in a lot of magazines and newspapers. Sometimes he would take photos of me frolicking on the beach with my younger brother who was about ten. Because my brother was along, the newspapers might run pictures of me in a bikini that they might not have run other-wise. My brother made it less risqué. Mark Harrison also published photographs under the name Harrison Marks.

Q: Did it embarrass you to be looked on as "a sex object"?

WILKINSON: It didn't bother me. I thought I was ugly as a kid, so I was happy when I developed a body. I didn't like it when someone only looked at me that way, but I thought there was nothing wrong with it.

Q: When did you first come to America?

WILKINSON: It was in 1957. I was brought over by American Beacons, a kitchen plastics company. I was to do a merchandise convention in Chicago,

and they paid for my mother to come along as well. When I got to New York, I got a spot on *The Today Show* with Dave Garroway. I also got a deal with Oleg Cassini. I got four outfits in exchange for going to some functions with him in the outfits. After I did *The Today Show*, I went to a function with Cassini, and there I met Ray Stark and Elliot Hyman. They offered me a long term contract with Seven Arts. It wasn't a large contract, but it had a good weekly stipend and extra perks like acting lessons, so it was all right.

Q: How did you meet Hugh Hefner?

WILKINSON: Well, I was very cocky. When I was doing the convention in Chicago, somebody showed me a copy of *Playboy* and I boasted my body was better than the girls in the magazine. So that night I called *Playboy,* and I never expected Hugh Hefner to pick up the phone. It turned out he was in the office all by himself. He was a night owl. Hugh had seen me on *The Today Show* I guess, because he knew who I was. He asked me to come down right then for a photo session. My mother and I were going to leave the next day, so I went right over there with the make-up I had on and my hair in a pony tail. It was totally impromptu. Hugh held those pictures until 1958 because I was under-age, even though he had my mother's per-mission. You know, Heff later coined a phrase for me, calling me "The Bosom" and it really became a nice tribute. Heff and I have remained gen-uine friends until this day.

Q: How did you then become the world's top model?

WILKINSON: Seven Arts was first taken aback somewhat by my *Playboy* layout, but seeing its success, they decided to use me as a model. They would make me the most photographed girl in the world. The Rogers and Cowans agency handled my publicity, and Russ Meyer took a lot of photographs of me. I did a lot of layouts for *Playboy* and others.

Q: How prepared were these layouts?

WILKINSON: They weren't really prepared. We would just grab a whole bunch of stuff and hit the beach or go to some interesting location or house. They would keep shooting, and see what came out. Sometimes the best photographs came this way, and sometimes you wanted to gag when you saw them.

Q: Were you involved in selecting the photos?

WILKINSON: I should have been more involved. I should have demanded the negatives of all that stuff. I should have had approval on what went out and what didn't. This was a mistake on my part. I could have had control, but I never forced the issue. There were some horrible pictures of me that got published. I was very careful, however, not to have anything taken of a pornographic nature. There was never anything out there of that nature. To me, nude photography is an art form, and there is a fine line between something with class and something crude. I tried never to cross that line.

Q: Was there anything about them which makes you uncomfortable today?

WILKINSON: The one thing I see now which I hate in these photographs with American photographers was that they were always trying to get you to put your tongue out. It was very much in vogue, and I did do this a couple of times, and I just find these photos very sleazy. I think it looks dumb. But my real objection were photographs that didn't make me look good.

Q: What was your first film?

WILKINSON: I had a brief scene in *Thunder in the Sun* [1959] when I was under contract to Seven Arts. That was a film with Jeff Chandler and Susan Hayward about a wagon train heading to California with French Basque immigrants. I later did a bit as a favor for Russ Meyer. It wasn't a movie that Seven Arts would approve of, so I just did a cameo, but I couldn't use my face. I'm at a window, and I pull the blind down. So you see me topless for a moment in *The Immoral Mr. Teas*. Russ Meyer was very nice and very professional. I never saw him put moves on anybody, and he was terribly in love with his wife, Eve. He talked about her all the time. Years later, around 1966, Russ called me and invited me to dinner. This was after his wife had died in a plane crash. He was casting *Beyond the Valley of the Dolls*, and he had me in mind for the part, but the studio had a contract player in mind. Since he felt he owed me a part, he took me to dinner,

June Wilkinson and Spike Jones in *The Spike Jones Show*.

because he felt he had owed me the picture. The odd thing was Russ later married the contract player, who was Edy Williams, so that was an interesting story.

Q: How did you come to work with Spike Jones?

WILKINSON: I loved working with him as a singer. It was so much fun, and the band was great. You know he had a wild show, blending wacky humor with music. Spike was rather serious off stage, however, but I have one funny story. Spike would always dress me in really low cut dresses. Well, I saw this clingy black dress I fell in love with. I thought I looked sensational in it, but it had a high neck. So I bought it, and I decided to wear it that night. So I was waiting in the wings, and Spike comes by and says, "Get that dress off ... you don't sing that good!" [*laughs*] You know, Spike was an insomniac. I, on the other hand, am a morning person, and I would always head to bed as soon as I could. Spike would always call, and get me up when he couldn't sleep because he wanted some company. That was annoying, but he just wanted somebody to talk with. Spike's gang was a great bunch. I loved Bill Barty, a very sweet, nice man. He used to love to go out with tall show girls, and I would come into his room, and Billy would be sitting in their laps. I always thought he would marry a showgirl, but he ended up marrying a small girl like himself, and they were very happy.

Q: You also worked with Albert Zugsmith in *The Private Lives of Adam and Eve* [1959]. What do you recall about working with Albert?

WILKINSON: I didn't have any problems. Albert had a reputation as a ladies' man, but I was very patient, and I knew how to handle the situation. Things never developed to the level where there was a problem. In my entire career, the only time where something developed was with Otto Preminger. Looking back, I could have handled it so easily, but I was tired. He had asked me if I was as sexy off screen as I was on screen. I said no, that I was only a great actress. He had gotten the wrong idea, and tried to pressure me. To tell you the truth, that was the only time that happened.

Q: Any memories of the rest of the cast? Mickey Rooney? Mamie Van Doren?

WILKINSON: Things were just fine between Mickey and myself. I got along well with Mamie Van Doren. There was never any upstaging or anything like that. There were later some stories that we were competing for attention, but I don't recall that, and I think that was just something invented. Things were a little bit strained, however, with Ziva Rodann. This was on her part, and she didn't want to be friendly. It was the same with her on *Macumba Love* [1960]. I mean we never got into a fight. I know the producers had a problem with her when we were in Brazil, but I kept out of it.

Q: How did you get involved with *Macumba Love* [1960]?

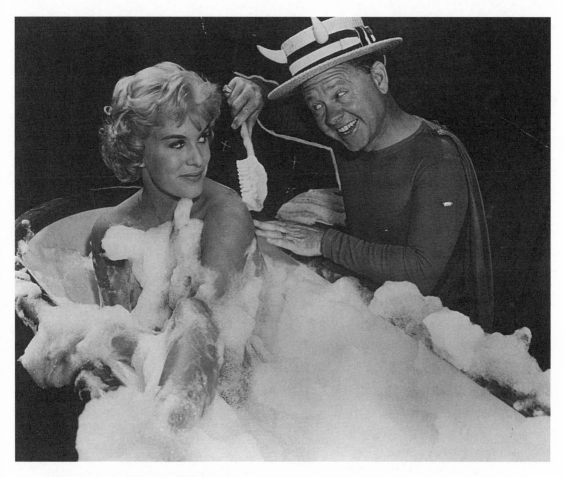

Mickey Rooney bathes a bubbly June Wilkinson in *The Private Lives of Adam and Eve* (1960).

WILKINSON: I was living at the Hollywood Studio Club, and I was going to acting classes several times a week. Bill Wellman Jr. was also in the acting class. He used to pick me up for classes because he knew I didn't drive at the time. One time he was with Doug Fowley, and he thought Bill and I looked good together, so he asked, "How would you two like to do a movie in Brazil?" That's how it came about. So we went to Brazil. The original title of the film was *Naked Love*.

Q: How long a shoot was this?

WILKINSON: We were there for about three months. I had a great time there. One of the biggest obstacles for a lady was the humidity in Brazil. It always made your hair go flat, and it also took its toll on you. But I loved the people. They were very friendly. We shot near the jungle, and, of course, snakes were used in the picture. At one point we went to an island resort for shooting, and that was simply breathtaking. You must remember, I was less than a year out of England, and here I was co-starring in a movie in Brazil. The exotic location

fit the voodoo plot just right. There was plenty of authentic dancing in the film.

Q: You show great charm in the film. How did you feel about the additional European footage?

WILKINSON: I had already done nude shots, and I was from Europe, so it wasn't a big deal. Doug Fowley, the director, was more uncomfortable with it than I was. The footage was very brief. Seeing this cut just recently, I must admit that this footage wasn't very natural. It seemed staged. I mean, Bill and I were married in the film. It seemed pointless to make it an accident and have the water take my top off. It should have been a joke between husband and wife.

Q: How did you enjoy working with Walter Reed?

WILKINSON: He was a real sweetheart. He later came to my wedding when I married Dan Pastorini.

Q: How would you sum up your experience in Brazil?

WILKINSON: I simply had a great time. If I had done the picture later, I probably would have been more interested in the technique of making it. I'm just a presence in the film. I was still new to acting. The picture had the stamp of the Fifties on it. You can just accept the film for what it is: a fun little "B" movie.

Q: What film did you do after Macumba Love [1960]?

WILKINSON: I did Career Girl

[1960], which took about a week to shoot. Brian Donlevy was down in Brazil making a film, and I would talk with him, and that's when I got approached to do Career Girl, about a starlet coming to Hollywood. It was a short, silly movie. There wasn't much to it, but I would love to track down a copy. There was one scene in it where I dive off the diving board nude. That scene struck a cord with a number of adolescents who grew up during that era, because it was the first nudity they ever saw. It was all very innocent. I only did innocent nudity. But I've had so many requests from people who remember that scene, and want to see it again. I would love to get a copy of Career Girl on video. I was appearing on Broadway while Career Girl was being shown at a theater on 42nd Street, and it was there for over 40 weeks. All my co-workers in Pajama Tops would tease me about the film. It was not a very good picture, but it could be amusing.

Q: You also worked in a few scenes for a film with Francis Ford Coppola and Jack Hill. What was this?

WILKINSON: They were paid to flesh out this German film called The Bellboy and the Playgirls [1961]. I'm sorry to say that I have no memory of Hill or Coppola. My scenes were shot in 3-D for the picture. I saw it in the theaters, and I thought it was awful. It was only when it was released on video that I realized that the director was Francis Ford Coppola. I wish we could have done a real movie. Anyway, Hugh Hefner came up to me after he saw it on video. He enjoyed it very much and thought it had an innocence about it.

Q: *Twist All Night* [1961] was one of those fun teenage pictures that was shot in a hurry to capitalize on the dance craze. What do you recall about this film?

WILKINSON: I was giving the trophy away at one of the big stockcar raceways in Charlotte, North Carolina. Maurice Duke called me to come quickly to New York to see this new dance phenomenon. So he took me to the Peppermint Lounge to see Joey Dee and the Starlights. Well, Maurice called Louis Prima and his boys and they got the money together to do the film. We started shooting about a week later. I had a great time because Louis Prima was wonderful. Louis had just gotten his divorce. So when we were doing love scenes together, he started looking at me cross-eyed. Then I introduced him to my girlfriend, and they began dating. Louis was always a gentleman. I loved working with him, and with Sam Gutera and the Witnesses. He didn't like it if any blue stories were told in my presence. So they had to curb their joke telling when he was around. He had given me a nice watch which later was stolen. Engraved on the back of the watch was "To June, a fine lady." I was very sad when he passed away in New Orleans after being in a coma.

Q: Did you find your film roles limiting?

WILKINSON: Absolutely. I never got a chance to do my best work on film. The only film where I got a chance to do real acting was *The Rage Within* [1963] or *La Rabia Por Dentro* in Spanish. It was made in Mexico. I'm not fluent in Spanish, and I learned my part phonetically, but I learned to handle the part pretty fast. It had a good director and a good story. It is the film of which I am most proud. I have a funny story. The leading man took me out on a date the night before our big love scene and tried to kiss me. He had pictures of me all over his house. You know the Spanish temperament. He got angry and said, "Your pictures are sexier than you are!" The next morning the director picks me up at the hotel and says, "Are you ready for your big love scene? How was your date?" So I said, "I think we're in trouble." [*laughs*] But the scene went OK.

Q: You have had great success doing theater. What play was your favorite?

WILKINSON: On the stage, I was most proud of *Wally's Café* with Avery Schreiber, Rita Moreno, Sally Struthers and James Cocco. It wasn't successful on Broadway, but we later toured with it for several years. Avery was a huge talent, and he was very creative. Even on the last day of *Wally's Café*, he came into my dressing room with some new ideas to improve the show. I also did *Murder at the Howard Johnson's* with him, and that was not an easy show to do. The characters as written were not very pleasant. Avery never stopped trying to make that show better.

Q: Was *Pajama Tops* your biggest stage success?

WILKINSON: Yes, I was a big hit on Broadway with it. It was a sexy farce and a fun show to do. At one point when I was doing *Pajama Tops*, I was the highest paid stage actress in the United States, because I was working on a percentage and the show grossed some very high numbers each week. I left the show to do a film, and they brought in Greta Thyssen (from *Terror Is a Man*), and business really fell. As soon as I finished the film, they rushed me back in, so that was very gratifying.

Q: Was there ever a chance that you could have done this on film?

WILKINSON: They were going to do it on television, and I was signed. But then there was an actor's strike, and their rights to do it on television expired. When the producer tried to negotiate to get the option again, the writers decided to go with Pia Zadora. They told the producer that I was too old for the part, saying I was 50. But I was really only 37! So they went with Zadora, and it flopped. It was horrible. I felt it was so mean of them to drop me and lie about my age, that I refused to do *Pajama Tops* again on stage for many years. I didn't want to put money in the writer's pockets. But a few years ago, I was offered a chance to do it again. It was a big hit all over, and I spent almost a year doing it in revival.

Q: Could you give us your recollections of some of the big stars you worked with on the stage?

WILKINSON: I worked with Milton Berle in *Norman, Is That You?* We had a real good time doing that show. I did *Fanny* on Broadway with Walter Slezak, and I loved working with him. He was delightful. He wanted to learn to scuba dive, and he asked me to come to the lessons with him. He never wanted to go in the ocean, and only practiced in the pool. I later teased him that he only wanted a view of the ladies in the pool. Walter was sure a lot of fun.

I worked with Vivian Blane and Louis Jourdan on *Marriage-Go-Round*. Louis was intimidating because he was letter perfect the first day, and never altered his performance to react with anyone else. He did his lines the same way no matter what any of the other performers did, so he didn't make it easy for Vivian or myself. Louis didn't make too many friends during the run of that show.

I appeared with Tom Poston and Elaine Stritch in *Any Wednesday* and I loved and adored working with them. Tom has such a great sense of humor. Elaine and I would play a game involving dinner. If she felt I had a great night on stage, she would buy me dinner. If I felt she had a great night, I would buy her dinner. So we had fun doing that.

I got along with Sylvia Sydney in *Come Blow Your Horn*, but she could be difficult. I was the star of the show, but Sylvia always came early and grabbed the star's dressing room. I didn't mind, and it never bothered me. She defended me because she thought I was never given credit for my acting. She thought I was a good actress.

Q: Do you have any recollections of working with Michael Jackson?

WILKINSON: There have been so many stories lately about Michael, but when I worked with him, he was a completely normal kid. He was about 13 when we performed together. I caught him giving my shape the "once over" and that was completely normal. I thought he was very nice and a typical kid.

Q: What can you tell us about Elvis Presley?

WILKINSON: When I first toured Hollywood, Patti Page and her husband Charlie O'Curran, the choreographer on *King Creole* [1958] were looking after me. I met Elvis on the set of *King Creole*. He invited me to dinner at the Beverly Wilshire Hotel. He had an entourage who spoke with Southern accents. The only one I remember was Nick Adams, the actor. Then Elvis gave me a tour of his suite, sat me on the bed in his bedroom and sang to me for two hours. That was it. The next day he called me again, but I was leaving at midnight. So he said, "bring your bags along," and we had dinner again. He was very sweet, and he was friendly. He had more than sex on his mind. He got me to the airport on time, and our paths never crossed again.

Q: Getting back to your films, how did you get involved with *Too Late Blues* [1962]?

WILKINSON: Well, I had known John Cassavetes and Seymour Cassel, and they always felt that my talent was overlooked, that filmmakers just exploited my body. So John wanted to find something for me in his film *Too Late Blues*. He actually wanted me for the leading part, which was cast with Stella Stevens, who was under contract. John kept bringing me back as a "daily" player. I made a small fortune, but I was only used in the final scene of the film. I had a good time hanging around with him, however, and watching the film take shape.

Q: Your next project was *The Candidate* [1964] with Ted Knight and Mamie Van Doren. How did you feel about this project?

WILKINSON: That picture had a number of alternate titles as well, such as *Playgirls and the Candidate* and *Party Girls and the Candidate* to distinguish it from the Robert Redford picture. I liked working with Mamie. She doesn't take herself too seriously. I'm always happy to see her. Ted Knight was "the candidate," and in the film he was running for the senate. We also did a European version, and we had a scene in bed together. Ted had never done a nude scene before, and he was extremely nervous. As the day approached, he kept saying how nervous that scene was making him. He was afraid he would do something embarrassing, but I told him not to worry. So the time came to do this scene, and we were finally both naked and in bed together, he said, "June, I'm so relieved. You were right. With all the cameras around, this is just business, and not sexy in the least." He found with so many people giving directions, there wasn't any thought of

anything else. I liked Ted very much. I think his wife even showed up on that day, and that put him at ease too.

Q: Let's switch to television. What appearances do you remember?

WILKINSON: I did a skit with Ed Wynn and Carol Burnett. I think that was on the *Gary Moore Show* [1958–67] in the very early Sixties. I was on *77 Sunset Strip* [1958–64] and *Alcoa Theater* [1957–60] and many talk shows. I once had my own special on Canadian television. I was also a villainess on *Batman*. On the set of that show I was in the chair being worked on by the make-up man. He put a base on, and had just slipped a lot of powder on my face. Then Adam West and Burt Ward, Batman and Robin, came into the room and sat down. Adam said, "Wow! I hear we got June Wilkinson coming in today!" They started talking about my physical attributes, and they had no idea I was the one being made up. Finally, the make-up man and I started giggling and gave ourselves away. That was funny. Anyway, Adam and Burt were fine to work with.

Q: What was the story of your appearance in *Hollywood Blue* [1970]?

WILKINSON: I was more or less tricked into it. I had an offer to do an interview in a bikini for a thousand dollars. So I figured, "Why not?" The interview was just a basic interview. The next thing I knew, that interview was spliced into this film called *Hollywood Blue* with a compilation of blue scenes. They made it appear I was talking about these scenes. I was totally aghast. They did the same thing to Mickey Rooney, and he was so disgusted by it that he actually left Hollywood for quite some time.

Q: You played a pilot in the film *Weed* [1974] also known as *The Florida Connection*. Some critics remarked that you really looked great in that film. Any comments?

WILKINSON: Yes, I think I definitely looked good in that movie. I guess I was a late bloomer. I mean, I was in *Playboy* not for my face, but for my body. My body was the type that was very popular for men's magazines. I also weighed a little more in the early Sixties. I was about 150 when I did *Macumba Love*. By the Seventies, I weighed less, and my face became prettier. I liked my look in this period much better. I don't think *Weed* is the best movie, but I liked how I appeared in it.

Q: You married football star Dan Pastorini in 1972, and he also was in *Weed*. How did this come about?

WILKINSON: Dan didn't like me to be called June Wilkinson. He thought I should be known as June Pastorini. We had an agreement. I wouldn't work during the football season, and off-season he would travel with me when I did work. He hated to be thought of as "Mr." June Wilkinson. Now I first met Dan when I was doing *Pajama Tops* and he loved it. But after we were married, he became jealous of my career. When I did *Ninety Day Mistress* on stage in Las Vegas, I could feel his bad vibes out in the audience. So

when I did the film *Weed*, the producer put Dan in it, and he seemed to enjoy it.

Q: *Talking Walls* [1983] aka *Motel Vacancy* was a rather creepy anthology film. What do you recall about it?

WILKINSON: I don't remember much about the film. It was a cheap film, but very creative due to the director Stephen Verona who also wrote the screenplay. Stephen was always struggling to keep the production together, and I thought he had a lot of talent. He also did *Boardwalk* [1979] and *The Lords of Flatbush* [1974].

Q: You shot *Frankenstein's Great-Aunt Tillie* [1983] in Mexico. This satire featured Donald Pleasence, Zsa Zsa Gabor, Aldo Ray and Yvonne Furneaux. What do you recall about the cast?

WILKINSON: I loved Donald Pleasence, who played Dr. Frankenstein. He was a great actor and gentleman. He was very supportive of the other actors. He had a good acting technique, where he worked some things out in advance. I didn't have any scenes with Zsa Zsa, but Donald didn't like her. He seldom said anything negative, but he was negative about her. The producers weren't too happy with her either. In fact, she left with a negligee from the film. She told Donald she had a hundred negligees at home so he quipped, "Now she has a hundred and one!" The director, Myron Gold, had a problem with Yvonne Furneaux, who played Aunt

Tillie. The last scene of the picture was to be shot in the rain, so we could only do it once. Myron wanted me to play the scene one way, and Yvonne insisted that we do it her way. We rehearsed it and rehearsed it. When it was shot, Yvonne manipulated it so that I had to play it her way. Myron was furious. I think he edited the scene as best he could, but he wasn't happy with it.

Q: Did Aldo Ray have a drinking problem during this film?

WILKINSON: No, he had stopped. He was a sweet man, but very insecure. I think this was the last picture he did. He was supposed to stay in Mexico because he had a part in *Dune* [1984]. I was told he started drinking again, however, and they let him go.

Q: You had smaller parts in three more films, *Sno-Line* [1984], *Vasectomy* [1985] and *Keaton's Cop* [1989]. Any recollections about these projects?

WILKINSON: Well, during the first two I was very busy with projects, and they did my scenes near the start of the filming so I could get to my other commitments. The best thing about *Sno-Line* was I made friends with Paul Smith and his wife, and we still see each other all the time. I got along well with Paul Sorvino who was in *Vasectomy*. I enjoyed *Keaton's Cop* because it was shot in Texas, and I have a lot of friends down there from the days when I was married to Dan Pastorini. Lee Majors was in *Keaton's Cop* and our relationship was strained due to an odd situation. Lee had been married to Farrah Fawcett, and I had

been married to Dan Pastorini. We both knew that Dan and Farrah had an affair, so what could we say to each other? Lee was pleasant enough given these circumstances.

Q: It used to be that models and actresses were washed up in their thirties. Now, many women have glamorous careers well into their fifties. What are your feelings about this?

WILKINSON: Ladies in their forties today don't look like ladies in their fifties looked years ago. The other night on an old *Perry Mason* they had this dowdy, gray-haired woman in the witness box, and she gave her age as 35! It was ridiculous. Well, the image has changed. Sure there are improvements in make-up and even plastic surgery, but the big difference is attitude. Today, an older woman can look fabulous. Vitality is one of the elements of beauty, and you can have that at any age.

Q: What are your current projects?

WILKINSON: I'm developing a television concept called *Absolutely Glamorous* and it is still a work in progress. It is basically my idea, and this is the first time I have ever tried to sell a project. Every show will have a glamour girl over fifty. The pilot features Julie Newmar. The cast is good, plus there will be appearances by Phyllis Diller, James Woods, Jeff Goldblum, Jacqueline Bisset, Peter Graves and Ed Begley Jr. A large number of stars have given commitments to doing guest shots on the series. Milton Berle wants to do one if it gets picked up. So I am excited about this project. I've also been in *Playboy* again in December 1997, and I think that was just wonderful.

Q: Any final thoughts?

WILKINSON: I have been lucky in my career. I was just an ordinary girl from Eastbourne, England, and I have been able to do so much in America without any real connections. But in some areas, I've yet to do my best work and I haven't given up yet.

INDEX

Abbott, Bud 71, 87, 89, 108, 134, 136
Abbott, John 146
Abbott and Costello Go to Mars (1953 film) 71
Abbott and Costello Meet Frankenstein (1948 film) 87, 89
Abbott and Costello Meet the Killer, Boris Karloff (1949 film) 134, 136
The Abbott and Costello Show (TV show) 108
Absolutely Glamorous (TV show) 238
Acquanetta 6
An Actor Prepares (book) 13
The Actress (1953 film) 205
Adams, Casey 108
Adams, Nick 235
Adam's Rib (1949 film) 198, 200
Adamson, Al 210, 212
The Adventures of Casanova (1948 film) 179
Agar, John 21, 31, 32, 143–151, **144, 149, 151,** 189, 191, 192, 194, **195,** 196, 208, **211**
Aguilar, Luis 124
Akins, Claude 30
Aladdin and His Lamp (1952 film) 180
Alcoa Theater (TV show) 236
Alda, Robert 25, 42
Alexander the Great (1956 film) 10
Alfred Hitchcock Hour (TV show) 156
Alfred Hitchcock Presents (TV show) 144, 156, 172

Ali Baba and the Forty Thieves (1944 film) 8
Alland, William 189, 192
Alleman, Miguel 38
Allyson, June 54
Along Came Jones (1945 film) 62
Althouse, Charles 109
Amateau, Rod 28, 33
An American Guerrilla in the Philippines (1950 film) 40
American Heritage (TV show) 140
Ames, Leon 202
Ames, Ramsay 3–11, **4, 7, 8**
L'Amore Breve (1969 film) 59, 75, 76
Anderson, Howard 182
Anka, Paul 30
Ankrum, Morris 150
Annie Get Your Gun (1950 film) 202
Annie Oakley (TV show) 140
Antony, Marc 24
Any Wednesday (play) 234
Apache Rose (1947 film) 134, 135
Apache Woman (1955 film) 213, 214, 217
Apenas un Delincuente (1947 film) 59, 63
Arau, Alfonso 125
Armstrong, Del 217
Arness, James **50**
Arnold, Jack 53
Arnow, Max 199
Around the World in Eighty Days (1956 film) 140
Arsenic and Old Lace (play) 84
Asesino S.A. (1956 film) 129

Asher, Bill 29
Assigned to Danger (1948 film) 180, 183
Astaire, Fred 192, 213
Athena (1954 film) 40, 41
The Atomic Man (1955 film) 57, 72
Autry, Gene 139, 140
Avalon, Frankie 30
Aventura al Centro de la Tierra (1964 film) 123, 126, **127,** 129

Babe (1995 film) 55
Back Street (1961 film) 156
Bad Influence (1990 film) 156
Baker, Carroll 172
Baledòn, Raphael 126
Ball, Lucille 23, 33, 177
The Bandits of Corsica (1953 film) 205
Bankhead, Tallulah 162, 163
Barcroft, Roy 9, 10
Bard, Ben 24
Bari, Lynn 81
Barker, Lex 217
Barnes, Binnie 41
Barrett, Claudia 13–19, **16, 17**
Barrows, George 13, **17,** 18, 19
Barry, Gene 134
Barrymore, Ethel 162
Barrymore, Lionel 162
Barty, Billy 230
Basehart, Richard 168
Bat Masterson (TV show) 134, 199, 207
Batman (TV show) 28, 236
Battle Cry (1955 film) 207

239

Battle Zone (1952 film) 40
Baxter, Frank 189
Beachhead (1954 film) 159, 168
Beal, John 63
The Beast from 20,000 Fathoms (1953 film) 197, **198**, 205, **206**
Beatty, Warren 28
Beaumont, Hugh 189, 191, 194
The Beauty and the Bandit (1946 film) 9
The Beauty Contest (1964 film) 44
Beery, Wallace 120
Begley, Ed, Jr. 238
Bel Geddes, Barbara 163
The Bellboy and the Playgirl (1961 film) 232
Below the Deadline (1946 film) 9
Benedek, Laslo 164, 165
Bennett, Joan 120, 136
Benny, Jack 113
The Benny Goodman Story (1955 film) 192
Bergen, Polly 43
Bergman, Ingmar 147
Bergman, Ingrid 93, 145, 162
Berkeley, Busby 217, 218
Berkey, Amelia 213
Berle, Milton 234, 238
Bennett, Joan 31
Beutel, Gloria 208
Bey, Turhan 176, 179
Beyond Glory (1948 film) 95
Biano, Solly 60, 176
The Big Clock (1948 film) 64, 95, 101
The Big Fix (1947 film) 176
Bishop, William 140
Bissett, Jacqueline 238
The Black Cat (1934 film) 93
Black Tuesday (1955 film) 59
Blair, Linda 172
Blake, Amanda 201, 208
Blane, Vivian 234
Blanchard, Mari 71, 72
Blaze of Noon (1947 film) 95
Blondie's Secret (1948 film) 198
Blood of Dracula's Castle (1967 film) 198, 210, 212
Blowing Wild (1953) 63
The Blue Dahlia (1946 film) 179
Blyth, Ann 217, 218
Boardwalk (1979 film) 237
Bogart, Humphrey 15, 170
Bolger, Ray 192
Bonanza (TV show) 73, 134, 135
Bond, Raymond **99**
Born Innocent (1974 film) 172, 173
The Bottom of the Bottle (1956 film) 52
Bouchet, Barbara 76
Boyer, Charles 40, 180
Bradbury, Ray 197, 207

Brahm, John 166
The Brain from Planet Arous (1957) 143, **144**, 146, 147, 148, **149**, 153, 157
Brando, Marlon 159, 164, **165**
Brent, Evelyn 136
Brian, David 15
The Bride of Frankenstein (1935 film) 116
Bridges, Lloyd 155, 217
Broadway Rhythm (1943 film) 176
Bronson, Charles 15
Brooks, Richard 52
Brown, Gilmore 215
Brown, Joe E. 180
Bruce, Nigel 62
Brynner, Yul 112
The Buccaneer (1958 film) 111
Burnett, Carol 236
Burr, Raymond 24, 156
Burson, Polly 9
Burton, Richard 10, 43, 187
Bustamante, Adolfo 129
Butler, David 202
By Love Fulfilled (book) 186
Byington, Spring 200
Byron, George Gordon, Lord 22
Byron, Jean 21–34, **22**, **26**, **27**

Cagney, James 170
Calhern, Louis 180, 200
California (1964 film) 59
Calling Dr. Death (1943 film) 6, 8
Cameron, Rod 74, 160, 168
Campbell, Jim 201
El Campeòn Ciclista (1956 film) 129
Can Do (TV show) 25, 26
The Candidate (1964 film) 235
Cantinflas 131
Captain from Castile (1947 film) 37
Captive Women (1953 film) 96, 99, 100
Capulina 125
Career Girl (1960 film) 232
Carlson, Richard 21, 24, **27**
Carmen (short story) 61
Carson, Johnny 23, 45
Carradine, John 6, 11, 31, 76, 210, 212
Carre, Mateo 75
Carrie (1952 film) 159, 162
Cartwright, Veronica 112
Casino Royale (TV show) 35, 44, 45
Casino Royale (1967 film) 76
Cassavetes, John 235
Cassel, Seymour 235
Cassini, Oleg 227
El Castillo de los Monstrous (1957 film) 85, 87, **88**, 90, 91

Castle, William 25, 40, 154, 207
Chain Lightning (1950 film) 15
Chain of Circumstance (1951 film) 95
Challenge of the Range (1949 film) 200
Chamberlain, Richard 54
Chandler, Jeff 67, 196, 228
Chaney, Lon 3, 4, 6, 8, 119
Chaney, Lon, Sr. 119
Chaplin, Charlie 53, 121
Chapman, Ben 196
Charisse, Cyd 177
The Charlie Farrell Show (TV show) 186
Chekov, Anton 101
Chester, Hal E. 205
The Cherry Orchard (play) 101
Cheyenne (TV show) 28, 134, 207
Chicago Deadline (1949 film) 95
The Children's Hour (1961 film) 107, 112
Christian, Linda 35–45, **36**, 179
Christian, Paul **198**, 207
Christians, Mady 120
Christine, Virginia 5
The Christine Jorgensen Story (1970 film) 155
Citizen Kane (1941 film) 23, 199
City of Chance (1940 film) 81
Clarke, Robert 96, 97, **99**, 100
Clary, Charlotte 161
Clavillazo, Antonio Espino 85, 87, **88**, **89**, 131
Cleopatra 21, 24, 184
Cleopatra (1963 film) 184
Climax (TV show) 44
Clive, Colin 119
The Cobweb (1955 film) 51, 53
Cocco, James 233
Cohn, Harry 5, 39
Colicos, John 217
Collins, Joan 75
Colomba (short story) 61, 62
Columbo (TV show) 28
Come Blow Your Horn (play) 234
Connor, Alan 146
Connors, Chuck 221
Conrad, William 30
Conreid, Hans 108
Conte, Richard 40, 102
Coogan, Jackie 53, 121
Cooper, Dorothy 201
Cooper, Gary 63
Cooper, Ted 183
Coppola, Francis Ford 232
Cordero, Joaquin 124, 125
Corey, Jeff 145
Corky of Gasoline Alley (1950 film) 105, 107
Corman, Roger 76, 217

Corso, Gene 137
Cossa, Paola 59, 75, 76
Costello, Lou 71, 87, 89, 108, 134, 136
Cowan, Lester 159, 163
Craven, James 133
Crawford, Joan 154
Crawford, Johnny **48**
The Creature from the Black Lagoon (1954 film) 196
Crenna, Richard 49
Crevenna, Alfredo 128
Crime and Punishment, U.S.A. (1959 film) 160, 171
Crisis (1950 film) 198, 201, 202, **203**
Crosby, Bing 95, 96
Los Cuervos Estan de Luto (1965 film) 129
Cugat, Xavier 37
Cukor, Elsie 199, 204, 205
Cukor, George 200, 204, 205
Cult of the Cobra (1955 film) 70, 71, **72**
Cummings, Irving 81
Curtis, Donald 71
Curtis, Tony 169, 196
Curtiz, Michael 77, 107

Daddy Long Legs (1931 film) 119
Daddy Long Legs (1955 film) 192
Dalton, Audrey 108, 109
Damone, Vic 40
Danger Island (1939 film) 81
Dante Alighieri 191
D'Arcy, Alex 210
Darnell, Linda 81
Darrow, Barbara 108
Davis, Bette 15, 183
Davis, Gail 140
Davis, Jim 155
Davis, Joan 5, 81
Davis, Nancy 201–203
Davis, Sammy, Jr. 30
Day, Doris 107
Day in Court (TV show) 52
Days of Our Lives (TV show) 144, 210
Days of Wine and Roses (TV show) 113
Dean, James 176, 184
Death Valley Days (TV show) 140, 210
Decameron Nights (1953 film) 59
De Cordova, Freddie 23
Dee, Joey 233
De Hombre a Hombre (1949 film) 59
de Hoyos, Kitty *see* Hoyos, Kitty de
DeMille, Cecil B. 33, 101, 108, 111

Denning, Richard 207
Denver, Bob 28
Descher, Sandy x, 47–55, **48, 50**
The Desperate Hours (1955 film) 159, 162, 166, 170
Destination: Moon (1950 film) 133
The Devil Commands (1941 film) 79, **80**, 81, 82, **83**, 84
Devil on Wheels (1947 film) 176
Devil's Doorway (1950 film) 198, 200, 201
The Devil's Hand (1962 film) 35, 41
Devine, Andy 155
Dexter, Maury 153
Dial M for Murder (1954) 170
Dieterle, William 218
Diller, Phyllis 238
Disney, Walt 85, 86
Dixon, Jeane 22
Dmytryk, Edward 83
Dolenz, George 62
Domergue, Faith x, 55–77, **58**, **65, 68, 72**
Domergue, Leo 60
Domingo, Placido 90, 91
Donde Mueren las Palabras (1946 film) 59
Donlevy, Brian 232
Donohoe, Ann 226
Doucette, John 217
Douglas, Gordon 49, 172
Douglas, Richard 202
Dowling, Doris 179
Dr. Kildare (TV show) 54
Dragnet (TV show) 24, 180
Drake, Christian 50
Dressler, Marie 120
DuBarry, Jeanne Bécu, Countess 204
Duchess of Idaho (1950 film) 198, 200, 201
Duel at Silver Creek (1952 film) 57, 66, 73
Duff, Amanda 79–84, **80, 83**
Duke, Maurice 233
Duke, Patty 21, 29, 34
Dune (1984 film) 237
Dunn, Irene 49
Durante, Jimmy 114
Duryea, Dan 63

Earth vs. the Flying Saucers (1956 film) 213, **214**, 218, 219, **220**
East Side, West Side (1949 film) 200
Eberhardt, Norma 171
Eddy, Nelson 217
Educando a Papà (1954 film) 86
The Egyptian (1954 film) 77, 105, 134, 140
Elam, Jack 150, 152, 210

The Electronic Monster (1957 film) 160, 168
Elephant Stampede (1951 film) 134, **138**
Elizondo, Evangelina 85–91, **86**, **89**
Emery, John 166
Emma, Joseph 213
English, Marla 146
Ericson, Leif 154
Escape (1939 film) 81
Escapement see *The Electronic Monster*
Escort West (1959 film) 59
Esposas Infieles (1955 film) 131
Evans, Dale 135

Fabregas, Manolo 124
Falk, Peter 28
Falkenberg, Jinx 6
Fanny (play) 234
A Farewell to Arms (novel) 75
Farrell, Charles 81, 180, 186
Farrow, John 64, 101
Farrow, Mia 101
Faulkner, William 96
Fawcett, Farrah 237, 238
Fellini, Frederico 75
Fernandez, Freddy 124
Ferrer, Jose 202
Ferrer, Mel 62
Field, Margaret 93–103, **98, 99**, **102**
Field, Sally 95, 100, 101–102, 157
Field, Sidney 201
Fighting Man of the Plains (1949 film) 214, 215
Finger of Guilt (1956 film) 168
Fischer, O. W. 44
Flareup (1969 film) 32
Fleming, Rhonda 24
Fleming, Victor 93
Flesh and the Spur (1956 film) 146
The Flight That Disappeared (1961 film) 198, 208, **209**
Florida Connection see *Weed*
Flying Nun (TV show) 100, 101
Flynn, Errol 36, 183
Foghorn (short story) 207
Follow That Dream (1962 film) 112
Fonda, Henry 43, 162
For Men Only (1952 film) 95, 102
Forbidden Planet (1956 film) 133
Ford, Ross 133
Ford, Wallace 30, 32
Fort Yuma (1955 film) 214, 216, 217
Four Girls in Town (1956 film) 192
Four Star Playhouse (TV show) 180

Fowley, Doug 230, 232
Francis, Arlene ix
Franken, Steve 28
Frankenstein (1931 film) 115, **116**, 118, 119, 121
Frankenstein Meets the Wolfman (1943 film) 192
Frankenstein; or the Modern Prometheus (novel) 115, 116
Frankenstein's Great Aunt Tillie (1983 film) 237
Frankovich, Mike 41, 66
Freeman, Y. Frank 218
Fregonese, Hugo 59, 62, 63, 73
Friml, Rudolf 217
From Here to Eternity (1953 film) 39
Frontier Gun (1959 film) 150, **151**
Fuller, Lance 60, 217
Fuller, Robert 143
Furneaux, Yvonne 237

G-Men Never Forget (1948 serial) 9
Gable, Clark 176–178
Gabor, Zsa Zsa 180, 237
Galindo, Alejandro 87
Gallager, Bill 39
The Gamblers (1970 film) 59, 76
Garfield, John 183
Garland, Judy 177, 183
Garner, James 112
Garnett, Tay 166
Garroway, Dave 227
Garson, Greer 177
The Gary Moore Show (TV show) 236
Gateway to Hollywood (radio show) 23
The Gay Caballero (1946 film) 9
Gaynor, Mitzi 107
Getz, Bill 39
Giant (1956 film) 176, 184
Gibson, Mimi 105–114, **106, 111**
Gidget (TV show) 95, 100, 101, 102
A Gift for Heidi (1961 film) 54
Gingold, Hermione 146
Girl Crazy (1943 film) 176, 177
The Girl in Lover's Lane (1959 film) 150, 152, **153**
Girls in Prison (1957 film) 214
Give a Girl a Break (1953 film) 134
The Glass Key (1942 film) 62
The Glass Menagerie (play) 157
Goddard, Paulette 179
Godzilla (1998 film) 197
Gold (1934 film) 24
Gold, Myron 237
Goldblum, Jeff 238
The Golden Girls (TV show) 33
The Golden Hawk (1952 film) 134

Goldstein, Leonard 67, 73
Goldstein, Robert 67
Gone with the Wind (1939 film) 73
Gonzàlez, Rogelio 131
Goodbye to the Clouds (1966 film) 44
Goodman, Fern 161
Gorag, Laszlo 189
Gordon, Robert 71
Gould, Harold 33
Goulding, Edmond 180
Grace Kelly (1983 film) 141
Grady, Billy 205
Grahame, Gloria 162
El Grand Pero Muerto (1978 film) 131
Grant, Cary 23, 105, 110, **111**, 201, 202, **203**
Granville, Bonita 120
Graves, Peter 15, 217, 238
The Great Concert in Munich (1961 film) 41
The Great Jewel Robbery (1950 film) 15
The Great Sioux Uprising (1953 film) 57, 67, 74
The Greatest Show on Earth (1952 film) 33
Green Dolphin Street (1947 film) 9, 37
Green Mansions (1958 film) 42
Greene, Richard 73
Griffith, James 140
The Gun That Won the West (1955 film) 198, 207
Gunga Din (1939 film) 23
Gunsmoke (TV show) 156, 207, 214
Gwenn, Edmund **50**, 51, 54

Haggard, H. Rider 30, 189
Hakum, Robert 178
Hallmark Hall of Fame (TV show) 15
Halsey, Brett 150, 152
Hamilburg, Mitchell 140
Hamilton, George 171
Hamlet (play) 144, 187
Hand of Death (1962 film) 198, 208, **211**
Hansen, John 156
The Happy Time (1952 film) 35, 40
Harlow (1965 film) 160, 172
Harlow, Jean 66
Harmon, David 30
Harrington, Merrill 157
Harris, Marilyn 115–121, **116**
Harrison, Mark 227
Harrison, Rex 41, 162, 202
Harryhausen, Ray 71, 197, 205, 214, 219, 220, 221

Harte, Bret 119
Hartleben, Jerry 112
Hartman, Don 204
Harvey, Laurence 202, 204
Have Gun—Will Travel (TV show) 199
Hawkins, Jack 39
Hayden, Jeff 221
Hayes, Helen 162
Hayward, Louis 33
Hayward, Susan 125, 153, 154, 183, 228
Hayworth, Rita 24, 150, 226
Head, Edith 107
Hefner, Hugh 227, 232
Heidi see *A Gift for Heidi*
Heinlein, Robert A. 135
Heisler, Stuart 62, 168
Hell on Devil's Island (1957 film) 134, 140
Hell's Island (1954 film) 160
Helm, Brigitte 24
Helman, Lillian 112
Helmore, Tom 207
Hemingway, Ernest 75
Henaine, Gaspar see Capulina
Henreid, Paul 102, 171
Henry, Ed 71, 77
Henry, Thomas Browne 143, 148, 149
Hepburn, Audrey 112
Hepburn, Katharine 33, 145, 177, 194
Herbert, Charles 29, 110, **111**
Heroin (1966 film) 131
Herron, Bob 193, 194
Hertz, Nathan see Juran, Nathan
Herzbrun, Walter 96
Heston, Charlton 216
Hickman, Darryl 28
Hickman, Dwayne 28
The Hideous Sun Demon (1959 film) 96
Los Hijas de Zorro (1963 film) 129
Hill, Craig 208, **209**
Hill, Jack 232
Hiller, Arthur 25
The Hills of Utah (1951 film) 139
Hitchcock, Alfred 80, 156, 157, 170
Hodiac, John 40
Hold, Harriet 13
Holiday in Mexico (1946 film) 37
Hollywood Blue (1970 film) 236
Holt, Nat 214, 215
Holt, Tim 108, 180
Hope, Robert 153, 154, 161, 162, 177, 216
Hopkins, Miriam 112
Hopper, Dennis 176
Hopper, Hedda 219

Hopper, William 219, **221**
Horne, Lena 201
Horton, Robert 156
Hotel for Women (1939 film) 81
House of the Seven Corpses (1974 film) 59, 76
House of the Seven Hawks (1959 film) 44
House of Wax (1953 film) 205
Houseboat (1958 film) 105, 110, **111**, 114
How Green Was My Valley (TV show) 52
Howard, Ron 28
Hoy, Bob 193
Hoyos, Kitty de 123–131, **124, 127, 128, 130**
Hudson, Rock 176
Hughes, Howard 38, 57, 59–63, 66
Hughes, Ken 72
Hunter, Jeffrey 210
Hunter, Ross 153
Hunter, Tab 207
Hutton, Robert 21, 31
Hyman, Elliot 227

I Saw What You Did (1965 film) 154
I Was a Shoplifter (1951 film) 136
If He Hollers Let Him Go (1968 film) 107
I'll See You in My Dreams (1951 film) 105, 107
The Immoral Mr. Teas (1959 film) 228
The Inferno (book) 191
Interrupted Melody (1955 film) 51
Invasion of the Body Snatchers (1956 film) 73
The Investigators (TV show) 172
Invisible Invaders (1959 film) 21, 31, 34
Ireland, John 76, 154
It Came from Beneath the Sea (1955 film) 73
It Came from Outer Space (1953 film) 175
It Grows on Trees (1952 film) 49
It's a Deal (1930 film) 81

Jackson, Michael 235
Jacobs, Herb **139**
Jagger, Dean 49
The Jimmy Durante Show (TV show) 114
Los Jinetes de la Bruja (1965 film) 129
Joan of Arc (1948 film) 93
John Loves Mary (play) 215
Johnny Concho (1956 film) 30, 31
Johns, Larry 133

Johnson, Ben 217
Johnson, Van 52, 201
Jones, Gordon 108
Jones, Jennifer 140
Jones, Spike **229**, 230
Jorgensen, Christine 155, 156
Jory, Victor 214, 215
Jourdan, Louis 234
Julia, Raul 90
Jungle Moon Men (1955 film) 30
Junior Bonner (1972 film) 160, 172
Juran, Nathan 150
Jurassic Park (1993 film) 197
Just Around the Corner (1938 film) 81

Karloff, Boris 79, **80**, 82, **83**, 84, 115, **116**, 117, 118, 134, 136
Katzman, Leonard 25
Katzman, Sam 24, 25, 30
Kaye, Danny 37
Keaton's Cop (1989 film) 237
Keel, Howard 217, 218
Keep Smilin' (1938 film) 198
Keep Watching the Skies (book) 191
Keith, Robert 164
Kellaway, Cecil 51, **198**, 207
Kelly, Grace 170
Kennedy, John F. 73, 184
Keyes, Eddie 194
Kim (1950 film) 134
King, Henry 119, 140
King Creole (1958 film) 235
King Richard and the Crusaders (1954 film) 198, 202
Kirk, Phyllis 30
The Kissing Bandit (1948 film) 63
Kitt, Eartha 114
Knight, Ted 235, 236
Knox, Elyse 5
Koch, Howard 179
Kovacs, Ernie 186
Kraft Playhouse (TV show) 52, 180
Kramer, Stanley 159, 164

L.A. Law (TV show) 144
Ladd, Alan 95, 96, 179
The Lady in Black (play) 88
Lahr, Bert 81, 217, 218
Lamas, Fernando 217, 218
Lancaster, Burt 113
Lanchester, Elsa 52
The Land Unknown (1957 film) 189
Landers, Harry 183
Landon, Michael 134
Landry, Bob 161
Lane, Rocky 18

Lanfield, Sidney 162
Lang, Fritz 40, 136
Lansbury, Angela 172
Laramie (TV show) 28
LaRoche, Mary 29
Las Vegas Sports Line (TV show) 223
The Last Time I Saw Paris (1954 show) 51, 52
Laughton, Charles 101
Laurie, Piper 39, 113
Lawford, Peter 112
LeBorg, Reginald 6, 140, 208, 217
Lee, Christopher 88
Legacy of Blood (1970 film) 59, 76
Lehar, Franz 90
Leiber, Perry 66
Leigh, Janet 152
The Lemon Drop Kid (1951 film) 159, 161
Leonard, Robert Z. 201
LeRoy, Mervyn 218
Letter from an Unknown Woman (1948 film) 61
Levathes, Peter 184
Levin, Henry 112
Levy, Jules 221
Lewis, Al 199
Lewis, Harry 15
Lewis, Jerry 15, 47, 52
Lewis, Milton 96, 161
The Life of Riley (TV show) 180
Like Water for Chocolate (1992 film) 125
Linda: My Own Story (book) 45
Lipton, Leon 199, 200, 204
Live Fast, Die Young (1958 film) 160, 170, 171
Lloyd, Harold 61
La Loba (1965 film) 123, **124**, 125, 126, **128**, 129, 131
Los Locuras de Tin Tan (1951 film) 86
Lohman, Augie 108
Lois and Clark (TV show) 144
Lombard, Carole 178
The Lone Ranger and the Lost City of Gold (1958 film) 186
The Lords of Flatbush (1974 film) 237
Loren, Sophia 10, 105, 110, **111**
The Loretta Young Show (TV show) 17, 54, 114
Lorre, Peter 45, 81–84
Lost Continent (1951 film) 108
Lost Horizon (1937 film) 5, 189, 194
Lourie, Eugene 207
Love Is a Many Splendored Thing (1955 film) 134, 140
Love Is a Weapon (1954 film) **160**

Lovecraft, H. P. 198
Lubin, Arthur 9
Lucky Penny see *Just Around the Corner*
Lugosi, Bela ix, 119, 192
Lupino, Ida 55, 172
Lux Playhouse (TV show) 27
Lux Video Theater (TV show) 27, 96

M Squad (TV show) 199
MacDonald, Jeanette 217
MacLaine, Shirley 112, 140
MacMurray, Fred 31
MacRae, Joel 63
Macumba Love (1960 film) 223, 225, 230, 231, 232, 236
The Mad Magician (1954 film) 160, 166, **167**, 173
Mad Wednesday see *The Sin of Harold Diddlebock*
Maddick, Tam 199
Magic Fire (1956 film) 41
The Magnetic Monster (1953 film) 24, **27**, 34
The Magnificent Ambersons (1942 film) 108
Mahoney, Jock 96, 97, 98, 100, 103, 134, 180, 192, 193
Main, Marjorie 217
Main Street to Broadway (1953 film) 159, 162, 163, 166
Majors, Lee 237–238
Make Haste to Live (1954 film) 159–160
Malone, Dorothy 207
Mame (play) 90
A Man Alone (1955 film) 160, 170
The Man and the Challenge (TV show) 146
The Man from Planet X (1951 film) 93, **94**, 95, 96, 97, **98**, **99**, 100, 102, 103
The Man from U.N.C.L.E. (TV show) 199
The Man in the Gray Flannel Suit (1956 film) 52
Man in the Shadow see *Violent Stranger*
Man with a Camera (TV show) 15
The Man with Icy Eyes (1971 film) 76
Mann, Anthony 200, 201
Mannix (TV show) 199
The Many Loves of Dobie Gillis (TV show) 28, 30, 34
March, Frederic 170
Maria (1971 film) 39
Mark, Michael 119
Markham (TV show) 134
Marks, Harrison *see* Harrison, Mark

Marlowe, Hugh **214**, 218, 219
Marquette, Jacques 146, 147, 148, 150, 156
Marriage-Go-Round (play) 134
Marsh, Mae 119
Marshall, George 216
Martell, Donna 133–141, **134**, **138**, **139**
Martin, Dean 15, 52, 53, 112, 184
Martin, Dewey 170
Martin, Mary 204
Martinelli, Elsa 76
Martinez, Alberto *see* Resortes
Marvin, Lee 164, 165
Marx, Zeppo 60
Mason, James 63, 145, 200
Maté, Rudolph 162
Matinee Theatre (TV show) 25, 172
Mature, Victor 74, 107
The Maverick Queen (1956 film) 160, 170
Maxwell, Elsa 81
Maxwell, Marilyn 162
Mayer, Louis B. 37, 201
Mayhoff, Eddie 15
Mayo, Virginia 202
McCleary, Al 25
McGiver, John 29, 30
McGraw, Charles 217
McGuire, Don 30
McNally, Stephen 40
McQueen, Steve 172
Me and My Girl (play) 90
Mead, Mary 199
Meadows, Audrey 154
Meadows, Jayne 154
Meadows, Joyce 143–157, **144**, **149**, **151**, **153**
Meeker, Ralph 32
Melnick, Al 81
Mendez, Fernando 86
Meredith, Burgess 179
Mérimée, Prosper 61
The Merry Widow (operetta) 90
Merry Wives of Windsor (play) 144
Mexican Hayride (1948 film) 134
Meyer, Russ 228
Meyers, Johnny 38
Middleton, Robert 170
Middleton, Wallace 134, 135
A Midsummer Night's Dream (play) 147
Milland, Ray 95, 101, 134, 160, 170
Miller, Mark 29
Million Pound Note (1955 film) 200
The Millionaire (TV show) 214
Milner, Martin 155
Minnelli, Vincente 54
Miracle on 34th Street (1947 film) 51

Miracle on 34th Street (TV show) 52
Miss Body Beautiful (1956 film) 176
Mississippi Gambler (1953 film) 39
El Misterio de la Hongos Alucinantes (1967 film) 90
Mitchell, Roberta x
Mitchell, Thomas 27, 33
Mitchum, Robert 57, 59, 63, 64, 177
Moby Dick (1956 film) 109
The Mole People (1956 film) 189–196, **190**, **193**, **195**
The Moment of Truth (1964 film) 44
Monroe, Marilyn 107, 176, 183, 184, **185**
Monsieur Beaucaire (1946 film) 176
The Monster and the Girl (1941 film) 62
Monster Beneath the Sea see *The Beast from 20,000 Fathoms*
The Monster that Challenged the World (1957 film) 105, **106**, 108, 109, 114
Montalban, Ricardo 42
Monteleone, Frank 60
Montez, Maria 8, 9
The Moon Is Blue (play) 163
Moore, Clayton 9, 186
Moore, Roger 52
Moran, Peggy 5
Moreno, Rita 233
Morgan, Dennis 207
Morison, Patricia 8
Morris, Chester 23
Morrow, Jeff 67, 69, 70
Morrow, Susan 216
Motel Vacancy see *Talking Walls*
Mr. Imperium (1951 film) 204
Mrs. Parkington (1944 film) 177
Muertos de Miedo (1957 film) 129
Mujeres Encantadoras (1957 film) 131
Mulgrew, Kate 135
The Mummy (1932 film) 5
The Mummy's Curse (1944 film) 3, 5
The Mummy's Ghost (1944 film) 3, 4, 5, 6, 11
The Mummy's Hand (1940 film) 3, 5
The Mummy's Tomb (1942 film) 3, 5
Murder at the Howard Johnson's (play) 233
Murders in the Rue Morgue (1932 film) ix
Murphy, Mary 159–173, **160**, **165**, **167**

My Friend Flicka (TV show) 53
My Friend Irma (1949 film) 95
My Little Margie (TV show) 180
My Pal Gus (1952 film) 49, 105
My Six Convicts (1952 film) 63

Nader, George 18, 19, 146
Naish, J. Carrol 8, 169, 178
Naked Love see *Macumba Love*
Nana (novel) 184
Napier, Alan 189, 191, 192
Nash, Noreen 59, 175–187, **176, 181, 185**
Nebuchadnezzar 40
Neilson, James 32
Nelson, Barry 45
Nelson, Gene 208
New Loretta Young Show (TV show) 54
New Phil Silvers Show (TV show) 54
Newman, Joseph 67, 69
Newmar, Julie 40, 238
Night Has a Thousand Eyes (1948 film) 64, 96
The Night Has Eyes (1942 film) 200
Night of the Living Dead (1968 film) 32
Ninety Day Mistress (play) 236
Noche de Terror (1987 film) 90
Norma Rae (1974 film) 101
Norman, Is That You? (play) 234
North, Jay 155
Novak, Kim 183
Novarro, Ramon **203**
Nyby, Christian 140
Nye, Bill 9

Oakland, Simon 32
O'Brian, Hugh 180
O'Curran, Charlie 235
Off Limits (1953 film) 159, 214, 216
O'Keefe, Paul 30
Olivier, Laurence 162
Omar Khayyam (1957 film) 146, 214, 218
One Hundred and One Dalmatians (1961 film) 113
One Step Beyond (TV show) 199
1,000 Years From Now see *Captive Women*
One Way Street (1950 film) 63
Ophuls, Max 61, 62, 63
O'Quinn, Terry 61
Orlak, el Infierno de Frankenstein (1960 film) 126
Ortega, Juan 90
Outer Limits (TV show) 172
Over the Hill (1931 film) 119

Packer, Doris 28
Page, Patty 235
Paget, Debra 107
Paid in Full (1951 film) 95
Paige, Robert 179
Paiva, Nestor 189, 191
Pajama Tops (play) 223, 232–234, 236
Palmer, Lilli 41
Pantano de las Animas (1956 film) 126
Parker, Eddie **190**, 192–194
Parker, Willard 152
Parla, Donna x, 59, 196
Parla, Paul x, 59, 196
Parton, Regis **68**, 69
Party Girls and the Candidate see *The Candidate*
Pasternak, Joe 63, 20
Pastorini, Dan 232, 236–238
Pat Paulsen's Half a Comedy Hour (TV show) 30
Patrick, Cynthia 189–196, **190, 195**
Patterson, Lee 72
The Patty Duke Show (TV show) 28, 29, 34
Paulsen, Pat 30
Paxton, John 165
Payne, John 74
Peck, Gregory 52
Peckinpah, Sam 172
Peggy (1951 film) 136
Perry Mason (TV show) 156, 199, 214, 238
Peter Voss, the Million Dollar Thief (1959 film) 44
Petersen, Paul 110, **111**
Petrie, Gary 32
Phantom from Space (1953 film) 175, 180, 182, 183
The Phantom of the Opera (1925 film) 66, 123
Philo Vance Returns (1947 film) 9
Pidgeon, Walter 52
Pilotos de la Muerte (1962 film) 129
Pinza, Ezio 204
Pitts, Michael 9
Pivar, Ben 6
Places in the Heart (1984 film) 101
Planeta Berg (1962 film) 7
Los Platillos Volantes (1955 film) 87
Playgirls and the Candidate see *The Candidate*
Playhouse 90 (TV show) 52, 113, 180
Please Don't Eat the Daisies (TV show) 29
Pleasence, Donald 237
Pleasure Boat (TV show) 226

Pleshette, Suzanne 32
Pollexfen, Jack 96
Pollyanna (1960 film) 113
Ponti, Carlo 10, 110
Poston, Tom 284
Potter, Luz 49
Powell, Dick 54
Powell, Eleanor 201
Powell, Jane 40
Power, Romina 39, 42
Power, Taryn 39
Power, Tyrone 35–40, 42, 43, 152
Preminger, Otto 163, 230
Presley, Elvis 112, 235
Preston, Robert 180
Price, Vincent 160, 166, **167**, 186
The Pride and the Passion (1957 film) 110
Prima, Louis 233
Prince of Foxes (1949 film) 43
The Private Lives of Adam and Eve (1960 film) 230, **231**
The Prodigal (1955 film) 47, 51
Project Moonbase (1953 film) 133, 134, **139**, 141
Provine, Dorothy 32
Psycho (1960 film) 152, 154
Pueblo de Proscritos (1955 film) 86
Purdom, Edmund 40, 41, 51, 77

Que Bravas Son las Costenas (1954 film) 124
Quinn, Anthony 112

The Rage Within (1963 film) 233
The Raid (1954 film) 59
The Raiders (1952 film) 102
Rains, Claude 64
Ramsden, Frances 61, 62
Randall, Ron 100
The Range Rider (TV show) 96, 134
Rathbone, Basil 62, 75, 171, 172
Rawhide (TV show) 156, 214
Ray, Aldo 237
Ray, Michel **48**, 53
Raymond, Gene 180
Raymond, Paula 197–212, **198, 203, 209, 211**
Raynor, Bill 183
Reagan, Ronald 140, 201
Reason, Rex **58**, 69, 70
Rebecca (1941 film) 80
The Red Shoes (ballet) 49
The Red Skelton Show (TV show) 113
The Red Stallion (1947 film) 179, 182, 184
Redford, Robert 235
Reed, Donna 52
Reed, Walter 217, 232

Reeves, Keanu 85, 90
Reeves, Steve 41
The Remarkable Mr. Pennypacker (1959 film) 112
Remington, B. F. 109
Renoir, Jean 178, 184
Renoir, Pierre Auguste 178
Resortes 87, 129
Rethberg, Elizabeth 204
Rettig, Tommy 53
Revere, Anne 82, 83
Reynolds, Debbie 15, 40
Reynolds, William 161
Richard Diamond (TV show) 156
The Rifleman (TV show) 215, 221
Riley, Jean 210
Rin Tin Tin (1924 film) 117
Ring Around the Moon (TV show) 133
Ritt, Martin 110
The Roaring Twenties (TV show) 207
Roarke, Hayden 133
Robertson, Cliff 113
Robertson, Dale 17, 134, 157, 169, 215, 216
Robin Hood (TV show) 73
Robin Hood of Monterey (1947 film) 134, 135
Robinson, Edward G. 96
Robles, German 42, 85, 87, 88
Robot Monster (1953 film) 13, **14**, **17**, 18, 19
Robothom, George 193
The Rocketeer (1991 film) 61
Rocky Jones (TV show) 133
Rodann, Ziva 230
Rodriguez, Roberto 125
Rogers, Roy 134, 135
Rogers, Will 157
Roland, Gilbert 9, 63, 134, 135
Romeo and Juliet (play) 101, 145
Romero (1989 film) 90
Rondeau, Charlie 150
Rooney, Mickey 177, 230, **231**, 236
Rosemarie (1954 film) 213, 214, 217
The Rosemary Clooney Show (TV show) 27
Rosenstein, Sophie 60
Rostova, Mira 145
Route 66 (TV show) 155
Royle, Selina 18
Rubin, Benny 179
Russell, Jane 38, 66
Rustlers on Horseback (1950 film) 18
Rusty Leads the Way (1948 film) 200
Ruvinskis, Wolf 129

Saddle Tramp (1950 film) 63
Sage, David 157
Salazar, Abel 90
Salkow, Sid 169
Salome (1953 film) 24
Samson and Delilah (1950 film) 95, 101
Sanders, Dennis 171
Sanders, George 23, 43, 202, 204
Sanders, Terry 171
Sands, Dick 175, 182
San Francisco (1936 film) 120
Santa Barbara (TV show) 144
Santa Fe Passage (1955 film) 70, 71, 74
Santo 131
The Savage (1952 film) 213, 214, 216
Savage, Ann 6
Scala, Gia 196
Schallert, William 29, 30, 102
Schary, Dory 201, 202, 204
Schneer, Charles 71
Schreiber, Avery 233
Schulman, Max 28
Schurr, Louis 177
Science Fiction Theater (TV show) 28
Scott, Randolph 214–216
Scott, Zachary 73
Sea Hunt (TV show) 155
Seaman, Jack 137
Searle, Jackie 120
The Secret Beyond the Door (1948 film) 136
Seecomb, Harry 226
Selander, Leslie 179, 217
Sellers, Peter 33, 226
The Sellout (1952 film) 205
Selznick, David O. 66
Sergeants Three (1962 film) 112
Serling, Rod 28, 183, 207
Serpent of the Nile (1953 film) 24
77 Sunset Strip (TV show) 156, 180, 199, 207, 236
Shakespeare, William 144, 157, 204, 214
Shawn, Dick 186
She Knew What She Wanted (play) 214
Shearer, Norma 81
Sheffield, Johnny 134, **138**
Sheldon, Sidney 29
Shelley, Dave 22
Shelley, Mary Wollstonecraft 115
Shore, Dinah 37
Showboat (1936 film) 120
Showdown at Abilene (1956 film) 192
Sidney, George 37
Siegel, Don 73, 74
Siegel, Lee 176, 177, 184, 186

Los Signos de Zodiaco (1962 film) 129
Simmons, Jean 77, 140, 205
The Sin of Harold Diddlebock (1947 film) 61
Sinatra, Frank 30, 31, 63, 112
Sirk, Douglas 31
Sirocco (1951 film) 216
Sitting Bull (1955 film) 160, 169
Skelton, Red 113, 114, 205
Slaves of Babylon (1953 film) 40
Slezak, Walter 234
A Slight Case of Larceny (1953 film) 105
Small, Paul 52
Smith, Alexis 177
Smith, Paul 237
Sno-Line (1984 film) 237
Snookums (short subject series) 120
Soler, Andres 124
Soler, Fernando 131
Soler, Julien 87
Solis, Javier 126, 129
Solomon, Jack 182
Solomon and Sheba (1958 film) 39, 42
Something's Got to Give (unfinished film) 184
Sondergaard, Gale 8
Sorensen, Ricky 113
Sorvino, Paul 237
Sothern, Ann 33, 81
South Pacific (play) 204
The Southerner (1945 film) 178
Space Children (1958 film) 47, **48**, 53, 54
Space Patrol (TV show) 133
Spin a Dark Web (1956 film) 72
Spreckles, Adolph 177
Stack, Robert 217
Stacy, James 32
Stanislavsky, Konstantin 13, 145
Stanton, Helene 30
Stanwyck, Barbara 31, 63, 170
Star Trek (TV show) 147
Star Trek: Voyager (TV show) 135
Stark, Ray 227
Starrett, Charles 200
State of Seige see *L'Amore Breve*
Steele, Tommy 226
Stevens, George 176, 184, 186
Stewart, Larry 24
Stewart, Paul 199
The Sting (1972 film) 33
Stone, Milburn 216
Storm, Gale 23, 180
Storm Over Wyoming (1949 film) 180
Strange Intruder (1956 film) 105, 107
Stratton, Gil 15

The Story of Will Rogers (1952 film) 95, 96
Storybook Theater (TV show) 200
Streep, Meryl 157
Stritch, Elaine 234
Struthers, Sally 233
Studio 57 (TV show) 28
Sturges, Preston 61–63
El Superflaco (1957) 87
Swanson, Gloria 146
Sybil (1976 TV miniseries) 101
Sydney, Sylvia 234

Talking Walls (1983 film) 237
Tallman, Bill 156
Talmadge, Richard 134, 137
Tarzan and the Mermaids (1947 film) 35, 45
Tate, Dale 147
Taylor, Elizabeth 43, 52, 54, 125, 176, 186
Taylor, Joan 213–222, **214, 220, 221**
Taylor, Mary 83
Taylor, Robert 44, 81, 200, 201
Taylor, Rod 43, 176
Temple, Shirley 81, 213
Temple Houston (TV show) 210
The Ten Commandments (1956 film) 105, 107
Ten Wanted Men (1955 film) 134, 137
The Tender Years (1948 film) 180
Terror Is a Man (1959 film) 234
Texas Carnival (1951 film) 205
That's My Boy (TV show) 15
Them (1954 film) 47, **50,** 51
There's Always Tomorrow (1956 film) 31
There's No Business Like Show Business (1954 film) 107
These Three (1936) 120
Thirty Seconds Over Tokyo (1944 film) 177, 179
This Is My Love (1954 film) 57
This Island Earth (1955 film) 57, **58,** 60, 66, 67, **68,** 69, 71
Thomas, Danny 107
Thompson, Carlos 41
Thompson, J. W. 26
The Three Faces of Eve (1957 film) 109
Three Ring Circus (1954 film) 47, 52
3,000 A.D. see *Captive Women*
Thunder in the Sun (1959 film) 228
Thunderstorm (1956 film) 41
Thyssen, Greta 234
Time Slip see *The Atomic Man*
Tin Tan 86, 87, 125, 129
To the Actor (book) 145

Tobey, Kenneth 71, 207
Toby Tyler (1960) 113
The Today Show (TV show) 227
Todd, Michael 140
Tonge, Philip 31
Tonight and Every Night (1945 film) 226
The Tonight Show (TV show) 23
Too Hot to Trot see *L'Amore Breve*
Too Late Blues (1962 film) 235
Too Young to Know (1945 film) 9
Toren, Marta 63
Torrianni, Amy 145
Tors, Ivan 146, 154, 155
Totter, Audrey 154
Tovarich (play) 61
Track of Thunder (1967 film) 59
Tracy, Spencer 198
Tropicana (1956 film) 90
Tucker, Phil 18, 19
Tugboat Annie (1933 film) 120
Turner, Lana 9, 37, 51, 54, 204, 217
Tutankamen 3
Twain, Mark 200
20th Century–Fox Hour (TV show) 52
20 Million Miles to Earth (1957 film) 213, 219, **221,** 222
Twilight on the Rio Grande (1947 film) 139
The Twilight Zone (TV show) 28, 183, 208
Twist All Night (1961 film) 233
Two Before Zero (1962 film) 171
Two Latinos from Manhattan (1942 film) 6
Two Senoritas from Chicago (1943 film) 5

Ulmer, Edgar G. 93, 95, 97
Una Sull' Altra (1970 film) 59, 76
The Untouchables (TV show) 199
Up in Arms (1944 film) 37

Valdes, German see Tin Tan
Valentino, Rudolph 213
El Vampiro (1957 film) 42, 88
Van Doren, Mamie 230, 235
Vasectomy (1985 film) 237
Veidt, Conrad 81
Vendetta (1950 film) 57, 59, 60, 61, 63, 64, 66, 73, 77
Verona, Stephen 237
Un Viaje a la Luna (1957 film) 125
Vinton, Bobby 30
Violent Stranger (1957 film) 73
The V.I.P.s (1963 film) 43
The Virginian (TV show) 96, 172
Vogel, Virgil 189, 192

Voodoo Tiger (1952 film) 24, **26**
Voyage to the Prehistoric Planet (1965 film) 59, 74

Wagon Train (TV show) 96, 156, 172
Wake Me When It's Over (1960 film) 186
A Walk in the Clouds (1994 film) 85, 90
Walker, Clint 28
Wall of Noise (1962 film) 32
Walk Tall (1960 film) 152
Wally's Café (play) 233
War Drums (1957 film) 214, 216, 217
War of the Worlds (1953 film) 133
War Paint (1953 film) 214, 216, 217
Ward, Burt 236
Warner, Jack 205
Warren, Bill 191
Washburn, Beverly 54
Washburn, Johnny 53
Wayne, David 200
Webb, Clifton 112
Webling, Peggy 115
Weed (1974 film) 236, 237
Weissmuller, Johnny 21, 24, **26,** 30, 38
Welch, Raquel 32
Welcome Stranger (1948 film) 95
Weld, Tuesday 28
Welles, Orson 23, 43, 73, 108, 183
Wellman, Bill, Jr. 230
Wells Fargo (TV show) 17, 134, 156, 157
We're Not Married (1952 film) 180
Welter, Ariadne 35, 42
West, Adam 236
Westmore, Bud 69
Whale, James 117, 118
When Worlds Collide (1951 film) 133, 162
Where Danger Lives (1950 film) 57, 59, 63, 64, **65,** 66
Where Does It Hurt? (1972 film) 33
Whirlybirds (TV show) 114
A White Rose for Julie see *Where Danger Lives*
Whitmore, James **50**
A Wicked Woman (1934 film) 120
Widmark, Richard 49
Wild Girl (1932 film) 120
The Wild One (1953 film) 159, 163, 164, **165,** 166
Wilde, Cornel 146

Wilder, Billy 183
Wilder, Lee 183
Wilder, Myles 183
Wilke, Robert 217
Wilkinson, June 223–238, **224,
229, 231**
Williams, Edy 230
Williams, Esther 201
Williams, Kay 177, 178
Wilson, Henry 60
Witney, William 71
Wolff, Frank 76

Wood, Natalie 180
Woods, Ilene 85
Woods, James 238
Woodward, Joanne 109
Wright, Farnsworth 198, 207
Wyler, William 112, 120, 162,
170
Wynn, Ed 17, 236
Wynn, Keenan 30

Yancy Derringer (TV show) 180
Young, Loretta 54, 114

Young Widow (1946 film) 61
Yukon Manhunt (1951 film) 95

Zadora, Pia 234
Zanuck, Darryl F. 39, 183
Zebra in the Kitchen (1965 film)
154
Ziegfeld Follies (1949 film) 177
Zimbalist, Al 18
Zola, Emile 184
Zucco, George 38
Zugsmith, Albert 230